In his highly original study, David Wyatt takes a broad yet personal look at the cultural legacy of the sixties through ten creative figures who came of age during the Vietnam War. Wyatt argues that it is each artist's "personal engagement" with his or her own era that binds together the achievements of storytellers such as filmmaker George Lucas; songwriter Bruce Springsteen; playwright Sam Shepard; journalist Michael Herr; writers Ann Beattie, Alice Walker, Ethan Mordden, and Sue Miller; and poets Gregory Orr and Louise Glück.

For some their work is marked by the war and concerned directly with it; for others, Vietnam embodies the tension between history and the personal that shapes the form of story. Out of the experience new voices emerge – from Michael Herr's landmark invention of a new journalistic voice in his war reporting, to Bruce Springsteen's musical narratives about the working-class decline in postwar America. The thread that ties the various genres and visions together, as well as Wyatt's own critical aesthetic, is the centrality of the personal response and the seamlessness, therefore, of identity and history.

Out of the Sixties

CAMBRIDGE STUDIES IN AMERICAN LITERATURE
AND CULTURE

EDITOR: ERIC SUNDQUIST, *Vanderbilt University*

ADVISORY BOARD

NINA BAYM, *University of Illinois, Champaign–Urbana*
SACVAN BERCOVITCH, *Harvard University*
ALBERT GELPI, *Stanford University*
MYRA JEHLEN, *University of Pennsylvania*
CAROLYN PORTER, *University of California, Berkeley*
ROBERT STEPTO, *Yale University*
TONY TANNER, *King's College, Cambridge University*

Continued on pages following the index

D'YOUVILLE COLLEGE
LIBRARY

Out of the Sixties
Storytelling and the Vietnam Generation

DAVID WYATT

University of Maryland, College Park

CAMBRIDGE
UNIVERSITY PRESS

Published by the Press Syndicate of the University of Cambridge
The Pitt Building, Trumpington Street, Cambridge CB2 1RP
40 West 20th Street, New York, NY 10011-4211, USA
10 Stamford Road, Oakleigh, Melbourne 3166, Australia

© Cambridge University Press 1993

First published 1993

Printed in the United States of America

Library of Congress Cataloging-in-Publication Data
Wyatt, David, 1948–
Out of the sixties : storytelling and the Vietnam generation /
David Wyatt.
p. cm. – (Cambridge studies in American literature and
culture : 66)
Includes index.
ISBN 0-521-44151-X. – ISBN 0-521-44689-9 (pbk.)
1. United States – Civilization – 1945– 2. Arts, American.
3. Arts, Modern – 20th century – United States. 4. Vietnamese
Conflict, 1961–1975 – Influence. I. Title. II. Series.
E 169.12.W88 1993
973.92 – dc20 93-18179
 CIP

A catalog record for this book is available from the British Library.

ISBN 0-521-44151-X hardback
ISBN 0-521-44689-9 paperback

E 169.12
.W88
1993

JAN 1 4 1994

FOR ANN

Contents

Acknowledgments

This book is dedicated to Ann Porotti, who lived it with me.

Five friends kept me going. Al Filreis brought into focus my early thinking about decades and generations. Bob Schultz provided the term *scatter* and gave what I showed him the benefit of his generous attention. Don Sheehy helped reshape my Introduction and Conclusion. David Van Leer supplied not only an invaluable reader's report but also the gist of my title. As the book took final shape, Howard Norman read and reread with exemplary care.

Individual chapters found their own sponsors. Bob Kellogg gave the "Star Wars" pages their first critique. Ernie Gilman invited me to NYU to talk them through in public. Martha Smith helped me to keep faith with Springsteen and got me the tickets that let me see him in the flesh. Sam Shepard proved a hard man to track down, but Mike Plunkett kept at it and secured access to the papers on deposit at the University of Virginia. Permission to quote from the Sam Shepard Papers is gratefully acknowledged. A trip to UCLA at Martha Banta's invitation allowed me to present my thoughts about Shepard in an exacting forum. Frank Lentricchia encouraged me to improve these thoughts into an article. About the relation between Ann Beattie's life and art, Jean Dunbar gave me sound advice. Dave Smith was an imaginative editor of the article these speculations produced. The questions Linda Kauffman asked me about the Sue Miller manuscript gave it a keener edge, and a letter from Susan Albertine about *The Good Mother* made me sharpen my critique. A casual aside by Mary Helen Washington gave me the confidence, in my section on Alice Walker, to enlarge a hunch into a thesis. Gregory Orr shared his work-in-progress and supplied the manuscripts that allowed me to tell the inside story. The graduate students at the University of Maryland who worked with me in a course on the generation of the sixties deserve credit for helping me to edit my book into a shape more consistent with its argument.

Four journals and their editors published pieces of this book. My thanks to Staige Blackford at *The Virginia Quarterly Review*, Mark Rudman at *Pequod*, Dave Smith at *The Southern Review*, and Jody McAuliff at *The South Atlantic Quarterly*. Permission to quote from "Star Wars and the Productions of Time," "Gregory Orr: Falling and Returning," "Ann Beattie," and "Shepard's Split" is here gratefully acknowledged. I also thank the University of Maryland for a GRB summer grant in support of this project.

At Cambridge University Press I was ably assisted by the peerless copy editing of Eric Newman, the enthusiasm of Andrew Brown, the editorial help of Clare Payton, Julie Greenblatt's knowledge of the ropes, and the continuing friendship of Eric Sundquist.

Final acknowledgment goes to the members of the Pacific High School class of 1966, who gave me their confidence when I was a boy and who, twenty-five years later, asked me to say the few words that made me realize what can be remembered and what should be forgotten.

Introduction: the form of story

In the wake of Desert Storm, there has been talk of "erasing" America's experience of Vietnam. I can think of no erasure that would do more harm to our national psyche. The election of Bill Clinton while this book was in production argues that the nation has chosen to proceed through rather than around the memory of its defeats. If Vietnam is the wound, the looming mistake and defeat of this half-century, it is also a great and terrible resource – not just a reminder of our pride and our fallenness, but the defining thing, *our* war, *our* story. People – and presumably nations – draw strength from feeling their hurts. "You never let the early hurt be felt and so / it governs you." So writes one of my generation's strongest poets, Gregory Orr. The poet picks the right word; memory is the foundation of government, both personal and political. Orr reminds us that the repressed will return, and that what we seek to erase rather than confront and feel will surely come to govern us.

Vietnam is the iceberg, a mostly submerged history that cruises through our dreams. As Hemingway said, "the dignity of movement of an ice-berg is due to only one-eighth of it being above water." Writing for Hemingway meant, as it means for many of the writers of my generation, keeping the iceberg in mind. Not by direct allusion to it – there are few references to the war in the careers I explore in this book – but by keeping oneself open to the many pressures of history, and to their specific burdens of loss.

I live in Washington, D.C., and the Vietnam Veterans Memorial is my favorite public spot. It seems to be everyone else's too, the city's most visited monument. We have only begun to remember that story, and the site discreetly accommodates our need. The monument brilliantly fuses form and content; it entails a story, and a way of reading it. The black marble gash in the ground is at once a mirror and a common grave; you must walk down, below the level of the grass, to see it all, and when you do, the polished stone walls give back a reflection of your face. Carved

I

into the wall are nearly 58,000 names. If you stand with your back to the base of the *V* and look outward, the left wing points to the Washington Monument; the right, to the Lincoln Memorial. The founding and the second founding; the Vietnam Memorial offers a direct and somber prospect onto the nation's other and not quite finished civil wars. It is one of the few places in the United States where history and the personal are allowed to intersect without cant or grandeur. It is a place where anyone can enter, physically and symbolically, into what Robert Penn Warren calls "the awful responsibility of Time."

Standing there, in a spot entirely submerged and yet full of prospect, I imagine a standpoint from which to tell a generation's story. I am forty-three years old, and hence a member of what has been called the Vietnam generation. We were born in the 1940s, between Pearl Harbor and Ike's election. We now find ourselves in our forties, facing middle age. What have we done with our lives? How have we marked and been marked by our time? These are the questions I set out to answer about six years ago. My very limited response was to begin a book. I knew it would be a book of literary criticism – I teach English for a living – a book about people working with words. I initially gave it the title *America and the Fall from Grace: The Literary Generation of the 1960s*. I did not intend to write a history of the decade of the sixties but rather a first reckoning of the work now being done – "now" means during the seventies and the eighties – by people who lived through the sixties in their youth. Before settling on my list of writers, it seemed important to define my central term. What is a literary generation? What are the forces that shape it? I came up with six causes or determinants, and I began with Vietnam.

The Traumatic Event: Generations are forged, it can be argued, by the impact of a traumatic historical incident or episode. The event creates the sense of a rupture in time and gathers those who confront it into a shared sense of ordeal. Ground troops were committed to Vietnam in 1965, so anyone born before 1939 (the draft age ran up to twenty-six) was able to avoid induction during the war. Troops were withdrawn by 1972, so anyone born after 1953 (the lower limit for eligibility was nineteen) was unlikely to see combat. In actual fact, men at either end of this spectrum were rarely compelled into direct engagement with the war, so for the sake of accuracy as well as symmetry, I have contracted the defining dates to include those born between 1940 and 1950. That young women were not eligible for the draft did not exclude them from sharing the moral and emotional dilemmas faced by brothers, friends, husbands, lovers.

Mentors: Generations are given impetus and voice by the work of salient elders. These are not the fathers or mothers but the dissenters – what Fitzgerald calls the "madmen and outlaws of the generation before." The group stands in an adversarial relation to the dominant culture and acts out a sporadic and uncoordinated rebellion. The Beats would certainly qualify as such a group (the first reading of "Howl" occurred in 1955), but the group could be expanded to include those who dominated the media and literary culture of the sixties: Mailer, Goodman, Leary, Ginsberg, Spock, Coffin, Steinem, King, Malcolm X, McCarthy, and many others.

Demography: Generations are forged by dramatic shifts in population patterns. The shifts affect not only educational and economic opportunities but make the generation a critical mass within the larger culture. The English generation of the twenties lost a million men and so almost ceased to exist; those who found a voice instead were the precocious young, the Auden generation. The generation of the sixties overlaps with the baby boom (the U.S. birth rate peaked in 1957; SAT scores, in 1963) and thus constitutes the cutting edge of the largest set of citizens born within a ten-year period in American history. The sheer size of the generation has compelled the culture to center its identity in the generation's changing fantasies and goals.

The Privileged Interval: Generations are forged not only by the events of a core decade but also by the conditions that bracket this privileged interval. The lost generation was weaned in the Progressive Era and fell into the Depression; buoyancy was followed by economic loss. A similar pattern holds for the sixties generation: Raised in the affluent society (GNP rose at an annual rate of 3.9 percent between 1947 and 1967; growth slowed to a rate of 2.9 percent from 1967 to 1979), survivors of the sixties became working adults in the seventies with its oil embargoes, inflation, and general contraction of economic mobility. Sheer force of numbers made particularly acute the theme of what Frost would call "the trial by market" – there was no room at the inn.

Sacred Places: Generations prosper through the enabling power of specific geographic locales. For the writers of the twenties, these were Greenwich Village and Paris – even the possibility of Europe as a whole. Had the sixties ended in 1965, the place of trial would have been the American South. The civil rights movement was an intimate struggle that brought a few people to a limited area: Selma and Montgomery were the places to be. But as the decade unfolded to touch a group far larger than could be gathered in a specific location – although Woodstock tried – the

common space for active participation shifted to the one most held in common: the university.

The Happy Few: Generations are formed through the work of people who know and support one another. Such a model holds for the first and second generation of the English romantics, even for the writers of the twenties. It may depend upon the possibility of a literary capital. The generation of the sixties was not a happy few; there were too many of us for that. We could not lay claim to a mystique of intimacy. But we were a generation in a self-conscious sense, aware, largely through the media, of being engaged in a common effort, or, if on different sides of a fence, of at least having to respond to a common test.

These, then, were my initial notions about the forces that might have shaped the generation of the sixties and set it apart. But I am not a historian or a sociologist – I am a literary critic – and I soon saw that the kind of evidence I was amassing had more to do, to adopt Wallace Stevens's phrase, with the violence from within words than the violence from without. All the time I was working on my list of causes, I was working up my list of writers. I felt much better about this second list, more at home with specific literary careers than with broad deterministic categories. Something was missing from the deductive approach to history, the question, as Joan Didion puts it, of *"how it felt to me."* I wanted to write from the position of a personal standpoint, and so I turned back to my list of writers and trusted them to reveal the generation as each told a particular story.

Didion's work provided a useful model. Though not a member of the generation, she was an essential forerunner who dedicated herself, in her stance and in her style, to forecasting the conditions in which we would work and live. At the end of the sixties, as she tells us in *Slouching Towards Bethlehem* (1968), Didion decided to marry and settle down. She was tired. Keeping up with the scene had left her nerves frayed. She had found America, and it was scatter. But the real strain was from thinking too hard about it, from trying to have a view or position or theory about the parts and the whole. Her book itself refuses to impose any totalizing form: It is fragments shored against ruin. In it she details the sickness of the body politic, and the diagnosis – and the felt responsibility to make one – proves exhausting. The reach out gets answered by the pull back; like Nick Carraway, she moves east only to return west. She temporarily opts for limited terrain. Writing in *The White Album* (1979) about ten years later, Didion argues that after the turmoil and commitments of youth "the personal was all that most of us expected to find."

This should not surprise us, as the key phrase in these books is *"how it felt to me."* Above all, Didion wants to argue from and for character. And character is defined as "the willingness to accept responsibility for one's own life." Responsibility points outward, back toward the burdens of culture and history from which Didion feels so often tempted to withdraw. Definitions of character and responsibility would be useless were Didion not continually providing the credentials that underwrite them. "If the ability to think for one's self depends upon one's mastery of the language," then Didion is burdened with almost too much character. It is an excess of style, of the unique turn her words give to what she takes in:

Here is a story that is going around the desert tonight: over across the Nevada Line, sheriff's deputies are diving in some underground pools, trying to retrieve a couple of bodies known to be in the hole. The widow of one of the drowned boys is over there; she is eighteen and pregnant, and is said not to leave the hole. The divers go down and come up, and she just stands there and stares into the water. They have been diving for ten days but have found no bottom to the cave, no bodies and no trace of them, only the black 90° water going down and down and down, and a single translucent fish, not classified. The story tonight is that one of the divers has been hauled up incoherent, out of his head, shouting – until they got him out of there so that the widow could not hear – about water that got hotter instead of cooler as he went down, about light flickering through water, about magma, about underground nuclear testing.

In the middle of her essay "On Morality," Didion delivers this story. It has plenty of interesting and even contradictory morals; one she does not draw is the difficulty of getting to the bottom of things. She here shows how her mind veers inflexibly toward the particular, and that minds should. Because it is in the rhythms, tones, and tropes of a personal voice that a vision of the conduct of life can powerfully and responsibly be argued, as it is here in the seductively casual offer ("Here is a story"), the awkward repetition of sentence endings ("hole . . . hole") to emphasize the difficulty of moving from the spot, the pathos in the contrast between the motions of rescue (going down and coming up) and the widow's still and fatal witness (just standing), the persistence of surprise even in catastrophe (the unclassifiable fish), the final delivery of a revelation achieved through the suspenseful dashes of an irony (the cold is really hot) that opens onto the invasion of the personal by the political in the country in which we live.

"We would survive outside history," Didion says with some irony about her expectations as a student at Berkeley in the fifties. History will come and find her, nevertheless, as the diver in "On Morality" discovers, and as books like *Salvador* (1983) and *Miami* (1988) have shown. Despite her chronic worldweariness, Didion insists after all in telling the story of the world. But "straight history," as Michael Herr calls it in *Dispatches* (1977), doesn't begin to tell the story of our wars. "Straight history, auto-revised history, history without handles, for all the books and articles and white papers, all the talk and the miles of film, something wasn't answered, it wasn't even asked. We were backgrounded, deep, but when the background started sliding forward not a single life was saved by the information." What is needed – and what his generation has produced – are a series of personal dispatches, testimonies that acquire their general truth through their singular beauty. As Norman Mailer said in the mid-sixties, "Form is the record of a war." The generation has fought many wars – against the charm of Nostalgia, the lust for Celebrity, the illusions of Family Romance, the guilt of Survival. The contest over these cultural themes is the subject of my book. From a study of the forms of the stories left us, a generational history can be reasoned back.

"Here is a story," Didion writes. This is what I offer as well. The stories I retell in this book are those by my contemporaries that have mattered to me most in the construction of my own. The ten have also been chosen by me because each exemplifies a cultural theme while also achieving "a certain intensity of artistic performance" that Raymond Chandler claimed to be the only thing worthy of the name of art. Because this is my study of tradition and the individual talent, I have also tried to set my figures for comparison among the writers of the past. These ten enter the ongoing conversation by refiguring past genres, voices, concerns. They forward literary history because they remember it.

If, as Stanley Plumly has said, writing in our time must be personal but not private, it can be useful in some public way only if it refuses to become lost, as so many of Didion's characters do, in someone else's story. Story is the act that mediates between Didion's two terms, between "history" and the "personal." As the sign of self, story gestures toward the unclassifiable, the original, the underdetermined. As a function of discourse, story registers the limiting powers of culture and convention. Personal style and historical fate vie for primacy in the strongest of our contemporary careers, and the tension between the two kinds of discipline issues in art, "the figure of the will," as Frost writes, "braving alien entanglements."

The forms of engagement pursued by the artists in this book have radical consequences for life in the United States, especially as it is lived in

the family. Each of my chapters recurs to a critique of this most resilient of our social forms. This is perhaps my most specific and time-bound conclusion: that for the generation of the sixties, the family proves an "instrument of grief" at once spurned and craved. As the site where socialization and privacy intersect, the family remains a living lesson in the tensions between history and the personal. Along with story, family is the generation's major metaphor for form; however ambivalent the attitudes toward its tensions, they cannot be wished away. These artists patrol the borderline between the personal and the historical and would therefore reject this definition of happiness:

> Happiness is not based on oneself, it does not consist of a small house, of taking and getting. Happiness is taking part in the struggle, where there is no borderline between one's personal world, and the world in general.

The speaker is the man who blew away the fifties. If generations can have anti-heroes, Lee Harvey Oswald is one both because of what he did and what he thought. He thought that it was better to confuse history and the personal, and so what he had left to shoot and die with was a human cipher, a self so thoroughly identified with its projections and emptied of any individual character that his story repels analysis, comprehension, judgment. He is the prototypical case of false surrender. He surrenders, as Don DeLillo has so powerfully shown, to the life of his time and so strikes his comically Faustian bargain – a page in history in exchange for his story, media fame in place of more little life. The people described in the pages that follow all survive well within history, but they also resist the dominant and violently inarticulate contemporary discourse and convert that resistance into the form of story.

NOSTALGIA

George Lucas

Bruce Springsteen

Vineland (1990) appeared at the end of the eighties to argue that the best hope for the nineties was that they might repeat the sixties. Pynchon published the novel after a seventeen-year gap apparently filled with longing for those "mythical days of high drama." After the "gilded age" comes the "Nixonian Repression," and then an even greater one. "The personnel changed, the Repression went on, growing wider, deeper, and less visible, regardless of the names in power." Pynchon's characters have mostly sold out, but he musters little anger against them. Written in "the grip of a merciless nostalgia," *Vineland* prizes its rage against those who have ended the party and the resulting tenor of loss. It is as if one of the most capacious minds of its generation had become stuck on a decade, arrested in time.

But Pynchon is smarter than that. Throughout *Vineland* he undercuts the tone of his nostalgia through the logic of his story. As Edward Mendelson has shown, the novel advances an "historical myth" highly critical of the intentions and actions of the forever young. It is the story of a Leda who collaborates with her Swan: Radical Frenesi Gates chooses to be swept up by FBI agent Brock Vond. The result is a movement betrayed, an establishment corrupted, a daughter abandoned. The "actions of both serve mostly to dramatize a single historical and political idea, the idea that the conflict in the 1960s between the radicals and the authorities concealed their shameful longings for each other." Like Gatsby, the players on both sides have sought a revenge against time. "In *Vineland*," Mendelson continues, "the whole culture of the 1970s and 1980s is the fruit of desires felt in the 1960s for an eternity without change – for a permanent historical love-death like the endless union sought by Tristan and Isolde." And, as in *Gatsby,* the power of tone to disarm the logic of story tests and misleads the reader, seducing him toward a nostalgia that the moral outcomes of the novel reveal as this world's single most destructive force. The accuracy of Pynchon's analysis can be questioned, but we are in his debt for the prevailing spirit of critique.

In the years during which Pynchon studied our longing, others had stepped in to fill his place. DeLillo perfected the novel of paranoia, and in forms more economical and as deeply felt. Wolfe warmed his feet at the bonfire of the vanities and wrote the book that *Vineland* sometimes struggled to be, an exposé of how a culture of relentless regulation and commodification reduces characters to types. Beattie caught the peculiar dynamic in which consumers become possessed by their things. And the nostalgia merchants worked overtime, giving us back an image of an age when desire once found its object, anger its righteous path. Pynchon's analysis of "the big Nostalgia Wave" is acute and shows how often we remain in thrall to what we analyze. *Vineland* reveals nostalgia as a habit

of mind to which we have become deeply addicted, a function, perhaps of living, as we can so easily think we do, at the edge and end of time.

The metaphor of the wave points to the recurring seduction of an emotion that characterizes modernism and the cultures that follow it – the conviction that something whole and better is over. The myth of cultural decline is so deeply embedded in our century that even the most heroic of modernists – the Stevens who gleefully watches the gods go over the horizon in "Two or Three Ideas" – still images his sense of what remains as an act of salvage, of man left on the dump. Nostalgia is the very token of modernism, and its descendant modes. In America the sixties put this emotion to a special test, because they promised a relief from it. No longer did it seem necessary to remember or repeat – so one could believe. It was a case of feeling as if we had power in relation to our world. Nowhere was this belief given greater rein than in the "popular" culture of movies and music. Could the modes that created the common language of that time survive, without nostalgia, the passing of it? Can we not, to repeat Emerson's question, enjoy an original relation to the universe? It came down to the old question of a revenge against time – for George Lucas (b. 1944) and Bruce Springsteen (b. 1949), to whether they were to master repetition, or, by looking away, to be mastered by it. In their romance with regression we can measure a generation's capacity for belief in the adequacy of what it has made, and for its commitment to an art that is more than a passing, an already warmly remembered thing.

GEORGE LUCAS

Looking away

"I'm always thinking about what's going to happen or what has happened." George Lucas's strength as a storyteller and filmmaker flows from his yearning for another moment in time. His work vibrates with the pressure of memory and hope. "All his life," as Yoda says of Luke, "has he looked away." Missing from his movies is a felt engagement with a sense of the present. In *American Graffiti* (1973) the young are prematurely old with regret; John Milner introduces himself by complaining that "the whole strip is shrinking" and voices the movie's insistent refrain: "It was really something." The characters do not so much enjoy their last night together as they remember or anticipate better ones. Awareness of this yearning is the special gift these movies confer, one the viewer is asked to acknowledge with regret. Unhappily, this awareness hardens into habit after the first two "Star Wars" movies. Since *Return of the Jedi* (1983), Lucas has affirmed the virtues rather than the limits of nostalgia. This brilliant career displays perhaps its generation's most principled refusal of the option we call growth.

Perhaps the reluctance to go or grow was implicit from the beginning. "It doesn't make any sense to leave home to look for home." Laurie says this to Steve on the night before he plans to leave for a new life in the East. It turns out she is quoting her brother Curt. Steve balks at the claim but will eventually buy it, while Curt will reject it and leave. The saying thus belongs wholeheartedly to no one: It originates with one character, gets uttered by a second, and is lived out by a third. The voice that speaks it is the voice of the movie, of the man who as he jotted notes for the script asked his essential question: "Why can't things stay the way they are?"

If the characters in *American Graffiti* are asked by their situation to front the future, anticipation proves no match for the lure of recall. Looking back emerges as *the* anticipatory response. "You don't remember anything" is Laurie's harshest charge. "Something to remember you by" is what the characters ask for and sometimes get. When Curt imagines a future, it is one appropriated by the past: "We are going to remember all of the good times." He later tries the combination of his old locker and can't get in; the image tells us that he has already begun to forget. But the scene was Richard Dreyfuss's idea, not Lucas's, and it points to Curt as the index of a theme at odds with the texture of the movie. For the viewer the overwhelming experience here is of remembered sound. The audience replicates the anticipatory nostalgia of the characters when

it recognizes one of the movie's forty-three popular songs. Once-heard sound becomes our primary avenue of sensory experience, and Lucas treats the music reverently, as a rich resource of cultural recognition and solidarity. The movie cannot work for people ignorant of this music; not to have one's memory triggered by "Maybe Baby" or "Runaway" is to be excluded from the magic circle of participants belonging to this generation's midsummer night's dream. John Milner's comment about music going downhill "since Buddy Holly" died makes the key point: Popular culture is a culture of instant nostalgia, one that generates its sense of tradition out of a planned obsolescence in which Top Forty hits pass from the charts only to be reconsumed as "oldies but goodies."

American Graffiti creates the visual equivalent of nostalgia in its use of lighting and montage. Lucas wanted the movie to have "the ugly neon look of a garish juke box." Haskell Wexler supplied it by taping the soft glow of RV lights to the inside of each car roof. Vehicles with jacked-up truck headlights cruised along outside to provide "the illusion of passing lights on the actors' faces." We move constantly in and out of cars and of darkness, suspended in the light of half-remembered things. The action does not build but glides from locale to locale, always eddying back through the strip and the drive-in. This combination of randomness and repetition gives the movie a dreamlike continuity; it has the logic of its lacunae. The sudden cutting between scenes is all gathered into the unity of time, place, and action possible on a single California night. "George makes his visuals come to life with montage," Steven Spielberg has said. "That makes him unique in our generation, since most of us do it instead with composition and camera placement." Montage here is the nostalgia of editing; shots end before we are ready to see them go. Here the connection between moments matters more than the content within them; it's a movie about kids learning how to replay and edit their lives.

American Graffiti was a movie worth doing once; its power comes from the rendering of a moment that cannot be prolonged or recaptured. (The 1979 sequel *More American Graffiti* foundered in part because the future had been foreclosed by the title cards at the end of the first movie.) You cannot remake a movie about the launching of a career. Curt is clearly the Lucas figure, the boy who overcomes his longing for home and leaves Modesto for the East – a.k.a. USC. Curt seeks out the Wolfman, discovers the limits of authority, surrenders the fantasy of home-grown success. Steve stays and dies into the life of an insurance agent. The fates of the four girls remain unknown; Lucas will maintain a wary commitment to his female characters. Like the next three movies he will make, *American Graffiti* can be taken as a parable of Lucas's growth as an artist. It is an auspicious beginning, a sensuous fantasy of nostalgia indulged, confronted, overcome. But its unqualified love for its materi-

als – the cars, the songs, the streets – sends a disturbing signal. The world being left behind affords the only perspective on the larger world. The movie argues that we should abandon what it has made irresistible. Lucas's head may belong to Curt, but his heart, it turns out, will belong to Steve.

The epic of return

Epics take time. As originally conceived, the "Star Wars" saga would have taken about as long to produce as its core action takes to happen. The nine episodes were timed to emerge over a period of about thirty years. The movie's technological complexity here serves its larger epic intentions, which must work themselves out through a palpable sense of elapsed duration. A sequence of widely spaced chords is crucial to the experience of an epic. Epics are long stories that return upon themselves, stories that continually predict and echo their emerging shape. In *Paradise Lost* the Fall keeps happening over and over, and the effect of this, when the actual "Fall" occurs, is that we experience it as an earned legacy, a consequence of our humanness that the poem repeatedly asks us to act out. These frequently spaced falls convey a sense not only of inevitability but of the beneficence of time itself, of the mercy of the medium through which we are able to recognize patterns and so move from innocence to knowledge. In its extended and repetitive structure, the epic makes one of poetry's best arguments for the redemptive possibilities of life in a temporal world.

The central epic of our culture – the Bible – tells a story of falling, wandering, returning. The pattern is a psychological and a cultural one: As Adam strays from, loses, and then returns to his best self, so the children of Israel betray, abandon, and eventually reunite with their God. It is an epic of return. In the epic of tragic fall – in the *Iliad* – the plot traces a parabola instead of closing a circle. Epics of return set out to undo loss, and they take their impulse from the refrain word in the *Odyssey: nostoi*, nostalgia, longing for home. Plot here complements the repetitiveness of structure. Both return upon themselves to confirm our belief that order and recovery are possible in human life.

In 1980 Lucas had just finished producing *The Empire Strikes Back*. When asked how many "Star Wars" films he still wanted to make, he answered, "Seven left." Three of the nine are now complete, and it is unclear whether more will be produced. My analysis treats the proposed as well as the actual shape of the whole. It also considers the first two films as an integrated story, with *Return of the Jedi* as a disappointing, even incoherent, epilogue. Before the completion of *Jedi*, Lucas's epic plan, still intact, promised a cycle of three generations. Darth Vader –

Luke Skywalker – "another": This was one probable line of descent. Fulfilling such a pattern would echo Homer's epic of homecoming. The *Odyssey* ends with Laertes, Odysseus, and Telemachus, after many wanderings, standing together defiantly in league. When Laertes says

> Ah, what a day for me, dear gods!
> To see my son and grandson vie in courage!

we feel that not only a poem but also a human cycle is complete. What we see in this moment is an ingathering of the familial circle, a recovery of the far-flung. It has been said that the working unit of human time runs from the youth of the grandfather to that youth as remembered in the mind of the mature grandson. The epic of return confirms such an interval as the one in which urgently memorable history occurs.

The unfolding generational pattern in "Star Wars" predicts that the full story begins with the youth of Darth Vader and Obi-Wan Kenobi and ends with the coming to maturity of the as yet unborn child. "Star Wars" offers itself as a *tessera,* a deliberate fragment designed to lead us on. The promised whole looks something like this:

I			
II	}	Fall of the Republic and the rise of the Empire	
III			
IV	*A New Hope*		
V	*The Empire Strikes Back*	}	Skywalker
VI	*Return of the Jedi*		
VII			
VIII	}	Rebuilding of the Republic	
IX			

The imagined order of presentation is as follows: (IV V VI), (I II III), (VII VIII IX). The story unfolds in trilogies and begins, as epics do, *in medias res.* It then doubles back to the beginning of the story and goes on to finish with its end. Such a structure emphasizes that the present – the middle of time – is first of all a function of the past and second of all an anticipation of the future. This elliptical order of presentation encourages an audience to explicate any one moment in an epic in the context of all the actually past and possibly upcoming moments. Even if George Lucas abandons "Star Wars" after having completed the "first" trilogy, the project will have stimulated a tension between expectation and memory sufficient to establish the origin and end of the cycle as something possible to imagine, if not actually to be seen.

Epics not only uncoil a timeline within themselves; they station them-
selves within the historical line of earlier epics. Allusion is the strategy
through which epics acknowledge and sometimes try to undo debts to
their generic past. Although it is most obviously allusive to fantasy clas-
sics like *Dune* (the desert planet and its messiah), the *Foundation* trilogy
(the rise and fall of empire), the Oz books (the lovable, motley crew of
heroes) Castaneda's *Tales of Power* (the "life force"), and *The Lord of the
Rings* (the burden of power), "Star Wars" achieves considerable reso-
nance when it refigures themes and moments from our literary tradition.
In such scenes – as when Yoda plays Merlin to Luke's Arthur – "Star
Wars" cannot help but assume its place in an imaginative line.

"Star Wars" is also a nearly apocalyptic summing up of the tradition of
film; it gives us back the history of movies as if that history were over.
Frederic Jameson calls "Star Wars" "a nostalgia film," a pastiche of ef-
fects meant to replay the experience of the Saturday afternoon serial.
"*Star Wars,* far from being a pointless satire of such now dead forms, sat-
isfies a deep (might I even say repressed?) longing to experience them
again: it is a complex object in which on some first level children and
adolescents can take the adventures straight, while the adult public is able
to gratify a deeper and more properly nostalgic desire to return to that
older period and to live its strange old aesthetic artifacts through once
again." But "Star Wars" proposes to engage more than a characteristic
art object from Lucas's youth. Anyone who really knows movies
watches these with a steady sense of *déjà vu*. We are treated to scenes
from *Tarzan, Fantasia, The Wizard of Oz* – even *Triumph of the Will*.
There is something like a Miltonic ambition to take up the materials and
conventions of an entire art form so as to exhaust them for future use.

John Ford's series of Westerns comes as close as anything in the history
of movies to anticipating Lucas's project. It can be seen as an epic that
gradually discovers the myth of heroism to be a fiction. In *The Searchers*
and especially in *The Man Who Shot Liberty Valance,* Ford ranges back
over his entire career to expose the promise of the frontier as based upon
a communal fantasy or at best upon a willing suspension of disbelief. His
willingness to see through a myth's illusions while cherishing them gives
these valedictory movies their special force. By binding all together in a
self-explicating chain, Ford rescues even his earliest Westerns from the
impression of a myth uncritically embraced. Lucas says that "the last real
fairy tale we had had was the Western." But when he returns to Ford and
his tradition, it is with such self-consciousness that recognition nearly
precludes response. Near the beginning of the first movie, Luke comes
upon his burned homestead in the same way that John Wayne comes
upon his brother's in *The Searchers*. But the scene fails to call up any
of Wayne's sense of frustrated love and angry sorrow. The intellectual

pleasure in catching the allusion does not compensate for the loss of un-
mediated response. Unless Lucas intends simply to pay nostalgic tribute
to the tradition he refigures, he will have to find a way of alluding to
earlier movies without emptying them of their emotional force.

Repetition assures us that a story can recover itself, that its times are all
interconnected. Allusion assures us that a story can recover other stories,
that we do not create alone. Both strategies keep time through patterns
of return. Digression keeps time simply by turning aside from it. The
major device for digression in verbal epics is the heroic simile. The simile
can set up a counterplot that reminds us of the stable world the epic tur-
bulence struggles to preserve. "Star Wars" uses visual asides to achieve
something of the effect of simile. The directors have been careful to fill
the screen. The snakes Luke flicks away as he sloshes through the swamp
are a reminder of the fullness of the world that burgeons on despite any
human quest. The movie's abundant use of adventitious detail betrays
its awareness of the need to digress from the relentless pace it has set
for itself.

"Star Wars" has not mastered, however, the simple narrative swerve
away from the main plot. We need more scenes of the "meanwhile"
world, moments of quiet in which a possible domesticity could be imag-
ined. They need not be frequent or extended, but they ought to image
the Ithaca we keep always in mind. The cycle has not yet dispelled the
initial mood set by a restless Telemachus at home. We need to see home-
steads (the script does describe Uncle Owen's garage as having "a
friendly atmosphere") through eyes not so eager to leave them. It is for
a return to such places that battles are fought and quests are made; Od-
ysseus must eventually plant his oar. We do not easily forget that the
most moving scene in the *Iliad* is the only one of a working family, Hec-
tor's farewell to his wife and child. The epic is a form that looks to a calm
beyond its own capacities to sustain. Only when "Star Wars" formally
incorporates Yoda's recommended patience into its narrative structure
will it glimpse the stillness that is the promised end of the epic of return.

Remember me

A menacing giant beckons to a man-child at the edge of the world. They
have been fighting with swords. The physical struggle now gives way to
mental fight. As the wind whirls upward through a vast cylinder, the
temptation unfolds. Acknowledge my power: This is the beseeching
command held toward the younger man. A hand reaches forth toward
the hero's lost hand. The wounded son wavers, cries out, then falls.

The genius of "Star Wars" is to collapse, in its first major climax, the
Satanic Temptation into the Recognition of the Father. "*I* am your fa-

ther": With these words, Lucas's epic acquires a resonance that stations it in line with the imagination of the past. When Luke Skywalker faces Darth Vader on the gantry, two central scenes from his tradition become fused in a suggestive and ironic tableau. One is Christ before Satan; the other is Hamlet before the ghost of his father. It is not necessary to prove the superimposition conscious in order to respond to it as a powerful refiguring of human origins.

Hamlet confirms his essence as a historical man through his obedience to the ghost's parting admonition: "Remember me." How should he begin to forget? The father's command transforms an inevitable psychic bequest into an obsessive obligation. (It is a stubborn ghost; the first thing he says upon return is "Do not forget.") This is a claim for acknowledgment that will nearly smother the surviving son: "thy commandment all alone shall live / Within the book and volume of my brain." The fact of paternity will now become the one unforgettable fact in Hamlet's world. When we hear Hamlet quoting his father's words back to himself – " 'Adieu, adieu! Remember me' " – we know that he is becoming a hero of memory. His is a world in which identity is achieved by assuming one's place in a line.

The scandal of this scene is that we are not more shocked by it. The weight of sonship is heavy enough without also being sworn to it. The conflict between his promise and a son's inevitable rebellions against pure faithfulness eventually breaks Hamlet. His is a tragedy of sonship raised to a pitch of self-consciousness that no one could sustain. If the scene did not have such symbolic power, we might judge it cruel. But surely the ghost isn't actually asking this of Hamlet; it's what any good son would ask of himself. The scene simply formalizes what it has meant to be heroic in a certain tradition – the son carrying the father on his shoulders out of the wreckage of the past.

Christ faces down Satan through an abundance of passive filial zeal. On "a high mountain" Satan shows him "all the kingdoms of the world in a moment of time." The temptation in the wilderness is to become fully his own man, though it's obvious that in succumbing to it Christ would only indenture himself to another and a pernicious authority. Christ chooses the father by renouncing the offer of worldly power. His steadfastness is imaged by his standing firm on a great height. He proves that he is the son of his father by refusing to fall.

The Empire Strikes Back literalizes the potentially satanic elements of the recognition scene. If it's the visual *homage* (a light and dark figure dueling with words in a wilderness of space) that initially links these three scenes, it's the emotional resonance that binds them. The father doesn't just look like the devil; the father *is* the devil. So Luke must choose between the father and fall. Luke's "fall" captures his complex

dilemma: No matter how true he is to himself in letting go, he betrays something primal in refusing Vader's hand. To stand with his father, to take his hand, would be to act *against* integrity, *for* the father. Luke chooses integrity and gets the abyss. He may return to Vader, but henceforth the claims of fatherhood have been radically compromised. We can't rationalize this scandal away by saying that Vader merely stands for "evil." The dream sequence in which Luke cuts off Vader's head only to find it his own makes the point that any character has a "dark side." Vader is not therefore reduced to a symbolic dark double of the hero. (These movies are full of suggestive doublings: Witness the physical likeness between Ben Kenobi and the emperor.) Vader is a character as well as a symbol and one that stands toward the hero in a uniquely privileged relation. The recognition scene is one of those that need not be further reduced or amplified. The scene goes to the heart of the series' vision of human life.

Is there any other hero who so abruptly confronts darkness at the source? Huck Finn stages his own murder by killing a pig before he can float away from his murderous daddy; surely this is the most gruesomely achieved independence in our literature. Huck is about as lost – or as free – as they come. He has no place to come to, and his story ends only once he hears the news that pap "ain't comin' back no mo'." His vision of the father is downright uncanny:

> His hair was long and tangled and greasy, and hung down, and you could see his eyes shining through like he was behind vines. It was all black, no gray; so was his long, mixed-up whiskers. There warn't no color in his face, where his face showed; it was white; not like another man's white, but a white to make a body sick, a white to make a body's flesh crawl – a tree-toad white, a fish-belly white.

The visual and aural ironies surrounding Darth Vader are just as complex. The actor portraying Luke's father is a white man – an ex–professional boxer – playing a "black" man and dubbed with a black man's voice. This designed darkness is scarcely as sinister, however, as the glimpse we get of the white seamed avocado pit that is Vader's head. This whiteness at the core of all this darkness insinuates, as in Frost's "Design," that we are in a world which beckons us with a chilling inversion of our moral categories.

Huck at least has some "pretty good times" with pap before he runs off. Luke enjoys these only with his adopted fathers, Ben and Yoda. "Star Wars" follows standard fairy-tale structure in delivering this "farm boy with heroic aspirations" (as the script describes him) up to Family Ro-

mance. What makes Yoda in particular a successful transmitter of sacred lore is that he is divested of all heroic glamour. He is the pure antidote to Charlton Heston – a Zen muppet. (Yoda is operated by the man who does Miss Piggy.) His visual presence – especially his wilting ears – tempers the sententiousness of his message. This is authority speaking with its tongue in its cheek.

Authority is of course the central fiction that "Star Wars" seems determined to undermine. The discovery that the father is evil only amplifies the premise from which the saga departs: that rebellion is by definition a privileged act. This is all supposed to have happened "a long time ago," but the revolutionary bias of the movie seems particularly appropriate to our historical moment, if not to our national history. Many have found here a story of the independent filmmaker versus the tyranny of Hollywood. On the other hand, the good fight against an "evil empire" certainly paved the way for Ronald Reagan's stance toward the Soviet Union in the eighties. If the movies rationalize Cold War politics, they also launch an attack on the entire "Remember Me" tradition: on fathers, history, and institutionalized power. In a published script labeled Revised Fourth Draft, the first thing said to Luke is by an old woman: "I've told you kids to slow down!" If the past here fleetingly rebukes the momentum of the present, the rebuke will find no place in a movie so committed to a love of speed.

A self untrammeled by institutions or memory would be a new kind of self, and the psychology implied by the movie's repression of history accounts for the complaints about the thinness of its characters. (The Force is the one thing held up by the movie as worth preserving, but it is too disembodied and fugitive really to root its disciples in time.) It's possible that the movie is simply adolescent, that it rebels against the past just for the sake of rebellion. Lucas told Empire scriptwriter Lawrence Kasdan that he wanted "no references to time." But we can also discern a serious fascination here with a nonhistorical being, a self to which the past has said, "Forget me." The self here is externalized as expertise; it is a sum of its special effects. Banter takes the place of conversation; jokes become a defense against self-revelation. The impression left is that there is no self to reveal; the movie seems to want to get beyond the notion of a psyche that can be tempted, bereaved, or guilty. The emotions aroused by Luke's encounter with Vader remind us of how thoroughly we have been enjoying an anesthesia of the heart. The droids are like the family pet; they have the task of expressing almost the full volume of repressed human emotion. Pain is scarcely a reality in this world. Luke gets his hand back immediately after losing it, and Solo seems only mildly offended after being held over the Empire's version of the kitchen stove. The most chilling scene in Star Wars is the one in which we are asked to look on

impassively while an entire world is destroyed. Nothing has been done to make life on Alderaan real to us and therefore to allow us to regret its loss. Desire fares no better here. Is "I know" a credible response to the declaration "I love you"? Only if the declaration is flat enough. The triangle shaping up in *The Empire Strikes Back* will seem merely obligatory until the film comes up with some comfortable beds – this is a world of hard surfaces – and receptive women. The one erotic scene in Lucas's work comes in his first feature film, *THX–1138,* wherein THX and LUH rediscover their civilization's lost awareness of sexual love. In "Star Wars," on the other hand, Lucas had Carrie Fisher's breasts taped to her chest. "No breasts bounce in space," she commented. Desire and loss station us in time, and "Star Wars" begins, for all its epic intimations, as a massive retreat from time into a fantasy of space. Space permits the illusion of detachment and distance: As See-Threepio says about the receding imperial starship: "That's funny, the damage doesn't look as bad from out here."

The Death Star wipes out a planet the way "Star Wars" blocks out the past. "Except for us," Stevens says, "the entire past felt nothing when destroyed." It is up to us to put whatever value we can on human history and loss, and a movie in which we watch unmoved the liquidation of a world is one from which we may wish to withhold assent. Our blocked response to the loss of Alderaan raises questions about the fictional mode to which the movie has committed itself. We care about loss in epics; in irony, there is nothing to lose. The movie seems nervous about its emerging epic structure. It plays epic ambitions off against ironic dialogue. We get the scope of Francis Ford Coppola and the sassiness of Howard Hawks. The discredited but still widely cherished myth of heroism is skillfully smuggled into the movie under the cover of farce. But a high romantic plot – one in which its characters have great power in relation to their world – cannot forever coexist with deflating rhetoric. The tension between the movie's epic structure and its ironic texture is the tension between long term and "special effects." In *Empire* Lucas relinquished the directorial role. He was then free to disengage himself from production schedules, actors' personalities, and technical gadgetry in order to let his mind range over the sweep of the story. The question of whether "Star Wars" would unfold as an epic romance or as a deflation of that tradition was to be resolved by the very magnitude of the structure to which Lucas finally committed himself.

Technique and vision

"Star Wars" makes a wonderful assault on the human eye. It also repeatedly calls eyesight into question. "Your eyes can deceive you. Don't trust

them." This is as clear a directive as Ben utters, and he does so during Luke's first instruction in the Force. The more we learn about the Force, the less confidence we can have in the eye. "It's an energy field created by all living things. It surrounds us and penetrates us. It binds the galaxy together." This is the movie's true subject, and it can be seen only through a camera darkly. The makers of the first two films have chosen to confront this dilemma head on. The treatment in *Empire* of episode IV's most stunning special effect reveals an intention to make the visible a little hard to see. Why is jumping to hyperspace an experience deliberately withheld in episode V? (The effect utilizes a camera trained on a backdrop of outer space dotted with stars. The film is shot one frame at a time, with the camera and backdrop moved forward simultaneously after each shot.) To inhibit, I think, our investment in a merely sensory event. After all the foreplay, the one belated jump proves anticlimactic when it comes. As the stars bleed past, the feeling of release is qualified by a sense that the visual thrill wasn't that much worth waiting for. It's like obligatory sex. Ecstasy here becomes insurance; by the end of *Empire* we care more about the achieved safety of the crew than the fanfare of deliverance. Such responses may make us wonder whether this is a movie fascinated with competence or concern. The growing knowledge of things unseen – of feelings and fictions that can't be filmed – puts increasing pressure on the machines that make these movies to render compelling the machines in them. The ubiquity of garbage is here linked to the limits of machines. By being thrown into the Sandcrawler, Artoo Detoo is reduced in one fell swoop from a computer to a piece of trash. In episode IV the heroes are nearly crushed with the garbage; in V, garbage provides their escape from the Star Destroyer with a saving cover. "Star Wars" makes the standard ecological point here: We are being buried by what once promised to save us. More interesting are the questions such juxtapositions raise about the human imagination and its material extensions of itself.

We come to these movies to see divinely inspired gadgets. But again and again starships that break down can be fixed only by a slap or a kick. The one ship that saves us faithfully is Solo's "piece of junk." There is a serendipitous relation between humans and machines in which the human hand or foot remains an essential extension of all of *its* extensions. (Director Irvin Kershner claims that *"Empire* is not a machine-made film. It's a handmade film and it has all the imperfections of anything that's handmade.") Bad men simply dump their garbage, and their machines always work. They live in a wholly technological world – there is scarcely a curve or a pillow in the entire Star Destroyer. Theirs is an illusion that power can be fully embodied in efficient objects. Their four-legged tanks show them reeling back, however, into the Jurassic age,

dinosaurs grinding to a halt in a superfluity of armor. Only Vader stands apart from the Empire's resolute materialization of mind. But as an official agent of the Empire he seems reduced to fighting the Force with supremely well-oiled force. He is unsuccessful in this largely because of the unpredictability of his opponents, a quality preserved by their tacit prizing of the hunch over the routine. Those of us who come to the movie for its technical wizardry must be surprised when we see what saves Luke on the snow planet: guts. If we come to "Star Wars" for the "special effects," we come, the movie seems to imply, for the garbage.

In creating a tension between its formal mastery of the technical and its deep skepticism of technique, "Star Wars" raises questions that it may never fully resolve. The technique most dramatically called into question here is that of movie making itself. A movie is the central example in American experience of a technical artifact meant to be confused with a natural fact. The illusion of life is achieved through all sorts of devices in which the medium strains against its own limits. The problems of dimension and scale in "Star Wars" have called for special ingenuity. The full Death Star as seen from space, for instance, was actually no bigger than a soccer ball, whereas more than 1,600 feet of simulated surface had to be built for episode IV's finale. The major challenge to the camera throughout these movies has been to achieve depth of field. In taking as its specific task the projection of dimension in *space,* "Star Wars" promises to become a somewhat rueful inquest into the ontology of film.

Movies project a three-dimensional world onto a two-dimensional plane. The image is suspended in an impenetrable space; as Stanley Cavell has pointed out, a moviegoer, in the presence of an image thrown upon a screen, is like someone haunting her own world. She resembles Emily in the last act of *Our Town,* present to a world she cannot enter. Why does *Empire* end with the assembled cast staring out of a window at space? We are thereby reminded of how alien, unlivable, essentially incapable of acknowledgment space actually is. From the standpoint of human use, space *is* two-dimensional. So we end with an image of what we – the audience – have just experienced: witness to a space (a movie screen) with the illusion of depth that we cannot effectively occupy.

Two-dimensionality is not only a formal limit that the camera must try to overcome; it is a thematic issue to which the movie frequently returns. People here fend off the impression of depth. Gadgets glitter and whir. Everything reflects light. The movie seems confident while filming a thing. But it can get hokey when it tries to image the life of the spirit. Ben Kenobi materializes at key moments in a haze of static electricity, and this, we are given to believe, is a vision of Skywalker's. But these appearings and disappearings, glimpses of a dimension even beyond the third, belong to the technology of De Mille's Biblical sagas of the fifties.

Perhaps they materialize mind in the way a movie must if it is not to abandon sublimity to a voice from off screen. John Williams's score plays its essential part here, conducting response toward operatic emotion. Carroll Ballard claims that "when you saw the film without the score, you couldn't take it seriously." Perhaps the score succeeds too easily in achieving Wagner's definition of the purpose of music – "to amplify what can't be shown." The deep truth is imageless – this "Star Wars" everywhere suggests – yet this is a medium of images. With all the technical know-how in the world, the movie has yet to photograph convincingly the reality of vision.

Technique versus Vision: This is a tension as old as America. Lucas might take example from the author of *Walden,* who ventures into the woods in the service of an ideal of transcendence and promptly embodies his vision in the building of a house. In this way Thoreau enacts a version of his major ambition: that a fact of the imagination (one's spiritual home) might be reduced to a fact of the understanding (Walden cottage). *Walden* is a triumph of the rooted sublime, of trying to bring the visionary down to earth. It, too, is engaged in a search for forms adequate to express the merging of realms, and perhaps its most ambitious sentence is also its shortest: "Sky water." This achieves a syntactic as well as a figurative union of the invisible and visible worlds. Finally happiest when he can station himself between these realms, Thoreau is a tonic example of the artist who converts his subject into the compromises (see the puns on "dwelling" and "indweller") through which his project is carried out. His book is a model of the self-questioning artifact that establishes the power of the creating mind by unsettling even its most fully realized verbal incarnations.

As a visual rather than a verbal artifact, "Star Wars" is bound to have more trouble than *Walden* in sublimating its technical resources into vision. Episodes IV and V wisely avoid the direct representation of the sublime attempted in the light show at the end of *2001*. Spin art won't do. What the cycle needs is more images of the self alone with its own thoughts, "the vacant spirit," as Stevens says, "in empty space." Stevens's image of transcendence was a man alone in a room reading a book. However uncinematic the prospect, the makers of "Star Wars" must move away from heroism as defined through physical trial. Aren't all those light sabers somewhat gratuitous anyway when Vader has the power to strangle with a look? It's clear that the entire galactic struggle could have been reduced to Vader and Ben Kenobi staring at each other across deep space. The fascination with Vader is that he is, like Milton's God, a self-limiting power. One wants to know more about the story of his descent into form. His willed decision to work through matter may be an act of love: Only by situating himself in time and space can he meet

and struggle with his son without destroying him. It is in this depen-
dence of spirit on matter that true mystery resides, the kind of mystery
that Blake celebrated in proverbs like "Eternity is in love with the pro-
ductions of time." Vader's predicament is also that of his creator, who
must continually straddle the gulf between being a visionary and an en-
gineer. As Lucas continues to brood over this abyss, his challenge will be
to make it even more apparent that film is a medium that radically com-
promises, even while it powerfully evokes, his vision of the Force.

In *Return of the Jedi,* Lucas embraces – even exploits – the limits of
film. He images the deep truth. The end of the trilogy gives us a literal,
visual triumph, and it cannot work, given the ethic of the preceding
movies. In the key scene in *Jedi,* Luke sees his father's face. "Let me look
at you with my own eyes," Vader says, as the reluctant Luke removes his
dying father's mask. With the sight of Vader's white and kindly features,
interest in the movie dissolves. In the three-way struggle among Luke,
Vader, and the emperor, Vader was masked, and the mask betrayed noth-
ing. A father watches his son being tortured, and we watch him. The
audience is asked to imagine what Vader feels as Luke cries, "Father,
please!" The scene is full of pity and terror because the onlooker must
supply it.

The Bible was definite about this. In that story, one cannot look upon
the face of the father and live. The assertion is not made simply about
God. Parents remain radically unknown because they must, the story
tells us. They must because the differentiation we call the self – and the
ordeal we call experience – depends upon our ignorance of and distance
from the source. Life becomes the refinding of the unknown parent
through our pursuit of scattered and substitute loves. Freedom lies in the
continual construction and revision of the fantasy called the parent. Im-
aging the deep truth is the big nostalgia, the desire to know and merge
with the source – to go and stay home. Of course to talk this way is to
remember that the original lost parent is the mother. The absence of
mothers or mature women in these movies, along with the recurring fas-
cination with being swallowed up (see the Space Slug, or Jabba the Hutt's
oral paradise), suggests that at bottom the motion backward repairs a
loss Lucas has only begun to articulate.

"I love that world," Lucas said in a television interview after the com-
pletion of the trilogy. He calls it a "homeland." He also adds, quite du-
tifully, that "sooner or later you have to leave home." In *Jedi* the
reluctance to leave home gets translated into a denial of its mystery, and
therefore of its hold. The departure here is no more Luke's than Lucas's;
as we watch the movie it becomes a parable about a director's withdrawal
from his chosen career. It now appears as though the first "Star Wars"

film is the last Lucas will direct. He has said many negative things about directing ("I hate directing"), but nothing so negative as *Jedi*. Direction is associated with evil: Early on, the emperor gloats that "Everything is proceeding according to my design." The emperor proves a monster of control, and Vader is his producer. He walks onto the Empire's set and says "I'm here to put you back on schedule." Instead of playing its part in a healthy drive to create, aggression gets equated with the dark side. Once Vader has told Luke to "use your aggressive feelings," the son has no way out except passive resistance. The script foundered on just this point; as the filming approached the climactic fight, Lucas found that "we didn't have that actual moment we needed." Luke had been drained of the will to power, and the only way he could be roused to castrate Vader's hand was after Lucas and his team cooked up a threat against Leia, now known to be Luke's sister. In *Jedi,* then, an anxiety about taking charge gets coupled with a will toward closure. The resulting ambivalence could have produced a movie of excruciating tension, but the outcome is rather a bland truce. Luke's three fathers stand in with him at the end in holographic space, and, in the final array of characters, the saga's tragic vision of Family Romance is reduced to the inconvenience of a curtain call.

So the end of *Jedi* does feel like an ending, albeit a premature one. Everything is sorted out. Sometime during the making of *Jedi* Lucas seems to have decided that it might well be the last "Star Wars" movie. But the resolution of the story's conflicts occurs too swiftly, given the expansive rhythm of the first two movies. The movie also mishandles its internal rhythms. The prolonged and unfunny scene with Jabba gives way to the jerkily cut fight in the desert: languid *mis-en-scène* becomes frantic montage. While director John Marquand tries to take his time, producer Lucas now believes that time is finished.

Lucas's subsequent career shows a man unable to leave the "homeland" of his early imaginings. Fascinated with the culture of his youth, he refrains from elaborating a vision of adult life beyond it. Movies like *Labyrinth, Howard the Duck,* and *Willow* succeed not in rejuvenating "the archetypal movie myths" but rather in repeating the effect of one phase of that tradition on the adolescent mind. These are the true nostalgia films. When Howard gets sucked out of his living room on some more perfect world, he tumbles into the alleys of our Earth, full of street people, speeding trucks, bikers, and grubby sex. So Lucas gives us a literal image of his deepest truth: The transition into experience is always an *un*fortunate fall. Howard's task is not to live in our world but to save it. When, at the movie's end, he destroys the spaceship that could carry him back, Howard hears the most terrifying words that Lucas knows. "He'll never get home."

Repeating the past

Just before Gatsby kisses Daisy under the bustling stars, Fitzgerald has
him argue with Nick about our power to revise time. Gatsby wants
nothing less of Daisy than that she should say to Tom – "I never loved
you." Nick cautions that there is no way to deny the event of the
marriage:

> "I wouldn't ask too much of her," I ventured. "You can't repeat
> the past."
> "Can't repeat the past?" he cried incredulously. "Why of course
> you can!" He looked around him wildly, as if the past were lurking
> here in the shadow of his house, just out of reach of his hand.
> "I'm going to fix everything just the way it was before," he said,
> nodding determinedly. "She'll see."

Gatsby's ambition is to relive the emotion of one moment and to deny
the reality of all succeeding moments. He believes the past to be a thing
merely "out of reach," toward which he need, as Fitzgerald writes in a
later passage, simply stretch "out his hand." It is this massive denial of
history that allows him to label Daisy's love for Tom as "just personal,"
as if nothing counts short of a dream of total possession. Gatsby's is a
nostalgic imagination because it invents a before of infinite value. His
backward-turning mind is imaged as a hunger for "the pap of life" and its
"incomparable milk of wonder." His fixation on a particular moment
with Daisy becomes a way of not losing or leaving the source. So it is
given to Gatsby's father to signal the death of the nostalgic dream at his
son's funeral by spilling a glass of milk.

As John Irwin has shown, Gatsby is a key figure in the genealogy of
American heroes who seek a revenge against time. His will to repeat the
past denies it any reality, since a past is only a past when acknowledged
as an irrevocable set of moments connected to present and future ones.
Repeating the past is thus a refusal to live at all, to enter the sequence of
moments we call experience. Gatsby does not live his life but spends it
looking away.

In *The Great Gatsby* Fitzgerald creates a structure in which nostalgia is
indulged and undercut. If we identify with a character who wishes to re-
peat the past, we also see those wishes subjected to the irony of a story
that refuses the repetition. George Lucas critically engages his nostalgia
until the making of *Return of the Jedi,* when he succumbs to it. He proves
finally unable to withstand the wish to be renewed. "To be renewed
is everything. What more could one ask for than to have one's youth
back again?"

One might ask for adult life. If George Lucas's career is a withdrawal from time, Bruce Springsteen's is a trial of development. He too makes the passage from the adolescent to the adult world his subject. Like Lucas, he survived a serious road accident in his late teens, one that left him with a sense of lucky survival, even election. Like Lucas, he honors our store of dreams, especially as they are embodied in the traditions of popular culture. But he is closer to Nick than to Gatsby in his apprehension about nostalgia. Gatsby had wanted to put out his hand to stop time, but when he reaches for it, he snatches only a "wisp of air." Nick senses that the past cannot be grasped with the hand. At most, it can be articulated with the breath. When he reaches out toward memory, it is with his voice, and all that the mouth can touch, in a phrase Fitzgerald means to repeat, is a "wisp of startled air." Nick's response to Gatsby's story is exceedingly modest – a re-saying rather than a re-grasping – and is premonitory of Springsteen's response to his own. Nick shapes his sense of what *he* has lost into a kind of unsung song:

> Through all he said, even through his appalling sentimentality, I was reminded of something – an elusive rhythm, a fragment of lost words, that I had heard somewhere a long time ago. For a moment a phrase tried to take shape in my mouth and my lips parted like a dumb man's, as though there was more struggling upon them than a wisp of startled air. But they made no sound, and what I had almost remembered was uncommunicable forever.

BRUCE SPRINGSTEEN

The momentum of time

"If I could take one moment into my hands": Bruce Springsteen imagines a rhythm that rides down all things. In response he builds up a song through three basic devices: images of distance and longing, plots and melodies suddenly broken off, a driving beat that overtakes the careful articulations of the lyrics and leaves the singer hoarse in his attempt to control its motion. His style thus enables him to translate an immediate social problem – the loss of economic mobility – into a music expressive of the enduring human fear that love cannot survive the sheer momentum of time.

In 1978 Springsteen released *Darkness on the Edge of Town,* his fourth album. The anchoring song on the album is "Racing in the Street." (It appears as well on the 1986 *Live* album, at the album's mid-point, at the end of Side Five.) Although he loves the song, Dave Marsh calls it

"impossibly romantic" – at least it seemed so to him at the moment of its release. As performed eight years later, "it has grown," he argues, "into the song that tells more about Bruce Springsteen and his accomplishments than any other, while still refusing to back off from its own romance." The romance inheres in the simple proposition that despite his other losses a man can hang onto his soul through work.

The song is about a guy and his partner who race their hand-tooled car all over "the northeast state." They are inspired amateurs; racing is what they do after they "come home from work." The singer remembers one particular night:

> I met her on the strip three years ago
> In a Camaro with this dude from L.A.
> I blew that Camaro off my back and drove
> that little girl away

The love turns suddenly bad – these are the next two lines:

> But now there's wrinkles around my baby's eyes
> And she cries herself to sleep at night

If she seems to "give up living," the singer refuses to die "piece by piece." Instead he imagines the release promised by so many Springsteen songs, one last ride out of town, down to the shore:

> Tonight my baby and me, we're gonna ride to the sea
> And wash these sins off our hands

The song then concludes with a chorus that invites us for the third time to get in the car and go "racin' in the street."

Racing is a matter of timing, and so is singing – and this song. "The time is right." This is the key phrase in the song, perhaps in Springsteen's career. It gets asserted twice, in the first and last choruses. It is a rare assertion for him. Usually the time is neither wrong nor right, and the singer fails to grab the moment. Time is something he wants to take into "his hands" – like a car, or a girl, or a guitar. Trouble is, there is also something on his hands, something that needs to be washed off. Springsteen calls it "sin." It is a big word, but his work gives it a specific weight. Sin has little to do with moral transgression. It is something more insidious – more original – than that. It is the refusal of those in the song who "just give up living." Sin is standing aside, refusing to race. It is a paralysis brought on by the looming sense that life is getting shorter, that we are getting older. Sin is wasting time.

In its words and in its sounds, "Racing in the Street" sets out to affirm the ways in which music – especially rock and roll – gives a meaning and a measure to the diminishments of time. It is a song of patience and slow accumulation. The first verse and chorus belongs to an unaccompanied piano. The piano plays around Springsteen's voice and then joins with it on the first chorus, "Tonight tonight." As the second verse starts – "We take all the action we can meet" – the percussion joins in. Five lines later the organ and its high, flute-like sound enters on the first strong drumbeat: "Now some guys just give up living." The word "Now" does not appear in the printed lyrics; when he performs the song, Springsteen adds it out of an instinctive assurance that songs, like lives, are a matter of unforeseen turns. The second chorus delivers the first big blast of harmony; all the instruments kick in. Then, with the third verse, the song quiets again, down to voice and piano. As his baby begins to sigh, a synthesized chorus intones "oh" and holds the tone until the verse ends. The last chorus invites all the players to rejoin the song. It ends with the piano cruising up and down the chords, a piano born to run. On the *Live* album the piano and organ join in an extended call and response as they play out the band's reluctance to conclude. On both performances the song swells and stills, at once admitting the isolation of the lead singer and the always available community of the band. In doing so, it achieves Springsteen's most delicate balance of silence and volume.

Rock and roll is a music of elongated moments; few of the classic songs last more than three to four minutes, and half of that can be refrain. Springsteen writes long songs. But they get shorter as the career moves along; as he gets older, he seems less desperate about filling up each next moment with something new. He comes to accept refrain. Refrain is, after all, what we listen for in a song. It conveys the illusion that we are *still there,* that time has not moved on. "Racing in the Street" contains perhaps Springsteen's most fully achieved refrain:

> Tonight tonight the highway's bright
> Out of our way, mister you best keep
> 'Cause summer's here and the time is right
> For racin' in the street

The poetic inversion in the second line shows that Springsteen will do what he has to do in order to get a rhyme – even a half-rhyme. More important, the refrain frames the song's core memory of victory and loss (winning and losing the heart of the girl), keeps the action in the present tense, and overcomes the sudden lapse of love through the repeated assertion that the singer can still race – or work – or sing. So it becomes a

song about redemption through rhythm and repetition, about surviving the hard moments by suspending them within the consoling length of a song.

Darkness on the Edge of Town projects a world in which the universal need for forgiveness suggests the prior fact of a fall. It moves in on its subject with the proper Biblical words: *baptized, sins, born, promised land, faith, angels.* Some horrible accident seems to have occurred, as in "Something in the Night," where, when we cruise up to "the things we loved / They were crushed and dying in the dirt." These lines are sung to the sole accompaniment of a drum; it beats out a dirge that is really the beat of the heart. Are we all just bad drivers, as Jordan Baker says? There is a carelessness at work here, as in *Gatsby,* but what happens behind the wheel is just a metaphor. The problem of being human lies less in the deeds we commit than in the condition we inherit. "The Promised Land" locates the trouble: "If I could take one moment into my hands." Here, as everywhere, the singer wants to put out his hand to guard all that he loves against the passage of time. Above all, perhaps, to stop his own heart. The fall in these songs is not some past catastrophe. It is what happens every moment, because of the next moment. The heart changes, turns upon itself. "But now there's wrinkles. . . ." In such a life, the only honest stance that can be taken toward the heart is to doubt what it feels.

So *Darkness on the Edge of Town* projects a world in which original sin is repetition itself. "You know it's never over, it's relentless as the rain." Bob Dylan had hoped to buy off repetition in what he has called his most typical song:

> An' here I sit so patiently
> Waiting to find out what price
> You have to pay to get out of
> Going through all these things twice.

As both singers know, the price you pay to get out of going through things twice is to go through them "again." "Stuck Inside of Mobile with the Memphis Blues Again" affirms this in its nine refrains, all of which end with the last word of the title. The best way out is always through, as Frost says, and so, on his next album, Springsteen will focus even more sharply on the experience of inexorability:

> But tomorrow's fall in number
> in number one by one
> You wake up and you're dying
> you don't even know what from

What we are dying from is life, its course, its passingness. Tomorrow –
the next moment – is not something we seize, but a betrayal into which
we fall. This is the essential vision, and the music is arrayed as a defense
against it. Springsteen uses the shape and sound of his songs to convert
our sense of this fall into a fortunate one.

The work has gone on for nearly twenty years and can best be under-
stood by following it over the length of the career. As Springsteen said in
1987: "I felt what I was going to accomplish I would accomplish over a
long period of time." Through 1987, he had released nine albums:

Greetings from Asbury Park, N.J.	1973
The Wild, the Innocent, & the E Street Shuffle	1973
Born to Run	1975
Darkness on the Edge of Town	1978
The River	1980
Nebraska	1982
Born in the U.S.A.	1984
Bruce Springsteen and the E Street Band Live/1975–1985	1986
Tunnel of Love	1987

Springsteen's music aspires to achieve the next most-inclusive form:
from songs to albums, from albums to a career. In 1984 he said that "I
guess what I was always interested in was doing a *body of work* – albums
that would relate to and play off of each other. And I was always con-
cerned with doing *albums* instead of, like, collections of songs." The *Live*
album went on to display this. Few American artists have performed
such an acute act of career criticism on themselves in the middle of the
journey. In its sequencing and its selections, the *Live* album shows that
Springsteen has not only created a unified story but also understood it,
and it is an epic of growth.

Bruce Springsteen was born on September 23, 1949. During his child-
hood his mother, Adele, worked as a legal secretary; his father, Doug, as
a taxi driver, rug mill worker, bus driver, guard at the county jail. He
was sometimes unemployed. The Springsteens supported Bruce, his
two younger sisters, and Doug's parents. Bruce spent his first eighteen
years in Freehold, New Jersey, in a neighborhood called "Texas" because
of its dominant population of Southern whites. His origins were Italian
and Irish, with the added spice of a Dutch surname. The family was
Catholic. Seeing Elvis perform when he was thirteen made Bruce want
a guitar. He finished high school but dropped out of Ocean County
Community College, according to Dave Marsh, "after his fellow stu-
dents petitioned for his dismissal on grounds of unacceptable weirdness."
In 1968 he suffered a brain concussion and damaged leg in a motorcycle

accident; it would later render his draft status 4F. He joined his first band, the Castiles, in 1965 and played his first gig with them six weeks later, at the West Haven Swim Club.

Springsteen's earliest songs try to outrun time. The cuts on the 1973 *Greetings from Asbury Park, N.J.* are as much short stories as songs. They are long and they keep moving forward. As "For You" puts it, they are songs of "ragged, jagged melody." They are crammed with words, words that typically get sung only once. "A million things in each song," Bruce admitted. "Most of them were just jets, a real energy situation." Missing here is the assuring power of a strong refrain. Internal rhyme does create an echoing effect; in a song like "Blinded By the Light," three sounds (e.g., *dumps-mumps-pumps*) get repeated within each unit of verse. But Springsteen engages reluctantly in more ambitious acts of repetition. These hurtling, unrecoiling rhythms express an anxiety about the singer's power to impose pattern on what comes next.

On Springsteen's second album we first become fully aware of the band. "The E Street Shuffle" starts things off with a medley in which each player gets to show his stuff; vocals here give way to an instrumentation that includes a tuba, a cornet, drums, guitars, three saxophones. In its movement from the slow, dirge-like opening to the closing double-time, the song traces a brief musical history: New Orleans street band becomes New Jersey bar band. The boys even get to sing along, on the chorus in which they urge "everybody form a line."

Which is what the cover photo does form – a line. Bruce stands in among the boys. An end of the sixties image: long hair, open shirts, cut-off jeans, and very uncool smiles. Two-and-a-half members are barefoot; Garry Tallent wears one shoe. The core of the E Street Band is here in place: Bruce and his guitar, Clarence Clemons on sax, Danny Federici on organ, Tallent on bass. Two essential additions remain, and they are made in the next year. Max Weinberg will add his ubiquitous drums; on *Tunnel of Love,* where Bruce can seem all but unaccompanied, Weinberg plays on eight of the twelve cuts. Roy Bittan's piano also arrives in 1974, with all the Gershwin-like freedom it will be allowed. Steve Van Zandt makes his debut after *Born to Run,* on which he helped with an arrangement, and lends his brilliant guitar to *Darkness* and *The River.* He departs before the completion of *Born in the U.S.A.,* in the spring of 1984, when Nils Lofgren replaces him. Patti Scialfa joins the band that summer, for the *Born in the U.S.A.* tour.

The first album was sung on the road; the second, from the boardwalk. Having gotten to the shore, the singer is stranded. "This boardwalk life for me is through," he says, but he can't leave. The Aurora – the big ferris wheel at Asbury Park – keeps "rising behind us." He goes for a ride, on the tilt-a-whirl:

I got on it last night and my shirt got caught
And that Joey kept me spinnin' I didn't think I'd
 ever get off

It's a paradise of circular motion, and "Sandy" is the song with Spring-
steen's first strong refrain, and his first complete melding of song and
story. The waitress may have "lost her desire for me," but the singer still
croons out the promise, despite the tone of exhaustion. "Love me tonight
and I promise I'll love you forever." On the *Live* version, the loss proves
more cosmic: "the angels have lost their desire for us." This is Spring-
steen's first song about the loss of love in somebody else's heart. But he
knows he's also tired, knows that *forever* is a word used to secure the
pleasure of a moment. What sounds like an invitation is really a farewell;
it's all farewell.

For eleven years – from 1973 to 1984 – every Springsteen concert
ended with "Rosalita." "Rosalita" is about trying to sell yourself to a
girl – it's the obverse of "Sandy" – and maybe Bruce dropped it from its
habitual slot after 1984 because he no longer had to keep selling, because
he was about to get married. (The wedding, to model Julianne Phillips,
took place in the spring of 1985.) But dropping the song also meant giv-
ing up the chance to jam with Clarence. "Rosalita" allows Clarence the
first real assertion of the sax; it's a song he and Bruce do as a duo. As
always, Clarence's role is to extend the emotion. He is the one member
of the band allowed to go beyond the Boss. His sax solos ratchet up the
tension in a song and carry the feeling off to where it dissolves in a pure
wail. He *answers* the cry of the lead. So in "Rosalita," the call to "come
out tonight" gets met not only by the girl but also by the big man already
there, by the intimate yet public call and response allowed by the con-
ventions of rock and roll. Giving up the song meant an end to at least one
of Bruce's favorite Huck and Jim routines – and a subtle loosening of the
ties that bound the band.

Women were more sung to than wanted; the anticipated rejection of
the invitation to Rosalita and to all the other girls gave the band an emo-
tion to rally around and sing about. An actual private, married love,
however briefly held, proves more awkward to share with the boys. So
on *Tunnel of Love* Bruce often sings alone or with only modest accom-
paniment. This is the solitude of a man who has too much to share, not
the isolation of someone who can say, as Bruce did in the mid-seventies,
"I eat loneliness, man. I feed off it." The images of women in the work
have certainly changed. "Rosalita" was a mere synecdoche – "a little
girl's tongue" – a piece. Girls were things that "unsnapped their jeans."
In "Tunnel of Love," a breathing adult woman sits beside Bruce in the
funhouse car. She wears grown-up clothes. "I can feel the soft silk of

your blouse." The likelihood of tactile experience is strong and imme-
diate, and the response is not glee but fear:

> Then the lights go out and it's just the three of us
> You me and all that stuff we're so scared of
> Gotta ride down baby into this tunnel of love

By locating this consummation again on the boardwalk, Springsteen re-
minds us that we don't escape the sense or even the site of our youthful
anxieties – we just have to ride through them. He doesn't even get to
steer the car.

Romantic dreams

The career, then, is a "waltz / between what's flesh and what's fantasy."
These words are from *Born to Run,* the album on which Springsteen let
the fantasies soar. It might seem as if Springsteen's work is about want-
ing a girl. (The three most commonly used nouns in the songs are *night,
street,* and *girl.*) Certainly the early songs present themselves as invita-
tions: "Mary climb in." Yet they also seem aware that the object is there
to enhance the singer's emotion; it is the possibility of the girl that fuels
the "romantic dreams in my head." Possession brings diminishment.
"Then I got Mary pregnant / And man that was all she wrote." It was
after finishing *Born to Run* that Bruce began looking for something in or
offered by the self that might last: "I looked at *Born to Run* and the things
people were saying about it, that it was just a romantic fantasy and all
that, and I thought, 'No, this is me. This is my story.' And I really felt
good about it. But later, as time went on, I started to look around and
see what other stories there were to tell. And that was really when I
started to see the lives of my friends and the people I knew, and they
weren't that way at all." The other stories would have to wait for *Dark-
ness, The River,* and *Nebraska.* In 1975, Springsteen had a single ambition:
to "make the greatest rock & roll album ever made."

There are people all over America who can remember the exact cir-
cumstances of first hearing a Bruce Springsteen song. For me, the day
came embarrassingly late, in the spring of 1981. My wife and I had sep-
arated, and I had stopped off at her apartment to pick up my two-year-
old son. He was playing upstairs, so I flopped down on the couch. She
said, "You've got to hear this album," and dropped a needle on the first
cut. A harmonica and a piano. Then a hoarse, plaintive voice. The room
slowly filled with the loud noise. In the singer's plea to Mary a shared
history subtly unfolds. He knows the sorrows of her changing face: "You
ain't a beauty but hey you're all right." He has come back to face her face,

however it looks, because he "can't face" himself "alone again." It was a song about a fantasy of remarriage, or at least a second chance. It's time to come down, from innocence. "Trade in these wings on some wheels." Second chances are "all right," perhaps better than first ones, because they are "real," fortunate, made out of a fuller knowledge.

I left her place in a daze. From across the country that summer I sent her postcards with quotations from that song. She was scared and thought maybe we weren't that young anymore. The first thing I did before I came east and moved in with her again was to buy a tape and put a tape deck in my car. The morning after I got back I brought her out of the apartment and we got in the front seat together and listened to the tape. "It's the nicest thing you could have done," she said. We separated for good a year later; the song was one of her last gifts to me. "Thunder Road."

So, yes, I acted out a scene from the song. "My car's out back / If you're ready to take that long walk / From your front porch to my front seat / The door's open but the ride it ain't free." My whole sense of Springsteen comes from that song, that moment. I was finding out that Springsteen shares with Fitzgerald the power to remind us of the persistence of selves we think we have outgrown. There was no resisting a music that promised the chance to once again take that "long walk." Except this time there would be "no walk down the aisle / No flowers, no wedding dress." For those of us who by the late seventies had broken our most public promise, the song helped to imagine a private ceremony of recovery. The adolescent vehicle – boy, girl, car, porch – easily assumed an adult tenor. Yet for all the song's high eloquence, it honestly admits how little the singer's efforts may accomplish. The emotional divorce never gets spatially bridged; at the end of the song the girl still stands on the porch, between her door and his car. The couple's pain may have accomplished little more than this aria about it. "Well I got this guitar / And I learned how to make it talk." "Thunder Road" promises that we can be spoken for – by a guitar if you're Bruce Springsteen, by a guitar *and* Bruce Springsteen if you're anybody else. It is not Mary alone who is being invited along for the ride.

If the ride is forward into the next, unpredictable moment, it is also geared toward the landscape of rock and roll, into a familiar brotherhood of sound. This is what he wanted: "In '75, when I went into the studio to make 'Born to Run,' I wanted to make a record with words like Bob Dylan that sounded like Phil Spector, but most of all I wanted to sing like Roy Orbison." And that's what he got: verbal bravado mixed with a sometimes portentous allegory, an enfolding wall-of-sound, an operatic, lonely, even florid wail. Not without a lot of help from Clarence; the album seems to belong to the sax solos, where it is not stolen, as it is on

"Back Streets," by Bittan's mournful, cascading keyboards. The goal is to create a noise adequate to the most powerful noise of the rock tradition, and he does it.

It is therefore surprising that the acoustic performance of "Thunder Road" on the *Live* album proves more satisfying. Gone are the instruments celebrated on "No Surrender," "These drums and these guitars." Performed at the Roxy in Los Angeles in 1975, the live version belongs to the sounds you first hear – Bruce's voice, his harmonica, Bittan's piano – and a little electric glockenspiel. The tone is haunted rather than strutting, and the beat has slowed. In most every case it is difficult not to prefer the versions of the songs found on the *Live* album. They have a quality that can perhaps best be called *resonance,* and it comes from more than an echoing arena. Dave Marsh devotes full chapters in his biography to the concert experience; Springsteen demands and feeds off of contact with, even immersion in – given his forays into the front row – his fans. His best music arises from specific historical encounters. This presents a challenge to criticism, because only a minority of fans can ever be there. But this too is part of Springsteen's promise. At any one unguarded public moment he is likely to be better than in the no-time of the studio.

"We fell in love I knew it had to end": Here the sudden finding and the sudden losing occur within the same line. The line comes from "Hungry Heart." If *Darkness* isolated the threat to love, *The River* openly rehearses the fear the way a child plays the game of "fort-da." Pain is mastered through the repetition of pain. The core image is of a process that cannot be stopped, "Like a river that don't know where it's flowing."

Springsteen loves his characters, as Fitzgerald does, and this leads him to take risks on their behalf that can feel sentimental. A new sympathy for women emerges here, especially in songs about those trapped in prisons of their own making, like "Point Blank" and "Jackson Cage." But the heart really bleeds for the wayward men. They seem incapable of hanging on to things. *Things* is the key word in "Independence Day," and the abstractness of the word reminds us of how inchoate emotion in Springsteen's work often remains. The husband in "Stolen Car" only knows that "something" has happened:

> We got married, and swore we'd never part
> Then little by little we drifted from each other's hearts

"Little by little" is a rare and arresting phrase. These losses happen fast in Springsteen's songs, however slowly they are said to have happened. These five syllables lay claim to an interval belied by the very structure of the song; a marriage is made and unmade in two lines. Falling in

love = falling out of love: The two events prove nearly simultaneous. This is Springsteen's difficult equation.

The title song is the pivotal cut on Springsteen's pivotal album. I rank "The River" among the five songs that have performed the essential dream work of the career:

> "Thunder Road"
> "Racing in the Street"
> "The River"
> "Dancing in the Dark"
> "Brilliant Disguise"

These songs trace a pattern in which the singer proves increasingly willing to see himself as not just the victim but also the author and willing survivor of his fall.

Springsteen has said that he writes about "action moments, moments when people are pushed to take a certain action, to do something, to do anything to get out of their present situation." The key word here is *pushed,* because the action taken often proves unconscious or compelled. The turn in "The River" comes at the beginning of the second verse: "Then I got Mary pregnant." This is the first thing to happen in the singer's life; up until *Then,* he has lived in a valley where you "do like your daddy done," a country version of Asbury Park's Little Eden. The deed proves a mortal act; it marks the fall into work and time. "And for my nineteenth birthday I got a union card and a wedding coat." This motion has been anticipated by the sudden swoop of the drums and piano as they enter in the first chorus, on the *down* in "We'd go down to the river." The song pauses before this burst of sound, as if reluctant to break up the acoustic past summoned by the quiet of Bruce's voice and guitar. It is the most bittersweet pause in his work. From then on there is no stopping the song's accumulation of momentum and volume. By the end Bruce's voice has been enlisted as an instrument too, an "o-oo-o" crooning out the loss.

A song of fatal adverbs, "The River" turns, like "Racing in the Street," on words like *Now* and *Then.* The disappointed husband attempts to penetrate the present, the "Now." But it proves an impoverished space – an economy without jobs.

> Now all them things that seemed so important
> Well, mister they vanished right into the air
> Now I just act like I don't remember
> Mary acts like she don't care

To say "I just act like I don't remember" is to remember when you did, and so, two lines later, he junks the act: "But I remember us riding in my brother's car / Her body tan and wet down at the reservoir." In a way that will prove irreversible for Springsteen, a fatal gap has opened between the singer and his dreams. About this time he said "dreams don't mean nothin' unless you're strong enough to fight for 'em and make 'em come true." The sheer will of this statement gets challenged by this song. The singer discovers that dreams cannot be fought for because they do not refer forward, to what might happen:

> Is a dream a lie if it don't come true
> Or is it something worse

It is something worse; living by a dream is an attempt to repeat the past. Dreams are a form not of hope but of nostalgia, as the previous two lines of the song have already served to establish:

> Now those memories come back to haunt me
> They haunt me like a curse
> Is a dream a lie if it don't come true
> Or is it something worse

The dreams of which Springsteen has so far sung are already memories, attempts to recover some original lost love under the cover of present obsession. As Fitzgerald says of Gatsby's dream – a dream he has mistaken for hope – "He did not know that it was already behind him." The price of "living for too long with a single dream" is the price Gatsby paid: not to fall, not to have a life. For when he does fall, it is into a world that seems "material without being real," a world beyond the scope of the dreamer's insistent innocence. "The River" discovers that dreams were never a way forward. "When people dream things," Springsteen said in 1987, "they dream of them without the complications. The real dream is not the dream, it's life without complications. And *that* doesn't exist." In "Two Hearts" the album defines a new stance toward dreams, and the question of belief:

> But I was living in a world of childish dreams
> Someday these childish dreams must end
> To become a man and grow up to dream again

This becomes the project of the next seven years. Springsteen does not discard his dreams; he establishes a critical distance from them that al-

lows the skeptical assent of a more mature – because it is based on experience – and organized innocence.

Love and doubt

Springsteen builds his work out of the collective popular fantasy we call rock and roll. In his fear that he can neither relinquish nor outgrow his fantasies – the very fantasies that give his work its power – much of his message lies. What Springsteen loves are all the "old songs." What he doubts is his ability to move out of them. And it is this anxiety, as it fights to escape the pressure of time and dreams, that the self has to offer another in love. He fears that, like Gatsby, he is in love with his fantasy and all that it has cost him. "He talked a lot about the past, and I gathered that he wanted to recover something, some idea of himself perhaps, that had gone into loving Daisy." Love is threatened then not only by the profound otherness of the object but also by the familiar comfort of mere ideas about it. In its stubborn refusal to believe that the self is ever undivided or wholly present and engaged, Springsteen's work has evolved into a troubled affirmation of doubt.

Nebraska is a lovely digression from this task. The album has no self-character for Springsteen; he feels for, not with, these characters. But then he describes this condition as the subject of the album: "*Nebraska* was about that American isolation: what happens to people when they're alienated from their friends and their community and their government and their job." The acoustic sound captures this mood. The singer joins with nothing. As Greil Marcus wrote in 1982, "*Nebraska* . . . is the most complete and probably the most convincing statement of resistance and refusal that Ronald Reagan's U.S.A. has yet elicited from any artist or any politician." Marcus has claimed elsewhere that Springsteen's "politics are buried deep in stories of individuals who make up a nation only when their stories are heard together." The pattern of these stories as told on the albums reflects the economic history of the past twenty years: a young adulthood of prosperity followed by a decade of contraction followed by an even more sinister false prosperity. Springsteen's explicit politics are liberal, even generous. He keeps alive an awareness of the doomed working class, gives financial support to and even unloads food for the homeless, helped get the Vietnam veterans' movement financially off the ground. The anger of songs like "Seeds" scarcely need be remarked upon. But for Springsteen, a workable public politics depends upon the cultivation of personal intimacy. How can we begin to be true to social contracts if we can't even manage our private ones?

Springsteen wrote the songs on *Nebraska* in two months during late 1981. "I wrote 'em real fast." Technically, the album dares to be

underproduced. Springsteen recorded the songs in "a couple of days" at his home in New Jersey at the beginning of the new year. He used a Tascan four-track cassette machine. "I could sing and play the guitar, and then I had two tracks to do something else, like overdub a guitar or add a harmony. It was just gonna be a demo. Then I had an old beat-up Echoplex that I mixed through, and that was it. It was real old, which is why the sound was kinda deep." Later, Bruce tried to re-record the songs with the E Street Band and failed; they were killed by the loud noise. Manager Jon Landau finally ventured a solution: "We can just put out the demo the way it is." So, with reluctance and relief, Bruce decided to go it alone. After Chuck Plotkin's heroic efforts to master it onto a disc, the homemade tape became the album, a muffled cry of self-sufficiency and withdrawal. It is Springsteen's most somber *and* spontaneous recording, a tribute to a unique moment of inspiration that could not be relived.

If *Nebraska* sprang forth, *Born in the U.S.A.* emerged from a deliberate, sometimes painful, act of album making. The search for one song that could anchor its desperate energies proved especially arduous. And the will to include the band shaped the album's tone; the original *Nebraska* tape had included versions of "Born in the U.S.A.," "Downbound Train," and "Working on the Highway," and, when it became clear that these songs did not play well in that album's subdued, acoustic format, Springsteen began separating them out for a further album-length project that would involve a bigger sound. Bruce proved so prolific and conflicted during this period that the next album necessarily resulted from the collaboration of friends who helped Springsteen hold true to himself. A review of the making of *Born in the U.S.A.* reveals three of Springsteen's important commitments: to the album as a coherent unit of musical meaning, to the band as a foil for the singer-songwriter's essential isolation, and to the ballad as a critique of the ideology of romantic love. The story is told by Dave Marsh in the second volume of his biography, *Glory Days*.

The first half of the album came together rather easily, in the spring of 1982. Landau had originally dismissed "Born in the U.S.A." Played on an acoustic guitar, the demo version was "much faster" than and had a "different melody" from the eventual cut. "To me, it was a dead song. It was one of the lesser songs on the *Nebraska* tape. Clearly the words and the music didn't go together." But Bruce still believed in the song, and one night in May he got the band together. Everything fell suddenly into place; "for everybody there, I know, to this day," Landau says, "it was the most exciting thing that ever happened in a recording studio." Bittan conceived a synthesizer riff on the spot; Weinberg generated a drum line without the help of any arrangement. They found the loud noise together, "that turbulence and that scale." Over the next three weeks six more songs got recorded: "Glory Days," "Downbound Train," "Dar-

lington County," "Working on the Highway," "I'm on Fire," "Goin' Down." The album looked solid, but then the matter of *Nebraska* intervened. The saga of the demo tape still lay ahead, and Bruce felt compelled to write more songs out of that voice. *Born* went onto some distant back burner.

The summer and fall of 1982 were a down time. Van Zandt had left for a solo project and was planning marriage. Landau was married on Labor Day. Plotkin was enduring a separation, and Bruce had broken up with Joyce Hyser, his girlfriend since 1978. The band stayed in the East while Bruce stayed in the West, doing songs alone in his Los Angeles garage. Finally, in May 1983, he came back to New Jersey. The band struggled all summer to cut new songs. When Plotkin was handed a list of songs and asked for some rough mixes he came back with bad news: "I can make one great side out of your song list, but I can't make two great sides. . . . What we have is . . . marking posts." The list did omit a lot; Bruce had discarded "Cover Me" – a song he had disliked ever since writing it for a Donna Summer video – as well as "I'm on Fire," "Working on the Highway," "Goin' Down," and "Darlington County." The project again seemed stalled.

The break came with the composition of "Bobby Jean." As Plotkin said, "It was like the fever had broken." Marsh argues that the song allowed Bruce some necessary farewells; to Van Zandt, who would not be back; to his past self, "burned up in the crucible and aftermath of *Nebraska*." Still, Bruce admitted, something was missing. "We have a lot of material, why don't we have a record." Landau now stepped in with an answer. He sent Bruce a long letter suggesting an eleven-song sequence, one that restored the strong, now discarded songs recorded in 1982. Bruce agreed to stay open to everything he had written. The band took a summer break, then reassembled that fall. They cut "No Surrender," "a last gasping breath of innocence from a rocker who has embraced adulthood." (The fate of this song would hang in the balance until a visiting Van Zandt insisted that it be dropped in at the top of Side Two, to make a final total of twelve cuts.) Now the task of "selection and sequencing" began. Springsteen makes albums, and "the discussion," in Landau's words, was "what plays best on an album – where's the unity, where's the balance of forces." As a debate grew over the relative worth of the 1982 and 1983 material, Bruce began polling his friends. The list got reduced to some fifteen songs. Landau asked for one more thing, a single that would capture Bruce's mood at the moment. Bruce admitted that he did not have such a song. Landau pressed, and Bruce blew up: "I've written seventy songs. You want another one, *you* write it."

"It was just like my heart spoke straight through my mouth, without even having to pass through my brain." When the song came, it came suddenly, as the fruit of over a year of frequent and profound isolation.

Bruce was alone in his hotel room. He had always liked the time before
sunrise, and he had been up all night. He was lonely and tired; the rou-
tine of putting out the album had taken its toll. He picked up his guitar,
and "The chorus just poured out of me." It might have been his first
song about middle age – "I ain't nothin' but tired" – but it was also
about being stalled as an artist – "trying to write this book." He asks for
a little help: "You can't start a fire without a spark." Rescue me, cover me.

If the complaint here seems directed outward, the hard charges are
brought against the self. "Dancing in the Dark" is Springsteen's break-
through song because it refuses to project blame, and thereby it not only
completes an album but a motion in the career. Personal pronouns get
used here in a new way: the "I" accuses the "I." He looks in a mirror.
The lover has done nothing wrong, or at least we get no evidence of it.
The singer has brought himself down, and the details deal with him. On
an album full of repetitive or compulsive motions – swinging a sledge-
hammer, laying down the black top, following a heart beat going down,
down, down – the most repetitive of all is *having an identity*, with all the
fatigue and boredom that involves. The song's hypnotic beat drums out
this sense of the dailiness of living with one's own irreducible self. It is a
mechanical sound, one enforced by the synthesizer as French horn, and
the only riff allowed to intrude is Clarence's sax, and then just barely, at
the very end. The song invites us to move, but by running in place: dance
as trance. The singer has tried to fight the repetition of life through mu-
sic, and then repetition has won.

The momentum of time in Springsteen may finally be a register of his
precarious stance within a market economy, of the suddenness with
which one can fall into ("And for my nineteenth birthday") and out of
("She sits on the porch of her daddy's house") the pressure to produce.
What the singer feels pressured to produce is one more song. So the song
that completes the "internal balance" of *Born in the U.S.A.* chronicles a
crisis of production: Springsteen's sources of inspiration have dried up.
The sexual impasse figures an incipient loss of audience – he needs to
give it something to consume. "Dancing in the Dark" deals with the way
in which Springsteen's audience creates and consumes him, calling forth
increasingly desperate attempts to bring to market a self that will arrest
the attention of the buying public.

Born in the U.S.A. sold 18 million units worldwide. Seven number-
one singles were to be quarried from it. Next to Michael Jackson,
Springsteen was to prove the biggest commercial hit of the decade. Five
million people would witness the live tour; tickets grossed $100 million.
In Los Angeles fans purchased 340,000 tickets for four shows and so en-
sured the band "the biggest collective audience any single performer has
drawn" in the city's history.

After the exhausting tour had ended, in November 1985, Landau sent Springsteen a tape of some live performances. Bruce later called it a "casserole," and it included "Born in the U.S.A.," "Seeds," "The River," "War," and two long raps, one of these about being rejected by his draft board. Jon urged Bruce to work with the tapes of ten years; Bruce resisted. Then he heard the tape of "Thunder Road" from the show at the Roxy on the 1975 *Born to Run* tour. "Well, if we ever did do a live album and it was a retrospective," they agreed, "*that's* what should open it." By Christmas Landau had sent Plotkin a rough of the first side; early in the year Plotkin had assembled tapes from fifty to sixty shows, about 200 hours of music. Picking the takes took two or three weeks, and then the sequencing began. "Sequencing was real important," Bruce said, "because that was how we were setting up the story to be told." The album followed a rough chronology based on date of composition rather than on performance. The majority of songs were drawn from five shows given between 1978 and 1985. The final version had forty songs and ten sides.

Stephen Holden finds the songs "arranged in thematic sequences" about growing up in the America of recession and Vietnam. Dave Marsh emphasizes the relation of artist to audience, the transitions on the album from club, to arena, to stadium. The most telling analysis is Springsteen's own, worth quoting at length:

> "Thunder Road" is the birth song; it's the panorama, the scene and the characters, setting the situation. . . . Then you get "Adam Raised a Cain" . . . a gut punch . . . then you get to "Spirit in the Night," which is kinda the cast of characters – friends. . . . Then you get "Sandy." That's the guy and he's on the boardwalk. . . . And there's the girl. . . . This is the beginning of the whole trip that's about to take place. . . . And then you flip the thing over. "Paradise by the 'L' " – the Clarence instrumental – that's bar band music, that's who we are. . . . And now the underside starts to kinda sneak in there. . . . I realized that, unattached from community, it was impossible to find any meaning. . . . So you've got that situation, where I turn around . . . that's where "Badlands" fits . . . from "Badlands" through to "Reason to Believe," that's kind of an investigation of that place . . . you run up to "Reason to Believe," and at that point, well, that was the bottom. . . . The answer to "Reason to Believe" was "Born in the U.S.A." . . . particularly the live version. . . . That was the moment . . . that I stopped – I didn't stop using my job; I stopped abusing my job . . . you gotta save yourself. And you're gonna need a lotta help. . . . The Born in the U.S.A. side, that's everything I know –

at the moment, or at that time . . . the opening section of "The River" was the real center of the record. It moves out in all directions. . . . "Born to Run" tops the tenth side and you go all the way back to "Thunder Road." And it restates the central question. And the central question of "Born to Run" is really "I wanna know if love is real."

Springsteen sees the album tracing a circle in which the singer is born, bands together, falls, wanders, and returns. On the last side everyone regathers: "the cast of characters and friends, it's the band." But how to finally end? Jon Landau suggested Tom Waits's "Jersey Girl." Bruce responds: "That's the same guy that's on the boardwalk in 'Sandy,' back in the same place. . . . You're back in the same place where you began. You got somebody beside you and you feel good, and you've been through all those things. . . . The most important thing, though, is that the question gets thrown back at 'Born to Run.' 'I wanna know if love is real.' And the answer is 'yes.' "

The *Live* album is the most ambitious attempt rock and roll has yet made to rescue a pattern from the momentum of time. The past is not redone – it is reheard. Bruce points out that "There were no vocal overdubs, no resinging, no replaying anything, unless something was actually broken or a channel wasn't on." The album respects the tone of specific occasions while claiming the right to return upon them in order to find "the story to be told." This act of self-understanding is the largest freedom the album allows, because, however spontaneous in the moment, live performance once recorded becomes essentially immune from revision, set and irrevocable if it is to be live. The self must surrender to what it has "been through." Love proves "real" because the singer has gone through "things," because it has been recovered after a fall. In its massive acceptance of what he calls the "integrity of the moment," Bruce Springsteen has performed an exemplary act for the culture at large. He abandons Gatsby's dream of a revisionary imagination and accepts the pastness of the past.

If the answer was *yes,* it was not a question that ceased being asked. Despite the confidence, even suavity, of its instrumentation and lyrics, *Tunnel of Love* doubts the possibility of a whole-hearted love. Springsteen plays solo on more songs than on any album since *Nebraska;* he needs to go it alone on this "mystery ride." Gone are all the angels that once promised transcendence; sex now takes us "down," into the tunnel of love. "You've got to learn to live with what you can't rise above." Unprotected sex isn't "any sin," "Spare Parts" tells us, but its consequences can be: desertion, depression, infanticide.

"Thunder Road" had asked the girl to "show a little faith." Now the man holds off, as fearful, "cautious." He has discovered his capacity for division; he has "Two Faces," a shadow. As in "Dancing in the Dark," the look out becomes the look in, and the accuser stands accused. This is the basic structure of "Brilliant Disguise."

The first two choruses taunt the woman with her perceived inauthenticity: "Is that you baby / Or just a brilliant disguise." But in the third, the singer turns the question against himself, asks it on her behalf. "Is that me baby, or just a brilliant disguise." Love as role playing: This is the singer's fear, that everybody has simply learned a part. "You play the loving woman / I'll play the faithful man." We get our notions about love from stories – above all, now, from movies and popular songs – and the singer here wonders whether love is not propaganda the culture sells the psyche. What do we talk about when we talk about love? his older contemporary Raymond Carver asks, and the answer can seem to be this: Love is a state we feel compelled to be "in," a word we apply to our experience so as to feel human, or alive. Love is a construct, and its origin in or relation to some given world of instincts or feelings is forever lost to us. Springsteen knows that he, as much as anyone, has helped to make up "love" for his generation, and that, now married and singing about marriage, he cannot lie about its status as a created thing.

"Show a little faith," the twenty-five-year-old singer had demanded. As he neared forty he saw that faith can only be belief in a fiction, in the provisional selves and compacts we and others agree to make. Believing in fictions means believing, as Wallace Stevens knew, in what is "not true":

> to speak of the whole world as metaphor
> Is still to stick to the contents of the mind
>
> And the desire to believe in a metaphor.
> It is to stick to the nicer knowledge of
> Belief, that what it believes in is not true.

This is the fully skeptical faith Springsteen at last ruefully accepts. The last lines of the song evince a special kind of courage:

> Tonight our bed is cold
> I'm lost in the darkness of our love
> God have mercy on the man
> Who doubts what he's sure of.

The "sure of" is sung with a lovely lilt, drawn out into three syllables, as if singing it pretty on a rising note could make it true. But "love" does

not finally rhyme with "sure of." The woman about whom the singer sings has all along been his wife ("We stood at the altar"), yet he sings to her as if she were just a girl being danced with on the floor of a bar. The wedding seems a thing at some remove in the past, while the fantasy of being strangers to each other is sung of as present. *Doubt* is simply Springsteen's word for the power that allows us to remember and project other selves, moments, loves. Doubt is the activity of a free imagination living in time. In its unbroken recollection that everything could well be otherwise – that wives were once girlfriends and, before that, strangers – doubt transforms every choice into a continual act of choosing and so also proves the force that makes love sure.

CELEBRITY

Sam Shepard
Ann Beattie

By the end of the eighties, America's most venerable commercial literary magazine was being jostled by its competitors. A February 1990 *New Republic* cover story wondered, "Is *The New Yorker* Mortal?" The *Washington Post* had it that "the perception in the industry is that it is no longer such a hot book, or a hot buy; *Vanity Fair*, a sibling Newhouse magazine, is one such book, one such buy." *The New Yorker* had been sold to S. I. Newhouse in 1985, and Robert Gottlieb had taken over as editor. He caused a furor by deciding to illustrate articles, for the first time, with photography. This violated, in a symbolic way at least, the longstanding split at the magazine between "the editorial and the business sides," a split embodied in the distinction between text and photographic illustration: Photographs belong to ads. Up through the sixties no magazine in America had sold more pages of advertising than *The New Yorker* (a sales peak was reached in 1966 with 6,143 pages), but the separation between word copy and photographic copy had been complete. In breaking its seventy-year taboo against mixing text with photographs, *The New Yorker* acknowledged the cultural shift toward the insistence of the camera image in the unconscious. (The shift was accelerated when *Vanity Fair* editor Tina Brown was chosen to replace Gottlieb in the fall of 1992.) *Vanity Fair* gives off heat precisely by confounding the distinction between copy and ad. It trades openly on the irresistible habit of validating taste by confirming it through the visibility – the celebrity – of authors.

Vanity Fair published serious articles too, and none more so than William Styron's "Darkness Visible," the moving essay about his depression, alcoholism, and psychiatric treatment that appeared in the fall of 1989. It was an article without photographs; the Miltonic title announced that words alone would make the story plain. Here a generous will toward self-exposure courts an embarrassment that does important cultural work. Styron spills his guts. He purchases the authority to do this by the sublimity of his style and by the notoriety of who he is. The article cannot work without an initial interest in the author's celebrity, our awe at his willingness to risk it through a confession so public and undefended. It is an article unimaginable in *The New Yorker* because it depends on a shift in the relations between authorship and audience in which that magazine has only gingerly begun to participate. For better or for worse, Styron's article signaled the triumph of a market in which the darkest secrets of the soul can be commodified. We picked up his confession because he was famous, and we kept reading because the fame was being stripped of its mystique.

Yet perhaps withholding is still the nearer way toward fame. Salinger and Pynchon remain the fascination of millions – especially undergraduates – precisely because of their refusal to do advertisements for the

self. Their reluctance to be known argues that in America today only the unexamined life is worth living. Privacy is the issue here, that space in which only we and our intimates have a say in how we look and feel to ourselves. Can that space be protected in a culture so insistent on performance and consumption, and does the trial by market eventually strip an artist of the power to embody anything more than collective fantasies? Sam Shepard (b. 1943) and Ann Beattie (b. 1947) have founded their work on the tension between city and country, renown and remove. Shepard saw his first play produced in New York at the age of twenty-one; Beattie became a regular contributor to *The New Yorker* at twenty-six. Both have become icons of early success, and both are still working out, against an announced desire to live in the daily world, and among the fields and towns of central Virginia, the value and cost of their precocious fame.

SAM SHEPARD

Sam Shepard does not write dramas of recognition. His characters renounce insight and resist growth; they seem rather the scene for their author's projection of violent, contradictory, inchoate emotions. The language of the plays remains acutely aware of this, but it is an awareness in which the characters scarcely participate. Few of the characters believe in any existence apart from a role, and one purpose of the plays is to explore this. Yet it also seems a limit by which they are bound, a repetitive irony through which the playwright asserts his superiority over his players. The conception of life is essentially dramatic, as Richard Gilman argued about Shepard in 1981:

> we either take our places in a drama and discover ourselves as we act, or we remain unknown (as some indeed choose to do). In the reciprocal glances of the actors we all are, in our cues to dialogue, the perpetual agons and denouements that we participate in with others, identities are found, discarded, altered but above all *seen*. Not to be able to act, to be turned away from the audition, is the true painful condition of anonymity. But to try to act too much, to wish to star, the culmination and hypertrophy of the common desire, is a ripeness for disaster.

This seems so brilliantly right as nearly to forestall the need for future criticism. If it speaks to the basic thematic tension in the work, it also reveals a stance *toward* tension, Shepard's stubborn – almost willful – ambivalence. Ambivalence has been less his subject than his mode: His imagination craves what it spurns. "I think we're split in a much more devastating way than psychology can ever reveal," he has said. In the 1991 *States of Shock,* Stubbs has been literally split, by a projectile through his chest. "Friendly fire" has left the parts of him that survive and remember "separated for all time." But Stubbs's split proves enabling; it alerts him to the need for a labor of recovery inconceivable to his bullying, intact father. Shepard's torn mind has given his work its thrilling and irritating air of irresolution; he seems to like being split. "To be right in the middle of a conflict – right exactly in the middle – and let it play itself out where you can see . . . well, that's where things begin to get exciting. You can't avoid contradictions." Only in the most recent work for the stage does he begin to move beyond this habitual ambivalence toward a vision of resolution, of a world offering the possibilities of change and even choice.

Shepard's plays explore the troubled relation between our fear of perfor-
mance and our lust for attention. They do so by taking the careful mea-
sure of the spaces between us; there is nothing casual about the physical
positions of the bodies on his stage. The blocking explicit in his stage
directions and implicit in his scene dynamics advances a complex argu-
ment about the possibilities for character and action in his world. Exits
and entrances reveal themselves as perilous moments of definition or
self-loss. Characters seek without knowing it an instant of distinction or
notice. Shepard's management of "where we stand" in respect to others
reveals his conception of life as an unending and often unwilling com-
petition for space and love.

Shepard's most celebrated play won the Pulitzer Prize in 1979 and
takes as much of its power from how the actors move as from what they
say. The subject of *Buried Child* could be called "the stark dignity of en-
trance." The phrase is from the William Carlos Williams poem in which
he imagines the way a new shoot shoulders the earth crumbs and pushes
up into the light. *Buried Child* ends with Halie's great speech about how
shoots and people come into the world:

> Good hard rain. Takes everything straight down deep to the roots.
> The rest takes care of itself. You can't force a thing to grow. You
> can't interfere with it. It's all hidden. It's all unseen. You just gotta
> wait til it pops up out of the ground. Tiny little shoot. Tiny little
> white shoot. All hairy and fragile. Strong though. Strong enough
> to break the earth even. It's a miracle, Dodge. I've never seen a
> crop like this in my whole life. Maybe it's the sun. Maybe that's it.
> Maybe it's the sun.

If Shepard ends the play with this appeal to a sustaining natural order, it
is because the cultural space of the family has so utterly botched the task
of nurturance. What makes us grow, draws us out? The play foregrounds
such questions by focusing on the birth of each character into the space of
the stage. The moment of truth is the one of coming on to the set.

A set summary of *Buried Child* might read like this:

> Lights come up on a living room, with stairs upward to the left and
> a screen porch to the right. Wife Halie begins speaking upstairs,
> unseen, and husband Dodge talks back from his seat on the couch
> at center stage. Dodge yells for son Tilden, and Tilden "*enters from
> stage left, his arms loaded with fresh corn.*" Halie finally enters slowly,
> down the stairs, and "*continues talking.*" She does so after introduc-
> ing by report another character we will never see, dead son Ansel.

Near the end of Act I, son Bradley drags himself in on his wooden leg. He slips, enters from the screen porch *"laboriously,"* shaves and bloodies his father's scalp. Act II begins with Shelly's offstage laughter. She and her boyfriend, long-lost grandson Vince, enter the house unnoticed. The final entrance is effected by Tilden as he again carries something on, the last character to be granted entrance, the bundle of the buried child.

If kinds of entrance bespeak types of character, we get this reading of the play: Halie is the perpetually absent mother, a voice that speaks without loving or noticing. Dodge is the present but absent father, the paternal force who never leaves the stage and whose death occasions no notice. Memory-ridden Tilden carries the family burdens. Ansel exists only as rumor, the fantasy child who replaces the one his mother actually conceived and buried. Bradley's noise and violence measure his actual impotence. Stranger Shelly sneaks on and off and so will fend off this uncanny family by finding it temporarily "familiar." Vince must revise his unremarked first entrance with a second, forcing the recognition – only Halie briefly grants it – his initial homecoming fails to evoke. The buried child appears in the play's last scene – its father presents it to its mother – so as to bring an end to the repressions set in motion in the first one.

The major interruption in the play is Vince's second entrance; as Act III winds down he cuts his own door through the screen and climbs, knife in mouth, into the central space. By doing so he also cuts short the recognition scene, Dodge's articulation of the story of the buried child. But *interruption* may be too strong a word. No one recurs to the dropped stitch of Dodge's narration; attention simply shifts to Vince. An interruption can best occur during a continuing and focused act of attention, and this is what Shepard's plays do not provide. Instead, the inattentiveness of character quickly schools the audience to expect a series of arresting distractions. I once attended a production of *Buried Child* in a theater in the round, a space with fewer than 200 seats. At the end of Act I, as Bradley began to shave Dodge's head, a man in the front row fell into a seizure, his breath short, his head tipped back. The audience soon noticed him, called for the lights. The lights came up, and the house manager announced a ten-minute pause. A policewoman strolled in; the man's wife stroked his head. The three of them rose and walked quietly out of the theater. The house went dark; the lights came up on Act II. Nothing felt lost – only added. Asked to accommodate an unlooked-for interruption, the play did so as it had its other entrances, by revealing that its very structure was built out of whatever next thing managed to make us watch it.

"Me to play": Hamm's first line in Beckett's *Endgame* might well be the motto for Shepard's people. They insist on playing, on keeping the performance alive, without any solid faith or even interest in being comprehended or known. Attention without recognition: This is what they unhappily, desperately want. In *Buried Child, recognize* proves the operative verb. The verb gets attached to Vince, the unremembered son and grandson, but it extends to everyone, from the Halie who "*doesn't really notice the two men*" in her living room to the death of Dodge, "*completely unnoticed,*" against the T.V. "I recognize the yard," Vince says. "Yeah but do you recognize the people?" Shelly replies. Tilden's answer to the question "Do you recognize him" refuses Vince any fatherly recognition: "I had a son once but I buried him." Shelly persists in forcing the issue with Dodge, but he turns it into a comic interrogation:

DODGE: *(watching T.V.)* Recognize who?
SHELLY: Vince.
DODGE: What's to recognize?

To learn, see, know again – this is the burden of the verb. Shelly insists on keeping the fiction of recognition alive in a world in which no original cognition occurred that might be had again. Recognition is the promise of drama, the experience Aristotle thought distinguished it from other literary genres. Shepard's conception of drama is so pure that his characters have been reduced to the desire to perform in spite of the absence of an action to be imitated. The outcome is no outcome, no *anagnorisis* or *cognitio*. The recognition that would lead to catharsis and hence to the end of drama and the need for drama – this is what Shepard's plays do not give.

While watching a Shepard play we are not witness, then, to a world of character isolated by a deed. Things happen; there is plenty of noise and motion on the set. The scenery is relentlessly domestic or mundane; we are not allowed the escape hatch of thinking the action merely an allegory or a dream. Props play an abundant part. The major elements on stage at the end of *Buried Child* are less the actors than a wooden leg, a blanket, a rose bouquet. It is as if in the moment of discovering the expressive possibilities of the physical space of the stage this playwright had lost faith in the conventions of drama. The surviving given is the impulse to perform. Shepard's theater thus becomes not a space for the imitation of an action but one for acting out.

The space beyond roles, beyond the imperative "to act," is the unknown space within the self, the frightening realm of the "personal." This is the space Shepard has recently begun to explore. Jake uses the word *personal* in *A Lie of the Mind* (1985) to describe the part of himself

he would never tell. It is a space he can conceive yet one he refuses, consciously, to inhabit. He does this by refusing to remember. Through a recovery of Jake's lie of the mind, Shepard goes beyond the staging of behavior into his first sustained analysis of the motives for why we stage it. This inquiry into his characters' reasons for acting is made possible by his own deepening understanding of his reasons for writing.

Shepard's longest play, *A Lie of the Mind* takes four hours to produce on stage. Its three acts trace the collision of two families linked by marriage. Each family has four members. Lorraine absentmindedly mothers sons Jake and Frankie and daughter Sally. The father is mysteriously dead. Meg and Baylor maintain a Montana ranch where son Mike still lives, and to which daughter Beth returns to convalesce from one of her husband Jake's near-fatal beatings. The action follows the two brothers, Jake and Frankie, as they work their way back toward Beth and into a forgotten past. At the play's end, the major characters have assembled around Beth, and, as they slowly exit, she is left in the arms of her brother-in-law.

Repression is the lie of the mind, and Shepard's play turns upon the words *forget* and *remember*. The story features two crimes Jake *could* keep in mind: his beating of his wife, Beth, and his "murder" of his father. The first crime is as much "in" Jake's mind as the second is out of it. "You remember the night he died too, don't ya?" his sister asks Jake about his father. Jake answers: "That's the part I forgot." It is possible to wonder whether Jake abuses Beth because he killed his father, thereby submerging the taboo role of parricide into that of wife beater. (In his "Notes on Scenes" for *A Lie of the Mind,* Shepard himself asks the leading question: "What's the connection between Jake's break up with Beth & his quest for his dead father?") Forgetting – hiding a part of the mind from or in the whole – is what people do in this play, how they get by, live onward. Both mothers forget that their children have married. Baylor triumphs over anger and ennui by remembering how to fold a flag. "HOW COULD I KNOW SOMETHIN' THAT I DON'T KNOW?" This is Jake's rhetorical question, and Shepard's emerging definition of the human. To know what we don't know, to be perpetually threatened by the irruption of memory – this is the painfully anxious state that energizes performance and drives people deeper into their roles.

Except Beth. Through an irony so violent that it may be intolerable, she has had forgetting knocked out of her head. Jake has beaten her into a permanent state of remembering, a mind, perhaps, without an unconscious. She is returned to the eloquence of primary process; her work now is to "never forget." And she knows it, or at least says it. "This is me. This is me now. The way I am. Now. This. All. Different. I – I live

inside this. Remember. Remembering. You. You – were one. I know
you. I know – love. I know what love is. I can never forget. That.
Never." Beth lives "in" the permanent presence of her once and future
feelings – in a state of terrifying mental health. It is a freedom we might
also call madness, one no doubt purchased at too great a price.

Beth's oneness with her mental state defines by contrast the nature and
necessity of performance in her play and in Shepard's work as a whole.
Beyond pretending, she can speak now about its pleasures. "Pretend. Be-
cause it fills me. Pretending fills. Not empty. Other. Ordinary. Is no
good. Empty. Ordinary is empty." Frankie responds to this with "You
liked acting, huh?" and reminds us that the action of the play is set in
motion by the response to a play. Jake claims that he beat up Beth be-
cause she had fallen in love with an actor she was "in love" with in a play:
"I know what that acting shit is all about," he tells Frankie.

FRANKIE: What?
JAKE: They start doin' all the same stuff the person does!
FRANKIE: What person?
JAKE: The person! The – whad'ya call it? The –
FRANKIE: Character?
JAKE: Yeah. The character. That's right. They start acting that way
in real life. Just like the character.

So, according to Jake, Beth goes crazy before he makes her lose her
mind. This is madness for Shepard: to believe and become one's part. Yet
it is also the way of life; it is nearly impossible to locate in his plays a
"person" who does not mistake himself for a "character," who does not
reduce and perfect himself in a role. Shepard's people mount perfor-
mances that presume a massive act of forgetting; they become lost in
what they "pretend" to be.

So is self-hate at the bottom of it all, and is the action of the mind a sort
of guilty hiding? Yes, in part. Shepard's plays with families and psyches
in them operate to expose a secret, a buried child. Not the one out in the
back yard, but the one within, the angry and therefore guilty and there-
fore repressed survivor of early loss. The plays are remarkable not in
their grasp of this human pastime but in their sense of the vigor and va-
riety of performances that lying minds can conjure up.

Shepard's play about lying turns upon an act of physical abuse, a chill-
ingly beatifying exercise of male power, and yet its basic fantasy is of a
confusion of family and even gender roles. Sally takes Jake's place in bed;
Mike claims Frankie and Jake are "the same person"; Frankie even stands
in for a deer. Baylor maintains that "a deer is a deer and a person is a
person," but he's just shot the one for the other. Identity can so easily be

mistaken because it is so haplessly confined to the role words – *brother daughter wife son* – ticked off by Frankie in III. 2. But the one division Shepard most diligently explores is that between woman and man.

Beth imagines something new in Shepard, a "woman-man." She does so in her pretending with Frankie, the man whose wounded thigh has left him in her care:

BETH: Pretend to be. Like you. Between us we can make a life. You could be the woman. You be.

FRANKIE: What was the play you were in? Do you remember?

BETH: (*Moving toward* FRANKIE) You could pretend to be in love with me. With my shirt. You love my shirt. This shirt is a man to you. You are my beautiful woman. You lie down.

Beth tries to push Frankie down on the sofa; he resists and tells her he's come on Jake's behalf:

BETH: Your other one. You have his same voice. Maybe you could be him. Pretend. Maybe. Just him. Just like him. But soft. With me. Gentle. Like a woman-man.

 (BETH *starts moving slowly toward* FRANKIE. FRANKIE *stands awkwardly, supporting himself by the sofa, on his bad leg.*)

FRANKIE: I need to find some transportation outa here! I need to find my car! I can't hang around here, Beth.

BETH: (*Moving toward* FRANKIE) You could be better. Better man. Maybe. Without hate. You could be my sweet man. You could. Pretend to be. Try. My sweetest man.

This is an astonishing scene from a writer so concerned to shoulder the burden of American manhood, for better or for worse. *A Lie of the Mind* can shock in the way that Hemingway's *Garden of Eden* did, an unlooked-for outcry against the cost of the performance of being male. Yet both careers had left many signs of uneasiness along the way. Here, Shepard projects a fantasy, in the voice of a battered woman, that ought to become central to his future work. (It will not become so by simply clearing the decks of testosterone and then asking, as he does so endlessly in *Far North*, "Where's all the men?") But it is also a fantasy so embattled that he conjures here as its nemesis one of his most scary self-characters, Beth's brother Mike.

Mike inhabits the stage as the insane playwright, staging a revenge that requires Jake to memorize his lines. He compels performance and respects only roles. He lives within the myth of a solidarity (a family) that can be "betrayed." "I'm the only one who's loyal to this family!" he screams, and one hopes that, after Mike, Shepard himself will let his

own loyalty lapse. His plays present the family, in Robert Stone's phrase, as "an instrument of grief," and yet he remains on record as stubbornly attached to it:

> Family – in the truest sense of people related by blood, knowing they are in a relationship with one another from birth to death – that's unbelievably awesome. . . . There's no way you can deny it. If a person denies it, he only ends up like Faust, you know?
>
> No matter what your family situation is – whether it's wonderful or chaotic – you have to accept it as part of the process of life. You can't jump out of it and say, "I'm free. I'm an individual." If the family exists in some kind of hell, that means you have to live in hell. Family is the soil you're born into. You gotta use it. You got to get through it. You can't run away from it.

Whatever Shepard's future take on the family, he has exposed in *A Lie of the Mind* the limits of a structure in which men "protect" women, brothers avenge sisters. Here Beth speaks to her brother Mike:

BETH: *(Stiffens, stands back)* No! You make – you make a war. You make a war. You make an enemy. In me. In me! An enemy. You. You. You think me. You think you know. You think. You have a big idea.

Mike is a male who forces entry; he has no respect for Beth's "in." He thus becomes the double of what he sets out to punish, abusing what he is "tryin' to protect." Yet if the brother-avenger is merely an extension of the husband-abuser, it remains the case that Beth has been put into the position to be avenged and hurt and inspired by a man. If Jake's act has "killed" her, as he says, it has also created her, shifted her into a new vision and language. Upon this unresolved irony the play terribly turns and so continues to betray Shepard's ambivalence about the fruits of male power.

The manuscript versions of *A Lie of the Mind* suggest that Shepard has become committed to revision of his work as well as to the revisions of lives within it. If early on Shepard thought that revision was "cheating," by the eighties he had become fully committed to its possibilities. *True West* (1980) would be revised thirteen times. The papers on deposit at the University of Virginia contain at least five manuscript versions of *A Lie of the Mind,* from the "Notes on Ideas for Plays" he sketched on May 10, 1984, to the Final Script from November 1985, one in which the penciled cuts and revisions make their way into the typed text of the play. Two complementary motions of mind are revealed by these versions: one

away from the "expository," and one toward the fusion of the themes of repression, revenge, and manhood. An examination of these manuscripts shows a writer hard at work changing both his stance and style.

Shepard's working drafts make much more room for a discursive imagination than does his finished work. In June 1984, he jotted down a list of "intrinsic necessities of the play." Foremost was "the need to allow the thing to tell its own story without bothering it with asking its meaning every step of the way." He didn't want the play to ask obvious questions: "What scenes are too expository right now?" Yet it seemed useful to ask about meaning at the start. A handwritten list of characters reduces them to themes:

> Repentance – (Jake)
> Transformation – (Beth)
> Insanity – (Meg, Lorraine)
> Betrayal – (Lorraine)
> Revenge – (Sally, Mike)
> Time, Tradition – (Baylor)
> Love – (Lyle)
> Fear – (Lou-Ann)

Lyle and Lou-Ann would get discarded; Frankie, the pivot man, is missing here. The earliest list of characters included Frankie, but not as Jake's brother. It is dated 5/10/84:

> *The Man*
> *The Woman*
> *The Friend of the Man*
> *The Brother of the Woman*

Translated into the play's final terms, this list would read: Jake, Beth, Frankie, Mike. Here character gets reduced to gender or relational roles. Shepard begins with the function each character will essentially express. A third list can be found among Shepard's notes for the play:

> Imaginary Roles
> HEART SICK
> REAL LIFE
> Imitation
> Play Acting
> The War in Heaven
> Pretending to Die
> FRACTURED

Broken
On the Borderline
A LIE OF THE MIND
PROTECTION
Believing a Lie

These proposed titles are handwritten on a piece of white typing paper. Shepard made the right choice; none of those discarded pose themselves as a kind of riddle that governs the play without explicating it.

If *A Lie of the Mind* explores the logic of the unconscious, Shepard chose not to make that easily plain. In I.3 Jake insists upon Beth's hanky-panky during her work as an actress: "I knew what she was up to even if she didn't." Frankie responds: "So, you mean you're accusing her of somethin' she wasn't even aware of?" In the "First Version" of the play (dated 1984 May–Aug), the reply read this way: "You mean this was all unconscious on her part?" Strike the analytical term when everyday words will do. A more substantial revision involves the original I.9, a scene eventually removed from the play. Why did Shepard cut it? First, because it contains the discarded character Lou-Ann. Lou-Ann is an actress who was to have replaced Beth when she is forced by Jake to drop out of her play. Second, the scene is relentlessly thematizing – in Shepard's words, "too expository." In it, Lou-Ann does a monologue from the part she has inherited from Beth, and what she talks about is something called "a lie of the mind." The play within the play here becomes too obviously an exemplum of the whole, and Shepard decides, unlike Hamlet, not to have his "Mousetrap" snap so sententiously shut.

A final example suggests how Shepard allowed the play, in his words, "to tell its own story." In II.3 Shepard reaches for the most radical emotion of the play, Beth's attempt to convert Frankie into her "woman-man." In what he labels the "True Second Version" (dated 11/15/84), Beth tries to get Frankie to remember "making love to me." He cannot, because she has imagined it. She then says:

Nobody needs to have brain damage to wipe things out. You just chop it off. You just take someone in your arms and if it doesn't work you chop it off. You cancel the whole thing out like it never happened.

These lines are crossed out by Shepard's pen. If repression is a kind of self-castration, as these rejected lines suggest, it was a case Shepard chose to make through staging and action rather than through strict exposition.

If Shepard sought to protect his themes from his own literal intelligence, he did not stint from amplifying them through the careful elision

and revision of scenes. Three major scenes – they are the three on which my reading has focused – had to be invented or substantially altered after he had completed the first version of the play. These scenes were to become:

Act/Scene		Date
I.7	Jake and Lorraine: "How was it he died?"	8/24/84
II.1	Beth, Mike, Baylor, Meg: "You make a war."	11/5/84
II.3	Frankie and Beth: "Like a woman-man."	Nov. 85

The order in which these scenes compelled his attention suggests that Shepard had to work his way through many versions to his deepest and most original material.

The Jake we see on stage represses nearly everything about his father's death. "How was it he died?" he asks his mother. He does remember one thing, about the ashes. "Where's that box?" The focus here is on the fetishized remains. The end of the scene, where, in the original stage production, Harvey Keitel blows lightly into the box and sends his father's ashes up into a beam of light, has been called by Frank Rich the "play's most overwhelming theatrical moment." All that can be remembered is that remains remain. In the original version of the scene, the reach of memory does not stop with the ashes (Mrs. Willis will become mother Lorraine):

JAKE: Where's he?
MRS. WILLIS: He's gone. He's been a long time gone.
JAKE: Dead? I remember him. [handwritten]
MRS. WILLIS: Yeah.
J: He's dead. ⎡ ⎤
 ⎢handwritten⎥
MRS. WILLIS: Yes, he is. ⎣ ⎦

Jake's active remembering here – his volunteering of the word *dead,* a word Shepard typed and then crossed out – does not prove compatible with the emerging pattern of his lying mind. So Shepard adds the business with the ashes and the talk about the father's unremembered death. The theme of repression is protected and amplified through these changes.

Beth gets to say two wonderful things to her brother and her brother-in-law: "You make a war" and "Like a woman-man." The first makes a point about what men do for and to women; the second, about what they could become with them. These central sayings are part of dialogues that did not exist in Shepard's "First Version." It was in Charleston, West

Virginia, in early November 1984 that Shepard wrote the scene in which
Beth confronts Mike and tells him that his "love" makes a war. And it
was not until November of the next year that Shepard penciled these
lines into the "Final Script": "With me. Gentle. Like a woman-man." He
worked away on II.3 even as the play went into production, as five pages
of green lined paper torn from a notebook attest. In the archaeology of
Shepard's imagination the most radical material proves the most deeply
buried, or difficult to retrieve. His discovery that the male avenger could
become the androgynous lover was truly that, an emerging fiction he
wrote his way toward over the eighteen months he worked on *A Lie of the
Mind*. Shepard's growing willingness to revise suggests that self-editing
may someday replace self-assertion in his work as the exemplary human
performance.

Shepard's continual reimagining of *A Lie of the Mind* leads him into a
complex of insights about the relations between performance and male
power. And he locates these insights within the voice and experience of a
woman. Everyone complains that up until Beth, his women characters
aren't given much to do. They inhabit the stage as objects or audiences.
Shepard has said that "the real mystery in American life lies between
men, not between men and women." Shepard seems to be tiring not
only of the mystery "between men" – *True West*'s struggle of the broth-
ers – but also of the entire ethic of performance, of the desperate "vying"
such a mystique expresses and entails. But to give up performing – to
cease the lie of the mind – is also to risk being unmanned. This is the
dangerous territory into which he has now strayed, as he evolves from
the poet into the critic of American manhood.

David Leverenz has written that "If women writers portray manhood
as patriarchy, male writers from Melville to Sam Shepard, David
Mamet, and David Rabe portray manhood as a rivalry for dominance."
A woman's experience of men differs from a man's experience of being
a man, and although the latter certainly carries its cultural privileges, it
is not without its pains and burdens. Why recent American theater has
been centered on these men and their preoccupation with being male is a
question perhaps worth exploring. It is a theater dominated by hurt or
angry sons. Try as we will to incorporate Beckett, we seem to end up
recapitulating O'Neill.

Shepard's stance toward experience is an openly "male" one: confron-
tative, aggressive, penetrating. Entering "into" something is a recurrent
figure of his speech. "So rather than avoid the issue, why not take a dive
into it?" He asks this in response to a question about his supposed "ma-
cho" image:

Just because machismo exists, doesn't mean that it shouldn't exist. There's this attitude today that certain antagonistic forces have to be ignored or completely shut out rather than entered into in order to explore and get to the heart of them. All you have to do is enter one rodeo event to find out what that's all about . . . and you find out fast – in about eight seconds! So rather than avoid the issue, why not take a dive into it. I'm not saying whether it's good or bad – I think that the moralistic approach to these notions is stupid. It's not a "moral" issue, it's an issue of existence. Machismo may be an evil force . . . but what in fact is it?

The imagery of ordeal may be no more persuasive here than the work done by prepositions like *in* and verbs like *enter.* Shepard brilliantly begs the interviewer's question by answering in a language which presupposes that the world is a place requiring a certain kind of courage, one willing to get to the heart of things. It's a courage possessed by persons seasoned through many falls, persons – and here is the circularity of the argument – who usually happen to be men.

But there is another Shepard, one who antedates the uneasy machismo of *A Lie of the Mind,* one who even in his oldest surviving play longs for a different stance and style. This counterpressure issues in what I call the dream of liquidity.

The first image from the earliest play Shepard chooses to reprint is of spilled milk. "(*The* GIRL *drops her glass and spills the milk.*)" It is the same milk Gatsby's father spills from the glass he is handed at his son's funeral, the same "incomparable milk of wonder" Gatsby forsakes when he kisses Daisy and enters fallen time. The dream of the imperial self – of being an eternal suckling – tumbles out of the glass at the novel's end and so marks an end. Shepard begins with this moment. From the start the self is spilled, scattered, lost to wholeness or a sense of origin. Yet spilling and being spilled also appeals in early Shepard. It affords escape from the hardness of identity, the need to "practice" and perform. The closing monologue of *The Rock Garden* captures Shepard's ambivalence about overflow:

> *(A long pause)*
> BOY: When I come it's like a river. It's all over the bed and the sheets and everything. You know? I mean a short vagina gives me security. I can't help it. I like to feel like I'm really turning a girl on. It's a much better screw is what it amounts to. I mean if a girl has a really small vagina it's really better to go in from behind. You know? I mean she can sit with her legs together and you can

sit facing her. You know? But that's different. It's a different kind
of thing. You can do it standing, you know? Just by backing her
up, you know? You just stand and she goes down and down until
she's almost sitting on your dick. You know what I mean? She'll
come a hundred times and you just stand there holding on to it.
That way you don't even have to undress. You know? I mean she
may not want to undress is all. I like to undress myself but some
girls just don't want to. I like going down on girls, too. You
know what I mean? She gives me some head and then I give her
some. Just sort of a give-and-take thing. You know? The thing
with a big vagina is that there isn't as much contact. There isn't
as much friction. I mean you can move around inside her.
There's different ways of ejaculation. I mean the leading up to it
can be different. You can rotate motions. Actually girls really
like fingers almost as well as a penis. You know? If you move
your fingers fast enough they'd rather have it that way almost. I
learned to use my thumb, you know? You can get your thumb in
much farther, actually. I mean the thumb can go almost eight
inches whereas a finger goes only five or six. You know? I don't
know. I really like to come almost out and then go all the way
into the womb. You know, very slowly. Just come down to the
end and all the way back and in and hold it. You know what I
mean?

Here a Shepard speaker first steps into wild verbal space. The verbal
transgression matches the sexual one; the boy's saying is above all a dis-
turbance of speech, a protest against and relief from the talking past each
other of the play. Shepard has said that "*The Rock Garden* is about leaving
my mom and dad." Just as little in family life prepares us for the shocking
discoveries in sex, so nothing in the play has signaled the boy's latent
verbal power. The fantasy here is of control ("holding on"), and the chal-
lenge, as ever in Shepard, is to "go in." But what arrests and amazes the
boy is his own capacity for meltdown, the self "like a river." In the very
act of proving his manhood he dissolves it, confounding the categories of
loss and gain.

Men in early Shepard often turn to juice. *Juice* is a big word in *Hawk
Moon* (1981), Shepard's most violent meditation on the liquefication syn-
drome. *Chicago* (1965) imagines "a mound of greasy bodies rolling in
sperm." *Icarus's Mother* (1965) turns upon a pee on the beach. In the un-
finished "Machismo Sagas" (1978), Frankie fantasizes about being able
to "vomit like a man." *Red Cross* (1967) ends with a white world stained
red, the blood that streams down Jim's forehead. *La Turista* (1973) has
Kent reduced to a "stream of fluid" by dysentery. Here Shepard goes

beyond liquefication to "abjection." This is Leonard Wilcox's judgment on *Red Cross*. He reads the suddenly bloodied face as a castration "up-wardly displaced," the agony of a man caught between the maternal and patriarchal orders. If Jim is Shepard's sacrifice to such pressures, Kent seems to have passed beyond them. In the second act of *La Turista* his affliction gets refigured into a "thing of beauty" as he passes into a vi-sion of a completely unsolid and unsullied self.

Shepard shows that for a straight man the experience of sex requires entrance into another and an alien body, and that achieved union with that body requires a transformation of his own. Solid flesh melts. Ham-let puns this into a kind of suicide, and frequently Shepard's meltdowns mingle ecstasy with extinction. *Hawk Moon* delivers up a catalogue of exhausted males: "An orgasm would be nice but not all the love making preparation." This book poises stick shifts and guns and guitars against salt water, semen, blood, milk, urine, gasoline, sweat. The violence against women ("bleeding pussy") expresses the persistent fear of and desire for the loss of self in a woman's body:

> I keep waking up in whoever's
> Body I was with last.

Shepard's anger at sex flows from the sheer fact of sex differences ("Boy or girl?" the book asks), from a universe in which "The Sex of Fishes" could even be an issue. These unlike bodies compel some into an act of fusion as momentary as it is unforgettable. Sex risks the perpetual ful-fillment and frustration of the human desire to be, as expressed in the last line of *Curse of the Starving Class* (1978), "like one whole thing." And on the insufficient dynamics of this act the culture has built an entire further set of expectations and demands. Better to be beyond desire and its con-sequences, this despairing book suggests, better to be a "Stone man."

Shepard's sexual material, like Hemingway's, expresses anxiety rather than bravado, a felt need for alternatives, not a smug posturing from within an embraced stance. They both see and see through early the im-perative of performance. As the act that requires of the man the assertion and the loss of control, sex ought to provide a model for performance itself. But of course for Shepard's characters it is not. It is precisely the "give-and-take" of which the boy speaks in *The Rock Garden* (the 1970 *Operation Sidewinder* inverts the phrase: "it's all about take and give") that is absent from these performances, especially the mutuality of verbal exchange.

Dialogue becomes like liquidity, then, a desired and feared thing in Shepard, a state the achievement of which could signal a scary break-through to a new way of being. "You gotta talk or you'll die," Tilden

says in *Buried Child*. No one fails to talk in these plays, or at least to make noise. They are "Dyin' for attention," in the words of *The Tooth of Crime* (1972). These characters speak like actors, bypassing the intimacy of conversation for the insistence of monologue. Speech is directed outward, forensic, not to be heard but overheard. Talking forces with little to say press for a piece of turf on stage. The most poignant of questions may be Salem's, in *La Turista:* "Are you listening?" The typography of the play's final pages gives an answer: two columns of print each assigned to one speaker. The lines are meant to be spoken simultaneously; here the "back" does not wait for the "forth."

These are style matches, and victory depends less on physical strength than on the invention and mastery of a unique language. In *The Tooth of Crime* the duel unfolds between two visions of the status and power of words. For Hoss, language expresses; for Crow, it constitutes. Hoss displays a psyche; Crow inhabits a discourse. The values of sincerity and authenticity vie with those of arbitrariness and recombination. The price of victory is utter loneliness; Crow "wins" and becomes stellified, a star revolving in unpeopled space.

But these contesting plays – and *True West* is the other strong example – actually eschew victory for standoff. At the end one man has beaten or talked down another, but the real situation is parity, a kind of endless struggle of the brothers. *True West* gets divided into nine scenes, with each scene in turn divided into mood units by "pause." The lack of strong act or scene divisions or even of a simple rising action testifies to repetitive rather than climactic outcomes. And if shame is the ultimate weapon in *Tooth* and *True,* it may be because the vision of conflict proves so relentlessly male, so located in the specific anxieties of a gendered ego. When Crow says of Hoss that "He was backed up by his own suction," he simply points to the same vacuum of doubt behind any or every man, as Shepard sees it. The appearance of the mother near the end of *True West* confirms this. This may be the most astonishing entrance in Shepard's work. It is as if Lee and Austin have been fighting in order to grab a little of her notice, and this is what she cannot give. Her focus relentlessly elsewhere, she is the ever-present Shepard absent mother, the one for whom there is no here here. Shepard's plays explore the uncanny continual return of the prodigal parent:

> AUSTIN *makes more notes,* LEE *walks around, pours beer on his arms and rubs it over his chest feeling good about the new progress, as he does this* MOM *enters unobtrusively down left with her luggage, she stops and stares at the scene . . .)*

It will take five utterances from the sons before Mom finally speaks: "I'm back." If the moment of coming on stage is epiphanic for a Shepard

character, none enter with a greater sense of diffidence than these perpetually missing persons, the women whose bland, insistent, unnoticing voices seem beyond the register of dramatic change or effect. "I don't recognize any of you": the voice is Shelly's, in *Buried Child,* but she speaks for most of Shepard's characters and virtually all of his parents, especially the female ones. These are anti-Oedipal dramas which deny that the self can be found – recognized – at home. If so many of his plays dramatize the avoidance of love, it is because for Shepard, as Joseph Chaiken has written, "the human experience of love" risks "the difficulty of expressing tenderness, and the dread of being replaced." People keep exiting and entering in the hope that they will be uniquely loved, but at the beginning of things stands a woman who refuses to be an audience for her child.

To forget; to be male; to be loved, or, at least, noticed: The drive toward performance is perhaps Shepard's most overdetermined, one pressed upon him by all the complexities of his being. And although this last incentive seems to me the most comprehensive, performance for Shepard is finally an excess, a gratuitous human impulse beyond explanation or the need for it. That we perform is his redundant truth; why we do so, he, this least analytical of dramatists, usually wonders not. As Shepard says of Bob Dylan: "The point isn't to figure him out but to take him in."

Increasingly, then, the interest in the career lies less in the will to perform than in its consequences. Shepard's reluctant celebrity is one of the more curious stances of our time. He dislikes interviews and grants them. He prizes privacy and models for a photo spread in *Vanity Fair.* He has written brilliant plays but expends his time on mostly mediocre movies. Sam Shepard aspires to the very status his best work imagines to be death to the spirit. He wants to be a star.

In the small brown notebook in which he sketched out ideas for *A Lie of the Mind* can be found an early draft of the song Shepard wrote with Dylan for *Knocked Out Loaded.* "Brownsville Girl" ends with a lament for a time "long before the stars were torn down." The song centers on Gregory Peck in *The Gunfighter,* a movie that images the price of celebrity as continual and failed vigilance against the murderous admiration of fans. After Peck is ambushed by a rising young punk, the dying curse he passes on is that his murderer never escape the notice of those who will, in turn, try to supplant him. So Shepard teams up with the biggest star he can imagine in order to write about the cost of being one.

Is stardom simply one more cultural option that must be gone "into"? There seems more than a touch of bravado in Shepard's expense of spirit in a waste of fame. As he says, "So rather than avoid the issue, why not

take a dive into it?" Anonymity is an anxiety for our time, one producing a craving for notice at once stimulated and resolvable through the media. As Frank Lentricchia has written about Don DeLillo's media-driven characters, especially Lee Harvey Oswald, "to be real in America is to be in the position of the 'I' who would be 'he' or 'she,' " to abandon our obscure first-person lives and to enter the realm of the "third person singular," where we can speak of the self as an object of common attention, not the subject of our private fantasies. To make oneself something unique, to overcome the fury over likeness, to be irreplaceable – this dream drifts back over us as a collective wish, one Shepard has gone into with a reluctance almost self-sacrificing.

Between movies and drama Shepard now not only divides his time but also his imaginative needs. The pattern reveals an amazing fusion of talents; American life contains no precedent for an artist who is playwright, screenwriter, director – and actor. This more-than-double career allows Shepard to explore what it feels like – rather than means – to project an image.

It is as an actor that Shepard has become famous, and it was as an actor that he perhaps most dramatically confronted his ambivalence about performing. On April 29, 1971, Shepard's *Cowboy Mouth* had its American premiere. Shepard played the lead opposite Patti Smith. The next day Shepard had disappeared, and Smith had to apologize to the audience for the no-show. "I attempted to play a part once," he explained a few years later. "Opening night was the only time I did it. I was in a state and ran off to New England, which wasn't very responsible. I like experimenting with acting, but I don't like the performance part of it. That's where it seems to get deadly." Since 1971, Shepard has performed in thirteen movies.

Things were tense the night he took off. *Cowboy Mouth* was presented as an afterpiece to *Back Bog Beast Bait*. *Bait* starred O-lan Johnson, Shepard's wife. Smith was his new girfriend; he had been living with her at the Chelsea Hotel. The play rationalizes the predicament. Slim believes himself kidnapped away from his wife and child into a life of rock and roll stardom. "I ain't no star! Not me! Not me, boy! Not me!" These are Slim's words, spoken that one and only night by Shepard. Just what was he running from as he fled to New England? Perhaps not so much the split between but the awesome fusion of art and life, the terrifying convergence of the twain. Who is the character, and who the author here? And what of the double compulsion acted out by both – to mount and renounce a performance? The one split Shepard cannot maintain is the one he seems most deeply to desire, the split between the on- and offstage worlds. It has proven even tougher to maintain the split between the on- and off*screen* worlds.

The work in film Shepard has done since his first screenplay (nineteen movies from the 1967 *Me and My Brother* to the 1992 *Voyager*) can be read as a meditation on the difference between life on a stage and life on a screen. First and last, in America movies make you famous. Plays don't. When Shepard does his Gary Cooper imitation in *The Right Stuff* (1983) and rises phoenix-like from the burning plane, one of the ground crew sees a speck in the distance and asks, "Is that a man?" The other replies, "Yeah, you damn right it is." In this moment Shepard strides into focus and also into stardom, an actor who has earned, as the script acknowledges in these lines, his culture's most minimal and therefore highest term of praise: "man." In a further twist of fame, he also ensures through this performance Chuck Yeager's ability to finance his golden years by hawking engine lubricants on TV.

Because Shepard has been most successful in movies as an actor, his sense of the difference between movies and plays comes down to what it's like to be "in" them. The key variables are continuity and dimension. Movies lack much of either. They are made in lurches, short takes. The movie actor never acts, on one evening, his entire role. Moreover, although movies are acted in actual space, they are projected onto a two-dimensional plane, one the actor and audience cannot enter. The scale of a movie screen is inversely proportional to its accessibility, its vulnerability to intrusion or surprise. In the early eighties, Shepard wrote the script for the brilliant *Paris, Texas* (1984). At the movie's end, a man in search of a woman finally finds her, and she is hidden behind a mirror. The climax in the movie reenacts the experience of a movie; when Harry Dean Stanton gets to Natassia Kinski, it is an encounter simply with a screen. Movies provide, for the audience, the illusion of space (dimension) and time (continuity) without affording for the actor the experience of either. Yet they continue to share with plays the emphasis on speaking bodies that are seen. They thus allow the actor – Shepard – to keep on projecting an image without having to risk the open-endedness of an actual historical occasion, or a performance in "three dimensions."

The 1982 *Motel Chronicles* contains Shepard's most extended inquiry into the ironies of working for the screen. The movie actor in Texas tries "to keep his mind on his business. What the scene they were shooting was about. Where it fit into the continuity." He can find no fit and so drives away, out of the movie but into the character he was slated to play. Later a screenwriter remarks that "I've abandoned my film." "What happened?" a voice asks. "I lost the continuity." The continuity that a movie must evince proves shockingly fugitive in life, as the spliced-up structure of Shepard's book implies. One of its male voices simply intones, "The most intimate things were very broken off." There is a link here between formal structure and psychological concerns; one can see it

in the typed manuscript versions of *Motel Chronicles*. Originally titled "Transfiction" or "Transfixion," the book was begun in 1978 and composed over some three years. By replacing the *c* with the *x*, Shepard links fiction making and suffering – writing becomes a kind of crucifixion. By finally abandoning both titles, he backs off from the melodrama in the claim. But he does not back off from the personal. *Motel Chronicles* begins and ends with memories of the mother; the speaker's birth; a mother's final illness. The last section on his mother-in-law's stroke was added late – on "9/29/80." The opening about Shepard's mother was added on the first day of that month. So the book moved toward the classic fictional openings and closings – birth and death, origins and ends. Yet these memories provide not continuity but merely arbitrary starting and stopping points. The most powerful impression of the mother comes in a fantasy of seeing her body after the speaker's birth: "I watched her body. I knew I'd come from her body but I wasn't sure how. I knew I was away from her body now. Separate." This is a discontinuity that cannot be edited into shape. Movies are not "as dumb as life," the actor's stand-in earlier argues, because they project a seamless continuity in which parts of the story are not broken off.

But the price of continuity is impotence, the powerlessness of an audience to share, enter, or alter, the movie's space. Space is what plays provide. Kevin J. O'Connor says of Shepard that "Most of his plays were meant to take place on a proscenium – he writes for that – or a space in front of you. He sees things coming on from the side or going off from the side – that's part of the world he's creating." Shepard's stage directions, are, as we have seen, detailed and architectural: He maps out the walls, doors, rooms. But despite his affection for the dimensional world, Shepard's plays also express a desire to escape its mortal limits. They thus advance a subtle rationalization of his own professional shift from stage to screen, outlining as they do so a pathology rather than a poetics of space.

The pathology is distinctively American. "I take SPACE to be the central fact to man born in America from Folsom cave to now." So Charles Olson begins his 1947 *Call Me Ishmael*. "I spell it large," he says, "because it comes large here. Large, and without mercy." (*Paris, Texas* opens with a "lone man" crossing "A fissured, empty, almost lunar landscape – seen from a bird's-eye view.") Large, Olson seems to be saying, like Moby Dick. Olson's American stands toward space as Ahab does toward the whale. "We must go over space, or we wither." There is not a little phallic ambition in Olson's call for a continual westering, as if Manifest Destiny were a massive repression of castration anxiety. Lawrence would have agreed and had already supplied the word *phallic*. But he was less sanguine about the prospects for fulfillment in space, in

America's "true west." As he says in *Studies in Classic American Literature,* "Absolutely the safest thing to get your emotional reactions over is NA- TURE." It is a big claim, like Olson's, and each writer capitalizes his key word. SPACE. NATURE. Big words – like Mike in *A Lie of the Mind,* they "have a big idea." Big words. And today, Shepard seems to be telling us, nearly dead words.

Olson's book celebrates the discovery of a new American space: the Pacific. Lawrence's details the sentimentalization of a continent. We per- sist in both activities. America now lives in the era of the Pacific Rim, and there is no dearth of pieties about the renovating powers of the in- creasingly abused natural world. But to the immediate data of conscious- ness, the continuing colonization of space and valorization of nature are mere sideshows, distractions of history. To live in America as the twen- tieth century ends is to have withdrawn from the realm of the outside. We suffer from a greenhouse effect that owes more to the voracious will to enclosure imaged in Chandler's *The Big Sleep* than to excess ozone. We suffer, Shepard's work argues, from a sort of national agoraphobia – a fear of space.

In the southern California where Shepard grew up, the spaces inhab- ited had names like these: *playground, downtown, driveway, front yard.* The words imply a scene of relation and proportion between institutions in a built world of schools, roads, stores, and free-standing homes. Beyond all that lay the found world, what can be called the landscape. For many of us these words and spaces have become unrecognizable. We inhabit another order of terms focused on an interior world; in the True West of today, we can hear the sound of the crickets in the hills, but nobody gets to leave the house. If the primal American scene has heretofore been a body in a landscape – Stevens's "empty spirit / In vacant space" – then in the nineties it has become a pair of eyes staring at a screen.

The new words are *VCR, television, computer, fax machine.* People seem reluctant to leave them behind, to go outside, into space. I am married to a woman who owns a repertory movie theater. People have stopped coming; attendance dropped from 52,000 in 1988 to 40,000 in 1991. Per- haps it's an aversion to going out at night into "cities under siege" in order to sit with strangers in a large, dark space. Our audience appar- ently prefers to stay at home and manage the screening of experience on a reduced scale. (In 1990, 70 percent of American homes had one VCR; 25 percent had two.) The bunker mentality has triumphed, and we live less in space than in representations of space. What we increasingly have in common is not the physical landscape around our homes but, in Michael Herr's words, a "glamour space" projected onto a screen. This is where we live, and move, and have our being.

Since *The Tooth of Crime,* Shepard's plays have argued that the price of the celebrity we most value – stardom on a screen – is *dis*-location, the erasure of specific identity in local space. Because such stardom relieves us of an even greater anxiety – "Dying," as Tympani says in *Angel City* – it is a price we are perhaps willing to pay. The play in which Tympani appears gives this paradox its most elegant expression. The action of the 1976 *Angel City* follows a crazed Culver City production company as it tries to make a hit disaster movie. At one point, script doctor Rabbit and musician Tympani enjoy this exchange. Rabbit asks, "What is the most terrifying thing in the world?" Tympani replies: (*blankly*) A space." Space scares because it is the medium of vulnerability, even mortality:

> RABBIT: So now you're just taking up space?
> TYMPANI: I'm facing my death.

The human choice presents itself here as between facing death in space or achieving a dimensionless immortality on screen. Rabbit states the case for the power of film:

> The vision of a celluloid tape with a series of moving images telling a story to millions. Millions anywhere. Millions seen and unseen. Millions seeing the same story without ever knowing each other. Without even having to be together. Affecting their dreams and actions. Replacing their books. Replacing religion, politics, art, conversation. Replacing their minds.

If Rabbit tries to control this process, and its effects, Miss Scoons is content simply to be its victim:

> I look at the screen and I am the screen. I'm not me. I don't know who I am. I look at the movie and I am the movie. I am the star. I am the star in the movie. For days I am the star and I'm not me. I'm me being the star. I look at my life when I come down. I look and I hate my life when I come down. I hate my life not being a movie. I hate my life not being a star. I hate being myself in my life which isn't a movie and never will be.

The recognition that Shepard's plays honestly refuse to provide is not even a promise of the movies. The self is lost while watching a movie, merged into the infinite "I AM" of the star. The cycle of watching and coming down produces in the viewer an endlessly aroused and frustrated fantasy of imperial being.

Angel City sets out to show, despite its rhetoric to the contrary, that a screen is the most terrifying thing in the world. The play begins on a *"Basically bare stage. Upstage center is a large suspended blue neon rectangle with empty space in the middle. The rectangle is lit from time to time. . . . Upstage, directly behind the rectangle, is a narrow platform. . . . When the actors enter on this platform they have been framed by the rectangle."* This framing rectangle is the play's key protagonist, a kind of ever-present movie screen that treats the characters, as they enter, to a momentary apotheosis as a star. There is the illusion of being "captured in celluloid." It is a pleasant illusion, until it becomes fully literalized in the play's action. The company has been trying to introduce something "totally new" – something "three-dimensional" – into the medium of film. But the reverse happens. At the end, producer Wheeler gets trapped in the movie of his own imagining; one of the most terrifying moments in Shepard is when Wheeler's staff becomes an audience that watches him but refuses to wave back. They know that people on the screen cannot see people watching it. The terror here is that everyone collaborates in treating the stage as if it were a screen, as if it were not three-dimensional, as if Wheeler had passed from the space of drama's struggle to the nonspace of projected form. But this is what Shepard's characters typically do. They refuse the option of action and dialogue in a fully dimensioned space and play their parts as if they were audiences to – at best actors in – a movie. If "the plays," as Shepard said in 1977, "were a kind of chronicle I was keeping on myself," then his movies are perhaps a fable he is composing about us. Movies are for Shepard in his plays and prose a metaphor for American life as so often it is lived, and it is this urge toward withdrawal into the amplified, the dimensionless, and the continuity-ridden that he has set out, from the beginning, to set before us on the stage.

The conflicts that drive Shepard's career are not resolved – they are staged. By stepping with such willing reluctance into the felt tensions of American life, he continues to perfect his role as one of his country's leading cultural agonists. He takes things on, goes into them, acts them out. Experience must be overcome. The decision to write has been, he says, "a process of overcoming a tremendous morning despair. It's been diminishing over the years. But I still feel a trace of this thing that I can't really track down." The best way out is always through, and the end is not understanding, or reconciliation. The end is to keep the forces that make the play *at play*. Shepard remains willingly conflicted, generously divided. As he says of the Old Man and his feeling for the lovers in *Fool for Love*: "From his point of view, there's a danger of wholeness. Once they become whole, it shatters his entire existence, which depends on being split . . . But there are a lot of different ways of looking at it."

ANN BEATTIE

What Was Mine is the title of Ann Beattie's ninth book, published in 1991. It has taken her nearly twenty years to enact the promise of this title, to articulate what is hers. Her development as a writer unfolds as a reticent act of laying claim, and the issue is one of possession, especially the possessiveness of love. *Not* laying claim had been the apparent burden of the early work, and the coolness given off by it had been taken by many readers as an inveterate chill. Therefore Benjamin DeMott's 1984 claim that Beattie belongs to a generation of writers "bent on telling one and only one story, the changeless theme of which is human unresponsiveness." Yet the neutrality or standoffishness of Beattie's early characters had masked an angry competitiveness, one that longed for an exclusive love. The challenge had been to imagine stories in which this emotion could be nudged toward expression – however partial – rather than withdrawal. The turn for Beattie came in the mid-eighties, and her work, read backward from the position gained by the 1986 collection *Where You'll Find Me,* evinces a steady access of warmth and a willingness to extend it. In the closing pages of *What Was Mine* she can finally imagine, "after all these years, a perfectly well insulated house." These words are written about a woman who can give away rather than hoard or envy love, and the story of her learning to warm herself and others is the story of Beattie's career.

Beattie understands love as doomed and fulfilled by the triangle. In her four novels and five collections of short stories, two figures recur with uncanny force: the hapless lover and the neglected child. Both figures are the odd thing out in a triangle, and together they constitute one figure: the Unloved Third. "It wasn't easy to be the younger extra person in a threesome," one of her narrators says. Beattie's children regularly endure this uneasiness, while her adults try to escape it. They simply don't like threes and search instead for the perfect dyad. Beattie's ubiquitous dogs fill out these twosomes without destabilizing them. Always there is the threat of having to share love. Beattie's work departs from the unhappy knowledge that life was better before the fall into the possibility of sexual generation and the humor, irony, and repression – the elements of style – needed to mask our feelings about it.

As Beattie's artistic vision matures, she redefines the fear of sharing into a kind of happy risk: the risk of being – or caring for – a dependent thing. The "thing" can be a person or a work of art, and its value and power is that it is shared. The triangle of woman/man/child and the triangle writer/reader/story each becomes for Beattie the figure of love, and it is perhaps fair to say that in her work a knowledge of the second

triangle grounds the possibility of the first. Through the making and sharing of her art, Beattie has come to experience the necessary triadic shape of love's production, and the promise it therefore extends to us – the promise of all true art – is of an understanding of the triangulation of desire in actual experience, even if it is an experience some of us will never have.

The hero of Beattie's first novel, *Chilly Scenes of Winter* (1976), fuses the roles of the hapless lover and the neglected child. Caught in at least three triangles, he can make himself the exclusive focus of none. There is the crazy "naked" mother in the hospital, tended by solicitous stepfather Pete. There is friend Sam and his parade of bedmates. And there is Laura, his beloved, and her husband, Ox. The structure of the novel – a long wait terminated by a "happy ending" – suggests that Charles can be delivered from his Petrarchan longing into the knowledge of love. Yet his final arrival in Laura's kitchen feels strangely sterile:

> "Say something," she says.
> "I was thinking about that snow fort we discovered in the park that winter when we had a bad storm. How strange it was that no kids were in it, just a big white enclosure."

A white enclosure with no kids will prove Beattie's image of the typical marriage. What Charles has won is the opportunity not to fall, and he has won it through perfecting an ability to embrace unconsummated desire.

Beattie connects Charles's deferral of love with his reluctance to edit his life into a story. For Charles, life proves brute sequence, the meaningless metonymy of a government job:

> The sun is in the middle of the window. In the morning it is on the left, at noon in the middle, and to the far right before it gets dark and he goes home. He amuses himself by thinking that the sun rises and sets in his window, that it is confined to this rectangle, that the window is like one of those games they have in bars, with the little squares that beep from left to right.

The passage conveys not only Charles's alienation from work but also the vanity of a life in time. For Charles, the sun also rises, but, as with Jake Barnes, he kills time waiting for a woman who will not convincingly be his. For Beattie, the basic transitional device is to have a character look around, see the next thing. "He looks around him." The self is reduced to counting moments, as it is also reduced to a list, "one of those Dewar's profiles." When Charles enters his mother's room to

"find her naked on the bed," his glaze slips from her body to her stuff: "There are things all over the floor: *The Reader's Digest,* Pete's socks, cigarette packs, matches." He wants to believe that his wait for Laura has not been a "waste of time," but the last lines of the book, spoken by Laura as she perches on his lap, argue otherwise. They are about a visit to another crazy woman, Ox's ex-wife:

> "she said, without even looking up to know that it was us, that the doctors had said that sitting and staring at the snow was a waste of time; she should get involved in something. She laughed and told us it wasn't a waste of time. It would be a waste of time just to stare at snowflakes, but she was counting, and even that might be a waste of time, but she was only counting the ones that were just alike."

Likeness here is the fantasy of an insane mind; we occupy a world of radical differences, unconnected moments. Beattie displays no early ambition to assert connections, give us a story. Doing so would be a waste of time. Her first novel instead measures the price of realizing a fantasy, of achieving a state from which there is nowhere to go. What love has taught Charles is a lesson that will kill love – how to wait.

Charles waits for Laura out of an assumption of sympathy, likeness. The world Beattie builds around him argues otherwise. Where everything is unalike, unconnected, everything becomes interchangeable. Beattie's early work subscribes to this principle of indifference, of a world where nothing matters because comparisons, and hence human linkages, cannot confidently be made. After someone in *Secrets and Surprises* (1978) likens a woman to a figure in an Edward Hopper painting, Banks objects. " 'Nah,' " Banks says, head swaying. " 'Everything's basically different. I get so tired of examining things and finding out that they're different.' " Then he proceeds to get "very excited" when the narrator admits to having thought, during his automobile accident, of *Jules and Jim.* " 'Wow,' Banks says, 'I wonder if anybody else flashed on that before you.' " The urge to confer a resonance upon our lives by resorting to easy allusions and glib comparisons drawn from popular culture is one Beattie is out to expose, not to exploit.

So Beattie begins with a distrust of story that she will gradually abandon. As the old man says in "Imagined Scenes," a story from Beattie's first collection, *Distortions* (1976), " 'I've had enough make-believe.' " "Wally Whistles Dixie" gives us four possible endings, each "pointed out" and so made to seem arbitrary by the repeated graphic of a finger-pointing hand. Stories are the lies we impose on randomness, an inauthentic defense against the need to count and take account.

Counting. Making lists. This is what Beattie's early characters do, and ought to do. "She often counted things." It is an activity of which she has not yet tired; *Picturing Will* (1989) contains lots of lists, as in the early sentence whose cascading semicolons enforce the slight pause – "the pegs . . . ; the mantel . . . ; the built-in corner cabinet . . . ; the window seat . . . ; the chair . . . " – each numbered thing deserves. Lists are the order we give to things, and *things* – a word repeated in *Picturing Will* more than fifteen times – things, Beattie thinks we believe, have the power to relieve anonymity by making our differences plain.

The problem with Beattie's mistrust of story is that it also curtails her own imagination, inhibits her will to impose shape and form. The early stories can seem merely an accounting, a knowing roundup of cultural debris. At least they have often been taken as offering little more. In 1983 Pico Iyer argued that "Their main activity is refining inactivity." Yet Beattie's is a sustained meditation on the status of things in our culture, on the status we have because of things. Her career can be read as an attempt to explore the loss of the realm we call the personal amidst the white noise of things. Beattie has not yet stopped imagining characters for whom the possession of things serves as a diversion from possession in and by love.

A story in *Distortions* shows a character distracted from people by things. "A lot of things haven't been going the way I figured," a man named David says. Then he corrects himself. "Not really things. People." Beattie's work can be read as an act of growing resistance to this confusion, as a search for the right relation between people and things. This proves a difficult balance to achieve, given the fact that hers is a world in which value typically *floats,* like the space-borne astronauts mentioned so often in *Secrets and Surprises*. In beginning her career at a time when the value of objects had been unmoored by advertising into the weightlessness of the market, Beattie seemed destined to write about a scene in which, as in "Taking Hold," Reeboks have displaced Rilke. (The same story mentions the Nylons, Walkman, Accord.) Beattie's things do not do anything. Their power is registered through their aura, and we acquire status by knowing their names – gilt by association. By immersing us in a "chaos of first names" and brand names, Beattie ensures Blanche Gelfant's claim that "of all Beattie's qualities the most distinctive is contemporaneousness." In this continual state of up-to-dateness, people have become anonymous, interchangeable, while objects have become capitalized. Identity is trapped by the very things it has sought to own.

Beattie's work is as sophisticated an account of class and commodification as her generation is likely to give or get. When critics lament the loss of a political vision, hers is some of the first work that should be

offered forth. Explicit, high-powered theory about culture she refuses to bring to bear. This is the poet Robert Hass: "The establishment of distinctions of personality by peripheral means is just what consumer society is about. Instead of real differences emanating from the life of the spirit, we are offered specious symbols of it, fantasies of our separateness by way of brands of cigarettes, jogging shoes, exotic food." Beattie has given us the best living picture of the new class flung up by America's post-industrial capitalism. Fred Pfeil argues that "the overwhelming majority of those United States citizens, who, in 1980, were between 25 and 35 years of age were members of that class." Barbara and John Ehrenreich have dubbed it the "professional-managerial class," or PMC. According to Pfeil, this class experiences the decline of the Oedipal ego (absent fathers and ubiquitous mothers); adopts television as its lingua franca; perceives no strong line between high and popular culture; does work that is bureaucratized, contingent (a series of "projects"), and mental; and suffers from "deindividualization," a sense that the self has been displaced into and can be represented only by received codes and clichés. Beattie's work registers the daily strain it takes to live such a life. Her prose "mimes the ceaseless process of the consumerized self's construction, fragmentation, and dissolution at the hands of a relentless invasive world of products." In "A Vintage Thunderbird," Nick loves to go to Karen's apartment and "look at her things." "She owned many things that he admired." Given the events of 1989 in Eastern Europe, Beattie's vision can even be said to be historical; we have seen how swiftly the lure of things can seduce whole cultures. As the graffiti on the falling Berlin Wall says: "They came, they saw, they did a little shopping."

Beattie's most hopeful work tries to oppose the woes of consumption with the risks of production. True production is making, the addition to the world of a thing that was not there before. Culture makes the task especially difficult for women, who must chart their way between two demanding kinds of making. Each entails a unique product, and its own kinds of negative and positive attention:

Beattie wants to clear a space in which a woman can satisfyingly make. Yet her characters seem permanently shadowed by the sense of what Pound calls "the not done," of, however much they have made, "the diffidence that faltered." They are threatened not only by the looming con-

sequences of what they have made but also by the fear, often expressed as an authorial judgment, that they have chosen to make the less than fulfilling thing.

Fame came early for Beattie and has held pretty steady. She began publishing regularly in *The New Yorker* in 1974. *People* magazine did a profile on the publication of *Picturing Will*. She has moved toward and away from the center of fame: Storrs, Charlottesville, Cambridge, New York, Vermont, Charlottesville again. Creative writing got taught at Virginia and Harvard along the way. A ten-year marriage ended in 1982. In 1988 she remarried, to a painter of national stature.

In 1990 Beattie told the *Washington Post*, "I wouldn't like a life without children. But to have children yourself is just, plain, a different decision. It's having a different life. And it would be a very different life than the life I have. And I must say, I'm not at all unhappy with the life I have, so there are lots of things I wouldn't set out to do – that among them." In moving toward the biographical, one could remind the reader that Beattie describes herself as "an only child," that as a child she looked at "these things called *families*" and saw "all the chaos going on," that she has no children, and is often quoted as not being interested in having them. But Beattie's understanding of and fascination with this "decision" antedates by at least a decade the moment at which it might have seemed irrevocable in her life. During the years in which she was establishing it as a subject for fiction, it may have scarcely seemed an issue at all. The bases for Beattie's interest in the child question are perhaps less biographical than generational. She registers our unease with the authority of parental roles and a yearning for a more fraternal relation with people – and things. As Nicole says to Lucy in *Love Always* (1985), " 'It's a thing from your generation that people have friends.' " One of the ironies of Beattie's career is that her ongoing chronicle of the breakdown of hierarchy and of the consequent and difficult choices facing women and men has also set her apart, made her famous.

At least it is a celebrity won through artistic integrity rather than through marketing or purchasing power. And it is quick to admit its own limits, or to wonder whether another kind of work might have been preferrable. This is the burden of *Love Always*, Beattie's novel about fame. One of the motions the book traces gets repeated throughout Beattie's work: the flight from New York. Lucy has left the city to settle in Vermont. Another is the winnowing of love; Lucy repulses the return of one lover and sees through the charms of another. A third is the assumption of motherhood – or stepmotherhood – within the momentum of a successful if only mildly stimulating career.

Lucy is an eighties Miss Lonelyhearts; she writes a wry column for the lovelorn under the name Cindi Coeur. Beattie's decision to make Lucy a

minor artist – a kind of pop journalist – skews the plot in favor of an alternative, and one arrives in the figure of Nicole, Lucy's adolescent niece come for a summer visit. Nicole proves a walking allegory about the perils of generation. Back home in California she stars in a soap opera called "Passionate Intensity." She plays an "abused child from a broken family." The internist helping to rehabilitate her proves sterile, is fixed, can't conceive. The internist considers an affair but settles instead for "probably the correct thing: a childless marriage." Meanwhile Nicole's character gets pregnant and wants to abort. Someone else in the soap is writing a novel called *Barren*.

The first strong image in the novel is of a miscarriage, when the hostess of an otherwise vapid party suddenly remembers, in the last sentence of the first chapter, the feeling of blood running between her legs. The focus will scarcely return to her; she is Maureen, Lucy's competitor for Hildon's love. But for this one chapter and in this one sentence, Beattie pans away from her heroine and lets a caricature become a character. And the measure of Maureen's capacity for emotion and power to elicit our concern flows from her having suffered this particular kind of loss.

Yet the big event of the book is not the loss of the child but of a parent. While Nicole rests up in Vermont her mother remarries and is promptly killed with her groom in a motorcycle crash. After not seeing her debate the question we learn from Lucy fifty pages later that "Of course she was going to raise Nicole." And Nicole happily adjusts. How have we earned such an unlooked-for outcome?

Lucy's fame, like Nicole's, is based on something "facile." Neither woman enjoys any passionate intensity in her work. It is not hard to give up such work, to find little of oneself in it. It has brought them *only* fame. In having Lucy opt for motherhood without worrying about compromising her career, Beattie finesses the conflict, clears away ambition and men by minimizing their attractions. *Love Always* betrays the desire to enjoy an achieved choice without acknowledging the immense difficulty of making it.

The limits of *Love Always* are due, in part, to Beattie's anxiety about the issue of expressive form. Art is *not* about its author. Like Lucy and Nicole, she has worked hard at creating a body of work in which she cannot be found, or found easily. "Where You'll Find Me" is one of those answers Beattie leaves consistently in suspense; there is a sense of a self well – even coyly – hidden. As Nicole says about her role in the soap opera, "A lot of me goes into my character, but other stuff goes into being me." This may be true for Nicole, but it can scarcely be true, here, for Beattie. The soap opera can be taken as an exemplum of her career. Yet it hardly compels serious attention, so massive has been her reduction of her concerns. Who would want to find herself in *that*?

Throughout *Love Always*, readers and viewers insist on identifying Lucy and Nicole with the roles they adopt, and the two women just as vehemently reject the notion. Yet Nicole's onscreen life merges violently with her offstage one, and Lucy, in Chapter 24, must surrender the cover of her pen name and field letters addressed to "Lucy" and "Nicole." Composed entirely of letters, this chapter forgoes the arch distancing tone of Beattie's narration and deals with one subject: mother-loss. These are letters about the power to recast the self, but only if its implication in the old scripts is realized. "Remember that you are not just a teenage girl who has lost her mother, but a character in your own life, and that your life is under your direction." The language of art and life get happily confused here. This could be advice that Beattie, however indirectly, gives herself by writing the novel. The decision to deliver Lucy up to motherhood rather than art is not a wish fulfillment but an honest recognition of the value of a road not taken. *Love Always* may be Beattie's most personal book, and that is why it is so highly defended.

Beattie is wary of vertical human ties, of identity as something forged across a generation gap. The positive word for horizontal attachment is *friendship*, and in "Friends," Beattie exposes her generation's tropism toward affiliation. "Friends" proves, however, nearly impossible to follow. Here the collapse of the gap is chaos, a maze of relationships so horizontal that they are interchangeable. People function in such stories as replacement parts. They are less friends than users. Again Beattie reduces down to a condition of indifference. The solution is to become lovers, as Perry and Francie temporarily do – to impose some erotic tension on the mess. A second ordering power is fame. Francie's painting will get her "what she wanted – she was going to be famous." A third way out of the chaos of first names is one that Beattie's work will go on to more openly prize: taking care. This is what Perry is left to do. "Some days he thought that his importance in life was to take care of other people – that he would be remembered as the person who housed them and looked after them." For all her attention to fraternity, Beattie has from the beginning exercised a deeply *parental* imagination, one devoted to the society of care.

But caring entails enormous risks. In each of Beattie's books, a child is abused or lost. *Distortions* ends with two children burning in a boat. In *Chilly Scenes of Winter*, Charles must mother his mother. A couple in the title story in *Secrets and Surprises* has lost a child to leukemia. In *Falling in Place*, a brother shoots a sister. The first story in *The Burning House* (1982) deals with a brain-damaged child. Jane refuses to play "the perfect little mother" in *Love Always* and is killed. The first couple we meet in *Where You'll Find Me* mourns a dead daughter. In *Picturing Will*, the father goes to jail, the mother retreats into fame, and the boy becomes the

project of his stepfather. Children are lost even before they are born: Beattie fills her stories with abortion, infertility, miscarriage. Damage and children are repeatedly associated: "each also had in common the responsibility for a damaged child." Beattie's theme might seem, therefore, to be the lost innocence of children. Yet she rarely writes convincingly from the perspective of a child. Her interest rather is in the effect of the idea or event of the child on the adult mind. Her adults are asked to imagine – to picture – children, and they usually fail. The work is less about a child's liability to fall than an adult's refusal "to rise to the occasion," as she puts it in *Picturing Will,* of being a parent.

This is why, for me, there is no more courageous writing than in the six pages of the story "Afloat," in *The Burning House.* The narrator is spending the summer with her second husband and his sixteen-year-old daughter. Every year Annie's mother, Anita, has her hand-deliver a letter to her father, and this prompts a discussion of first marriages. The narrator falls into a long, two-paragraph reverie: "I never had any doubt when things ended with my first husband." She remembers a moment when, on a country visit, he had swung "a little girl" repeatedly over his head. "He was keeping her raised off the ground, and she was hoping that it would never end, and in that second I knew that for Dan and me it was over."

Beattie's narrators rarely recognize drama or achieve insight. Here a speaker gets both. The energy flows from the sudden awareness of a lack, a lack that, at the story's end, becomes the ground for transforming sympathy. The narrator has just kissed both father and daughter while they all float in the water. Annie looks aggravated.

"I guess your mother's not very demonstrative," he says.

"Were you ever?" she says. "Did you love Anita when you had me?"

"Of course I did," he says. "Didn't you know that?"

"It doesn't matter what I know," she says, as angry and petulant as a child. "How come you don't feed me birdseed?" she says. "How come you don't feed the carrier pigeon?"

He pauses until he understands what she is talking about. "The letters just go one way," he says.

"Do you have too much *dignity* to answer them, or is it too risky to reveal anything?"

"Honey," he says, lowering his voice, "I don't have anything to say."

"That you loved her and now you don't?" she says. "That's what isn't worth saying?"

He's brought his knees up to his chin. The scab by his elbow is pale when he clasps his arm around his knees.

"Well, I think that's bullshit," she says. She looks at me. "And I think you're bullshit, too. You don't care about the bond between women. You just care about hanging on to him. When you kissed me, it was patronizing."

There are tears now. Tears that are ironic, because there is so much water everywhere. Today she's angry and alone, and I float between them knowing exactly how each one feels and, like the little girl Alison suspended above Dan's head, knowing that desire that can be more overwhelming than love – the desire, for one brief minute, simply to get off the earth.

This passage delivers one of the most satisfying emotional confrontations in Beattie because it converts her typically suspended emotion – or "heavy disembodiment" – into a kind of negative capability. It is difficult not to be moved by the drama of a child defending the dignity of an absent parent, and, beneath that, the stepparent's comprehension of her anger because she has not had a child. One does not have to bear children in order to love or understand them; few things seem more likely to threaten such capacities than a blood tie. In a social order based upon divorce, the lives and histories one is called upon to imagine multiply almost uncontrollably. Yet the only hope for love of any kind between anyone rests upon just such imagining; in the seventies and the eighties the fluidity of human bonds has asked many of us to form strong and sudden ties to stories in which we have played no early part.

Beattie's work reverses the familiar logic of fairy tales; for her, the stepparent is the good parent. Stepparenting is an imagined bond, an act of the mind. It ought also to involve a perpetual curtailment of the will. *Picturing Will* puns this logic into focus. If the novel details the difficulty of seeing Will, the child, it also delivers up an image of conflicting human wills, the struggle among child, mother, stepfather. Five years after *Love Always,* Beattie takes up again the story of a woman and an artist going after what she wants.

Beattie divides *Picturing Will* into three sections: "Mother," "Father," "Child." In the first, photographer Jody's rise to stardom is confirmed by herself being photographed in *Vogue.* In the second, stepfather Mel accompanies Will on a trip to see his natural father, Wayne, in Florida. On the way the two events of the novel occur. Will witnesses the arrest of his father, and the seduction of another boy by Haveabud, Jody's gallery-owning promoter. In the third, the adult Will, now an art historian at Columbia, visits for his mother's birthday and discovers that for twenty years Mel has been at work on a novel about child raising.

Jody chooses creation over generation. She turns people into things, photographs. Her perceptions are unfailingly aesthetic, and we are made to feel that they leave a great deal out. To see the world as a composition may be to overlook it, however, as field of action. Depth of field: This is what Jody's perspective seems to lack, a sense of how figures stand in emotional rather than physical space. She can picture Will, but can she feel him? He slips past her frame and falls into early pain. As a sentence in the third chapter begins, "His own experience of pain had been the result of falling. . . ." Will will survive – the brief and final section is meant to show that – and Jody will never know. The novel does not focus so much on the care a child has missed as on all an adult has missed in not giving it. Beattie looks hard here at the cost to an artist – and a woman – of choosing to do art for a life.

As the opposite of Jody, Mel has a creation anxiety. It happens that he's an artist too – a writer – but he has chosen to suppress this and to assume as his primary identity the role of a parent. The four italicized sections that punctuate the novel turn out to have been written by Mel. Their use of the second person and attempt to look from "*the child's perspective*" give them a disarming intimacy. Mel effaces himself as an artist and gives Will the key to his papers only on the novel's last page. In these italicized pages, which we have already read and that we imagine Will reading as the story ends, Mel wonders why he has not made more of them. "*The trouble might simply have been that I was wary of creating something. A child – I would have created a child; the physical creation of something didn't scare me – but words . . . perhaps I was reluctant to let language transport me.*" Mel does not define attention as fixing a thing in time and then moving on, as Jody does. "*Her feeling has been that people do things, then abandon the worlds they have created.*" Jody's love for her work also allows for something the love of a child does not – an exclusive relation. She can make it, and she can leave it behind. Works of art do not *depend*.

"How would Will deal with his mother's becoming a star?" How does the reader? If the judgment on Jody seems potentially harsh, there is also something inspired in her selfishness, a devotion to work that approaches self-sacrifice. Through her dedication to an ironic and elegant vision, she has, as is said about another character in the novel, "*lost his life and become, instead, a work of art.*" This is said by Mel about Orion, "*a perfect myth for the late twentieth century.*" The myth accurately registers Beattie's sense of the human cost to anyone whose "time and energy," as Will thinks about Jody at the novel's end, "are still reserved for her career." It is about "*a woman with the power to convert her mistake to splendor,*" the power to convert even the loss or destruction of love into the radiance enjoyed by a star.

Unlike *Falling in Place,* Beattie's fourth novel is not about negligence. It is not even about what to choose. It is simply about being honest about one's choice. Will admits that Jody "has been consistent" in her pursuits, and Mel admits that she has admitted it: *"You love someone whose mother has admitted, on occasion, to wishing him away so that the complexities of her life would become simple matters. She pursued fame, and left it to you to pursue baby-sitters."* *Picturing Will* argues that character is the refusal of regret. Jody knows what she has chosen and is honest about the price of things. And yet the novel's conception of the relation of art and life is too binary to satisfy. The seemingly exclusive choices made by Jody and Mel have in fact already been exposed as reductive in Beattie's strongest book, the 1986 story collection *Where You'll Find Me.*

"Forgetting a child": the phrase comes from "Janus," Beattie's most concentrated short story. In the story, the phrase forms part of a simile, one in which the central character searches for a comparison worthy of her attachment to a beloved thing. In these seven pages, Beattie engages in a complex study of the limits and powers of human attention and so generously confounds *Picturing Will*'s distinction between two kinds of love.

Andrea, a real estate agent, owns a remarkable bowl. The story's first sentence tells us that "The bowl was perfect." Her husband is asked not to leave his keys in it. Andrea places the bowl in houses she is trying to sell, and it seems to bring her luck. One day she leaves it behind – this is like "forgetting a child." She gets it back and begins to fear for "the possibility of the disappearance." At the story's end, we learn that the bowl was a gift from a lover, and that when she would not decide in his favor, he had left her and called her "two-faced," a Janus.

The story encourages at least two readings.

In a world based on "the pleasure of new possessions," the bowl is the ultimate thing. It is clearly compensatory; both Andrea and her husband "had acquired many things to make up for the lean years." Yet it is not a thing like other things – like the Bonnard, the Biedermeier, the Leica. It is a thing that is not a status object. Andrea feels grateful toward it, judges it "responsible for her success." She fantasizes a "relationship" with the bowl, becomes obsessed by its possible loss. The very structure of the story – beginning and ending with a paragraph focused on the bowl – suggests her secondariness, dependency. Beattie has fashioned a story to record again the ways in which people in a world of "prospective buyers" become functions of things.

Or: The bowl is a shape to fill a lack. In it Andrea finds compensation for not having a child. Clearly aligned with a woman's inner space – "There was something within her now, something real, that she never

talked about" – the bowl figures forth Andrea's unspoken decision about motherhood. "It was meant to be empty." Andrea's responses to the bowl reverse the standard developmental sequence. She begins by granting it independence, falls into an anxiety of attachment ("the idea of damage persisted"), recalls the moment of its conception – her lover's "I bought it for you." Beattie has fashioned a story to record again the ways in which a woman's imagination recurs to a displaced drama of generation.

Yet these are inadequate readings of this story and of Beattie's career. In "Janus," Beattie has so sublimated the themes of a lifework that they cannot be separated out from the experience of the story and carried away as portable truths. "Janus" implicates us rather in the impossibility of exposition and the necessity of *reading*. Reading involves a take on something, a submission to the wonder of unexpected supply. The bowl suggests "motion," and Andrea keeps circling it. Reader and character are caught up in an activity in which viewpoints shift. In the first sentence, the bowl is seen as "perfect." At the end, "In its way, it was perfect: the world cut in half, deep and smoothly empty." The repetition of the adjective recalls to mind the story's beginning, measures the distance we have traveled, admits the modification achieved, and asserts the integrity of a mind that continues to refine its perceptions without repudiating any one of them.

"Janus" marks Beattie's movement from irony to ambiguity. In thinking about her husband and herself, Andrea notes that "while ironies attracted her, he was more impatient and dismissive when matters became many-sided or unclear." Two stances emerge here: irony, or singlemindedness. Both are reductive, modes of simplification. Neither proves adequate in a story with language this flagrantly interpretative:

> it was both subtle and noticeable – a paradox of a bowl. Its glaze was the color of cream and seemed to glow no matter what light it was placed in. There were a few bits of color in it – tiny geometric flashes – and some of these were tinged with flecks of silver. They were as mysterious as cells seen under a microscope; it was difficult not to study them, because they shimmered, flashing for a split second, and then resumed their shape.

It would be a mistake to focus too much on the image here. Beattie's strategies are rhetorical, not iconic; she wants to throw us back on the status of our response, rather than make us "notice," as she writes at the end of this paragraph, "some object." Like our most famous verbal icons – Keats's urn or Stevens's jar – these things are summoned in order to tease us *out* of thought, or into thought about how we think. The men

in Andrea's life want to reduce the "many-sided" to the "two-faced," but Andrea reveals that through the act of attending to a thing we assume whatever irreducibility we have, give possibility its being. In its continual unstillness – its surges of warmth and chill, ascriptions of likeness and difference, findings of satisfaction and lack – Beattie's story becomes the story of the act of the mind.

Reading "Janus" returns us once again, then, to Beattie's true and indisputably claimed ground, to the story of how we keep a thing in mind. "What she believed was that it was something she loved." "Janus" and the career of which it is a part can be read as an inquiry into the sustained act of attention we call love. Her characters and narrators usually let their attention lapse, and irony rushes in. But in "Janus," a character's devotion to her study becomes a figure for Beattie's to her craft, and for, perhaps, her best reader's commitment to reading it. This is love, after all – to keep looking and studying and caring and going back to retrieve something forgotten even while the possibility of damage and disappearance persist. Love is risk, the chancing that what we give over to the love "object" may not be acknowledged, valued, or appreciated. And whether it is the child we conceive or parent, or the moving rather than the static story we write for a reader yet unknown, both must be sent out into the world protected only by the power of our care.

Beattie gets possibility into a book, then – both the familiar possibility of loss and the new possibility of imaginative adventure or love. *Where You'll Find Me* begins and ends with a party in the snow. From the first party a couple who have lost a child return home and lie down together in the living room, to keep each other warm in the dark. At the last, a boy "makes a lunge . . . toward wider spaces." This recreates the motion of the book as a whole, from a fear of "uncertainty" toward a willingness to lunge. In a world where "what happened happened at random," we can either try to "predict the future" or surrender to the "skid," Beattie's recurring image for the uncontrollable slipperiness of our lives. Yes, it is still true, as it was in *Chilly Scenes of Winter,* that "Very few days were like the ones before." What we see in these stories, however, is not a submission to the course of things but characters whose minds flash forward and backward in time. "She knew that people and things never really got left behind: you'd be surprised into remembering them; your thoughts would be overturned." On the same night a woman feels herself blocked in both love and work, an old friend goes into a skid and sees "her again, in a vision. *Nancy Niles!* he thought, in that instant of fear and shock. In a flash, she was the embodiment of beauty to him." An immense conservation of energy has begun its work here, as in the next story, where Renee accepts that things really never get left behind, that life mounts up. The offered option is to embrace the next

thing, to refuse the sense of life as brute, unpredictable sequence and to enter it as a field for expectation and gratitude.

"Where You'll Find Me" unfolds as a drama of responsiveness, of the ways in which people attend to or miss one another. Beattie's title story is as open about this process as Joyce's "The Dead" and places as much weight on the revealed capacity to imagine someone else. Instead of relying on feints and ellipses, characters openly confront one another about the meaning of behavior. " 'You know what you do, Mom? . . . You make an issue of something and then it's like when I speak it's a big thing.' " Beyond this, Beattie creates her most judgmental narrator, a woman not content to play it as it lays but who, instead, pounces on bad behavior and convinces us that we should care about it. She exposes her sister-in-law's banal cruelty in her asides – "my boredom and my frustration with Kate's prattle" – and in the conversation she chooses to quote: " 'You have to acknowledge people's existence.' " This narrator abandons any standard of detachment for passion and anger. "Who am I to stand in judgment," she asks, and then she judges. It is a great relief.

So, by her seventh book, Beattie abandons irony for ambiguity, coolness for arousal. She no longer prizes anything that could be taken for minimalism, the style of what she once called "things left unsaid." She still worries over what an artist and a woman can make. But she also takes the measure of what she has made and builds this, too, into "Where You'll Find Me." When the narrator and her brother finally get to talk, he says, " 'Confide something in me.' " So she tells him about a chance attraction to a man in a San Francisco restaurant, and the ensuing intrigue. She tells him very well, draws it out. " 'That's an amazing story,' Howard says." Then they go to get ice, and on the way Howard gives her the same thing back. " 'I fell in love with somebody,' " he says. When his sister asks him, " 'What are you going to do?' " Howard answers – " 'Get ice.' " He answers her literally about a figurative fate; he cannot prolong, elaborate, or even imagine that he has a story.

Not many people can tell stories, but anybody can learn to listen. It doesn't matter that both stories are about love, impossible love. They are *like* each other. Everything is not, as Banks says, "basically different." Because one story is told badly and one is told well, we can realize that beyond the comfort of likeness there lies a further need – for willingly sustained, expansive, romantic stories. Here, at the end of her strongest book, Beattie can find no more moving figure for the possibility of human response than an activity in which two are joined by caring about a third thing – a woman, a man, and a story.

FAMILY ROMANCE

Sue Miller

Ethan Mordden

Alice Walker

Freud taught us that the family had made us sick, and, that to grow well, our sickness must grow worse. He never imagines a realm of human fulfillment beyond a culture made of families. Any attempt to escape families is merely running in place: One's place is what one must accept and work through, and the evasion of the task only aggravates the need to submit to it. By running away from home, Oedipus runs into it; his meeting with Laius at the crossroads – a key moment in his story – is an encounter not with his father's authority but with his ubiquity. We cannot escape what we are, this argument goes, and what we are is a self in a system.

Feminist and Marxist literary theory mesh in their account of the family as an institution that oppresses. Books like Michele Barrett's *The Anti-Social Family* (1982) and Rosalind Coward's *Patriarchal Precedents* (1983) fuse these perspectives in a language as clear as it is dogmatic. Novels work upon us in different ways, exploring rather than imposing answers. They confront us with the complexity of an *is,* not the simplicity of an *ought.* The novel could almost be said to be the book of the family, despite the prominence in many traditions of the *bildungsroman* and other plots of solitary initiation. Novels embody in story what theories can explicitly pronounce, and the best of these so sublimate their positions and attitudes that they can work on us with an unconscious power.

In recent American novels, the critique of the family runs across gender lines while also betraying marked differences between male and female visions. Male writers like Robert Stone, Russell Banks, and John Casey have given us brilliant fictions in which male protagonists spurn what they crave, a family in which male authority and efficacy remain intact. In *A Flag for Sunrise* (1977), Frank Holliwell seems to have lost his family to a mysterious process:

> He was thinking about his wife and his daughters, and how, though he had stayed – would never leave now – he had lost them. He had thought to do everything right – he believed in love. There had been something, perhaps, that it was not possible for someone like himself to know and his not knowing it had lost them. The hard way, little by little, without an outcry of any sort.

Holliwell's lecture on Culture and the Family concludes that the family is "an instrument of grief," and the grief inheres in the inexplicable passivity with which Stone's husbands and fathers compromise or neglect its bonds. All is lost unknowingly. Banks's *Continental Drift* (1985) conjures an even more hapless hero, a New Hampshire oil-heater repairman who finds himself breaking his car windows one winter night in hatred of his

life. Bob Dubois breaks out of his family as if it were a cage, and then steps back in at the brink of having destroyed it. He dies, but not before his wife has agreed to one more try. In Casey's *Spartina* (1989), the man's willingness to gamble family away gets a positive twist. Dick Pierce risks his life at sea with his boat, and his marriage on land in the affair with Elsie. Wife May saves him from the latter loss by her profoundly understanding response to his adultery, by "her having a right to bitterness and choosing another kind of feeling." In this beautifully reassuring fantasy, the wife chooses above all to honor her husband's fatherhood, to insist that he care for the child he has conceived in the affair. Dick is thus allowed a kind of informal polygamy, as he and his wife pull together to protect the fruit of another union. As far out as he has moved, the story permits him to come back.

Common to these three novels, then, is that peculiar brand of emotion we call "ambivalence," a stance toward experience – a luxury, really – that proves characteristically male. The stance is available to persons who believe that the family is theirs to make or break, an institution or "instrument" they have built, and that they can destroy. These novels do not interrogate the family's structure, or its function, focusing instead on the heterosexual male's struggle to accommodate it. Even when lost, the family is affirmed as a fact, not explored as a construct.

Those most suspicious of this ambivalence are likely to be women and gay men and, when confronted by the subject of the family, are more likely to explore alternatives. In *The Color Purple* (1982) Alice Walker supplants an abusive patriarchy with a working colony of women, one in which men abide, but not in pants. Jane Smiley's *The Greenlanders* (1988) transposes the question to a fourteenth-century Norse settlement only to reveal that the abiding threat to the family is not male ambivalence but female desire – and the punitive social response to it. Gloria Naylor's third book, *Mama Day* (1988), finally invents a nurturing male and husband only to have him die that his wife might live. In *The Family of Max Desir* (1983), Robert Ferro imagines a family tree – imaged on a quilt – that openly displays the names of its homosexual bonds. There is nothing mysterious here about what makes families fail or demand revision – it is straight male power. These writers can situate themselves imaginatively beyond the horizon of the family because it is an institution that does not seem to belong to them. This does not prevent them from feeling possessed by what they do not possess. Male self-pity gets replaced in these stories by an emotion more like rage. For these novelists, the family is less the instrument of grief than the origin of anger.

In his essay "Family Romances," Freud details a syndrome in which patients seek to reinvent their parentage. The replacement of father and mother "by others of better birth" is a fantasy basic to fairy tales. Re-

sistance to the family of origin does not take the form of undoing but of refiguration, in a finer tone. A striking aspect of the contemporary literatures of "difference" – of gender, sexual preference, and race – is a similar fantasy, one that imagines a structure full of relation and yet free of the name of mother, father, son, daughter. Yet forgetting coexists with what is not remembered, and these forgetful texts can be shadowed by the imminent return of the social form they have repressed. The scope and persistence of the imagined alternative becomes a measure of the forces it resists. In their attempts to imagine new forms of filiation, Sue Miller (b. 1943), Ethan Mordden (b. 1947), and Alice Walker (b. 1944) forward a generation's moving and embattled Family Romance.

SUE MILLER

Sue Miller's *The Good Mother* (1986) tells the story of Anna Dunlap and her three-year-old daughter, Molly. As the novel begins, Anna and Molly are settling into Cambridge after the divorce from lawyer husband Brian. There Anna meets painter Leo Cutter, with whom she becomes, "finally, a passionate person." The phone rings one day while Molly is off visiting her father, and it is Brian calling to say that "She's not coming back." Molly has touched Leo's penis. In the custody trial that follows, Anna loses Molly to the law, and Leo to the rich confusion of her emotions. At the novel's end, Molly, now seven, lives with her father's new family, while Anna has resigned herself to a solitary life of part-time mothering.

In writing about a novel of a woman's experience, it may seem strange to begin with the penis, with Brian, with the father. But Miller's book honestly confronts what stands in the way of her writing it. "Women" are a category of experience available to the imagination only through the mediation of "men." As Jane Gallop argues in *The Daughter's Seduction* (1982): "If feminism is to change a phallocentric world, phallocentrism must be dealt with and not denied." Miller has no more free access to her subject than Anna does to her anger. And Miller is not a sexual separatist, although her heroine will become one, by default. The story of Anna Dunlap is the story of the search for her absent passion, her abducted body, and in the search Miller's novel launches a courageous inquiry into the pain caused by our familial and sexual arrangements.

At the center of Miller's story of a woman's life is a penis. What is done with it determines the fate of the characters. Anna accepts Leo's into her ass just before asking what he and Molly did with it. Punishment – painful sex – becomes the vehicle for reward. The mother's gesture may seem excruciatingly ironic; even at the moment when the penis has imperiled everything – perhaps *because* it has done so – Anna submits to the old law, to the notion, dismissed laughingly earlier, "of every woman simply needing a good fuck." Does the daughter's gesture betray a similar irony, or is it a verification of the very foundation of the law, one more case of "penis envy"? Molly asks to see and touch; Leo lets her do it. So the penis appears to answer Molly's curiosity just as it fills Anna's need. Mother and daughter live in a world in which the phallus is with them – and between them – always.

Yet, as with all transcendental signifiers, the career of the phallus is strangely fugitive. Miller never dramatizes the seduction scene, and Molly never gets to tell her story. We know of the crucial epiphany only by report. When Brian first calls he can give the act no words or name:

"Ask him how much fun he had with my little girl." Then Anna gets to
ask Leo about it, just after he has withdrawn from her body.

> I felt him slip away into sleep lightly, just as I moved sharply
> back into the world, just as everything returned.
> "Leo," I said.
> "God," he answered, his voice whispering slowly, dreamily.
> "What other wonderful ideas did you have while I was gone?"
> "Leo," I asked. "Leo, did you ever touch Molly, her body I
> mean. Did she ever touch you? Wake up," I said.
> His fingers reached towards my face, felt my wet hair, my open
> mouth. We lay in the garish silence a minute.
> "Yes," he said.

At this point the chapter ends. White space. The next chapter begins,
"When I called my lawyer on Monday. . . ." Within that space, Anna
falls out of the world of love and into the world of law. The reader must
wait to get the gloss on Leo's "Yes." The gap is the key formal gambit of
the novel. It not only marks off its two halves (the fiction of freedom and
the fiction of fate); it inscribes the rhythm of repression and delay at the
heart of Anna's story.

Two things get denied by the gap: the reader's curiosity, and Anna's
anger. The anger it would take to turn upon Leo, to fight for her child
("you never even *tried*, Anna"), to change the world – for herself, for
women – this is the fugitive power whose release the novel endlessly de-
fers. When Anna finally does get mad, she breaks some dishes, cuts her
hands on them, steals a gun, and shoots it into the sand. Anger for Anna
is a closed feedback loop; even her name is a palindrome, a figure for
self-enclosure. If, as Josephine Hendin argues in *Vulnerable People* (1978),
rage is the subtext of our novels about sex, *The Good Mother* invokes rage
by its absence, as the inferred thing. As a good mother, Anna seems to
forget her response to the "Yes" until, nearly one hundred pages later,
her lawyer, Muth, triggers it in the courtroom. "I remembered lying si-
lently a long time next to Leo in the half-dark after he'd explained it to
me. The light's glow made everything ugly. I didn't remember saying
anything. I had been crying." As a dutiful author, Miller satisfies our
curiosity about the event within only ten pages, when she lets Leo tell
his story.

Molly had come into the bathroom and talked to Leo while he show-
ered. When he pulled the curtain back to dry off, he noticed her staring
at his penis. He did a routine from *Singin' in the Rain*.

> "And then I finished, and I was just drying off, and she said, out
> of the blue, 'That's your penis?'" He cleared his throat. "You

know, she was learning that stuff, those words. She had a book that talked about it, and they did the body parts at day care. Her mother – Anna – had talked about it some too, telling her the names of stuff." He shrugged again. "So I said yeah. She was, she was standing up, she'd gotten closer to the tub. I was, actually, a little uncomfortable about it. But I'd seen how relaxed Anna was about it all, and I didn't want to screw that up or anything. So I tried to seem natural, not cover up or anything.

"But then she said, 'Can I touch it?' "

Muth looked up sharply at Leo, his pencil still on the yellow pad.

"I honestly didn't think about it for more than a second. I just said sure. And, um, she did. She . . . held it for a second. And just the contact, I guess. The contact, and I think, the kind of . . . weirdness of the situation made me . . . that is, I started to get an erection. And I said, 'That's enough, Molly,' and I turned away. I put the towel on. She made some other comment, some question about my . . . about it getting big. And I told her that sometimes happened with men. And I went and got dressed."

It is the account of this incident, told and retold, that makes Molly's father mad and her mother sad.

The plot turns upon the anger of the father. It's an obligatory anger; Brian has shown only modest interest in Molly before the event and disregards Dr. Payne's eloquent plea that "to move her to her father's care now would be to wound her, scar her again." The quality of Brian's anger partakes of a delayed response to a comment Anna made to him early in the novel, during the period of the divorce. When he had asked her why she found his admission of an affair unsurprising, she answered: "Well, the sex between us was always so . . . nothing. So terrible." What Anna did to him in saying this, what Molly does in touching Leo, provokes in Brian more than "the cry of wounded vanity." It provokes, in the words of Virginia Woolf, "a protest against some infringement of his power to believe in himself."

The rumor of seduction is the rumor of the father's power. The seduction withstood, that is; the father's power depends upon his ability to arouse and suppress the daughter's desire. Jane Gallop has shown us culture as the perpetual seduction and frustration of the daughter. "The only way to seduce the father, to avoid scaring him away, is to please him, and to please him one must submit to his law which proscribes any sexual relation." Lear never sleeps with Cordelia; Adam Verver never beds down Maggie. Even to put the thought into words is vulgar, a breach of taste, yet for nearly a century now we have had no trouble gossiping about Hamlet and his mother. Our fascination with the one

kind of desire proves inversely proportional to our interest in imagining the other.

And over what should Brian's anger be? The scene as narrated by Leo is ambiguous: Who seduces whom? The scene as it occurred goes undramatized and unseen; there were no witnesses, and only one participant speaks directly in the text about it. The effect of the scene upon Molly, which the experts seek to determine, is impossible to judge. We never get at Molly because Molly cannot be gotten at; a girl's – a woman's story – is mediated by silence, just as a patient's is by fantasy. The evidence offered by the text provides no way to sort out either complicity or consequence. In the early days of psychoanalysis, the women who came to see Freud had a recurring tale to tell: In childhood, they had experienced some kind of sexual abuse. Freud had begun by believing his female patients, but he eventually abandoned the "seduction theory" that posited actual abuse as the necessary origin of neurosis. "In the period in which the main interest was directed to discovering infantile sexual traumas, almost all my women patients told me that they had been seduced by their father. I was driven to recognize in the end that these reports were untrue." Freud concluded instead that these reports were fantasies that bespoke the daughters' own desires. Recent scholarship has shown us that the fantasy was acted out more frequently than Freud wished to believe. The resistance of the culture to imagining father–daughter incest finds its equivalent in Freud's resistance to crediting its reported occurrence. The actual cases get ignored, while the unimaginable seduction grows in repressive power. Miller's concern is not with our culture's rampant child abuse, or with the harm a completed seduction inflicts. She focuses instead on the ranges of reaction to a rumored seduction that constitute our sexual politics.

In many ways it is not Leo's but Brian's penis that gets touched, the penis of every one of us. It proves common, legal property. When Brian mobilizes his anger and the anger of the state, he reveals the literal penis to be the symbolic phallus, the organ whose lack or presence structures the unconscious in a patriarchal culture. When Molly touches the penis, she reenacts her own discovery of castration, and her entrance into the symbolic order, the world of separate, speaking subjects that forces upon her the lonely knowledge revealed in her first conversation, "That I can make love all by myself." In the cultural conflict ensuing from Molly's act, the penis gets caught up in an agony that reconstructs the process that allows Lacan to claim that the phallus institutes the human psychology of lack, the inevitable human sense of separation, loss, and interdiction he calls the Law of the Father.

Yet how much does Molly necessarily lose? Miller's treatment of the episode suggests that a phallocentric reading of it is just that – a read-

ing – and that Molly's fall is not naturally given but culturally enforced. Later, Dr. Payne will say of Molly that "There *is* some anxiety about sexuality. But my feeling is on that score, she's most anxious that something she said about Leo upset her father as much as it did. *And . . .* maybe a little interested in how much attention it got her." Molly's culture insists that the penis be seen just as much as it insists it not be touched. The onset of castration anxiety must not be confused with seduction; a socializing mystery must not be compromised by knowledge, or pleasure. But in touching the penis Molly fulfills a desire to touch the phallus. She touches it and lives; she even has the power to arouse it. The recounted scene is mildly comic; Leo dances and sings, Molly puts her hand out and does a magic trick. Here Molly disrupts the proper exchange or traffic in women; she gives *herself* away. When Molly moves beyond sight to touch, and so onto a mutual circuit of desire, she violates the acceptable mode of passage into the social and symbolic order and enters into a relation to the phallus that the Law and the Father must mobilize themselves against.

When Molly touches Leo's penis, she acts out an allegory the culture cannot afford to know. Henceforth life becomes mediated by "experts": lawyers, psychologists, family service officers. Even her maternal grandfather stands revealed as what he has always been: a judge. When Anna visits him to ask for money for her defense, he immediately puts her on trial. "The whole weight of the law is in your favor, isn't it?" he asks. The question echoes hollowly in a novel where the first thing we see a judge doing in a courtroom is telling a woman to "shut your mouth." Anna's subsequent treatment at the hands of this system allows us to venture this definition: Law is the structured power of male anger, and the anger is a measure of repressed desire.

Brian steals her daughter, but not before stealing Anna's dreams. Just after introducing Leo, Anna segues into a memory of Brian. "When I was married to Brian, I often had the sense of having been absorbed by my role or by him. Sometimes I felt that I'd absorbed him." As example she cites a day of recounting dreams with friends. Anna tells one, and then Brian "told an elaborate dream." As she listens, she feels "anger and pity for Brian. He had forgotten that it was one of my Chicago dreams." When the husband steals the wife's dream, makes it his story, one can think of another auditor of dreams, a man who assimilated the dreams of Irma and Dora to a male myth of development.

Miller writes about a world that has not listened to women's dreams, that converts female testimony into male discourse. My own analysis of Miller does this as well. I have imposed an aggressive, male-centered interpretation on a novel that patiently, almost languidly builds up a sense of a world through casual acts of digression, association, and repetition.

Any detail that one pauses to notice proves overdetermined – resonant – yet Miller obscures her art through the fiction of the narrator's insistent reverie. The pleasure of *The Good Mother* lies no more in its deep argument than in the play along the vagrant surface of the text.

Take the experience of touch. The action turns upon a moment of touching, Molly's "Can I touch it?" Yet Anna's "touching" imagination has so naturalized us to life's "exciting, random touch" that we should experience Molly's act as a shock, but not as a surprise. The first paragraph ends with Anna's remembering the postmistress in Maine and the way "her touch would leave powdery prints on the envelopes she slid towards you under the grille." This is a fantasy inside a reverie: Anna calls it up while watching her daughter enter the East Shelton post office, years later, and the full sentence admits that the prints themselves are an imagined thing, a trace "you half expected her touch would leave." Both the position and the complexity of the image announce Anna's romance with the indelibility of touch. There is the "tiny streak of grease" left by Molly's fingers, or Leo's "arched footprints" on the steamy linoleum floor. There is the necessity of resistance against the family's "sticky grip," or the thoughts all her own accompanying Anna on those mornings when she "began to touch" herself. "Can I touch it?" is finally the question Anna asks about the world, and the surest sign of her defeat is that she goes dead again, at the end, to touch. Her progress from pianist, to rat handler, to typist marks the declension of her hopes. Anna discovers that culture entails the codification of touch, the conversion of the sensory and the passing into the illegal or the forbidden. Her focus on the aftermath of touch – its prints – implicates her in the conviction that touch leaves something evidential behind. If Anna's body is brought to life by her own hands and by Leo's "touching me," it also proves the site of legislated touch, an entity always at risk through the acceptance or offer of the hand.

Anna has a vagrant imagination. It is extra-vagrant, or extravagant, in Thoreau's terms: "I fear chiefly lest my expression may not be *extravagant* enough, may not wander far enough beyond the narrow limits of my daily experience." Confined within a daughter's and a mother's domestic round, Anna's eye falls startlingly on things, wanders toward hidden possibilities of likeness. We notice this particularly in her life before Leo. There is the initial tropism toward metaphor in the first paragraph, where the "postmistress would appear from the similarly mysterious bowels of the house." At the notary's, she notices the cat's "wrinkled pink anus." Standing in the yard over a wounded bird being finished off by her father, the pregnant Anna looks down at her "extroverted navel like an obscene gesture." She dances before her "special record player just for the tiny 45s, with a thick phallus for a spindle." A baby, held out the

window of a passing car, drops pee into the air before her like "glistening jewels." When she thinks of cousin Agatha, arrested in New York as a prostitute, she remembers her saying, as her mother changed her diapers, "*Big* stinky." What may seem like adventitious detail actually registers Miller's fidelity to the obsessive integrity of human attention. As ever, free association proves the most binding form of self-disclosure. For Anna, memory is the persistence of shame, and the quirky turns her attention takes pay continual homage to this source. She senses the world as a hidden or scattered body. Intuitively, unconsciously, she tries to retrieve and integrate the lost pieces, to restore her "forgotten sense of self."

Restoration comes, for a time, with Leo, and the associations stop. *The Good Mother* explores, then, a terrible kind of freedom: the freedom to find and lose desire. Sex and sexuality are not born but made; the human adventure entails a continual construction and deconstruction of the erotic self. But this freedom stays limited in a culture in which the erotic is founded upon anatomical difference. Anna learns to privilege the act of penetration and so becomes another prisoner of (heterosexual) sex. Desire proves not free but structured, and around a complex that can be described as patriarchal.

Anna counts orgasms. With Brian "I'd always been frigid." After Leo, she does not "want to have sex." But in the chapter given over to the affair, sex becomes a project. "It was then, in the mornings in my room, that I began to come predictably with Leo." The repeated phrase "I came" comes to take on a curiously literal sound: I arrived, I showed up, I was *there*. It is a dutiful response, perhaps a daughterly one. Anna's litany of "comes" celebrates her mastery of obedience to another realm of achievement. With any stage of liberation comes the challenge to meet a new standard; we have learned since Masters and Johnson that knowledge of the route to pleasure is often purchased with a loss of power. Anna does love Leo, and they have what we call "great sex," but her style of enjoying it, along with the very brevity of the affair, fails to deliver her to a "life without limits."

So the discovery of pleasure leads, for Anna, to the castration of desire. The most eloquent paragraph in the novel – an extended simile on the double loss of music and love – reveals blindness as the price of fulfilled desire.

> I read somewhere that the blind who once were sighted see again in their dreams, and are grateful for the fleeting return of the faces of those they love. I can remember waking from dreams as a child, happy dreams in which I had things I wanted – sometimes forbidden foods or money. Occasionally I would be playing the piano,

making impossibly beautiful music. For a moment at the return of
consciousness I would believe so powerfully in the dream that I
could still feel the sticky coins in my hand, I could still hear the
accomplished music, taste the warm rush of saliva that filled my
mouth. The sense of loss on awakening those mornings was
wrenching, the grief at coming back to my impoverished, hungry
self. But what I feel when I dream of Leo, even sometimes just
when I experience his waking memory, is compounded in the way
I imagine the grief of the waking blind is compounded. They must
mourn not just the things which are gone, the faces they won't see
again outside those moments of sleeping grace, but also the lost ca-
pacity itself to see. The memory, the moment of sight behind
closed lids, is a memory too of the disease, the tragedy which took
sight away; the beloved face is also a talisman of that disorder, the
panic of that loss.

Miller here recovers the pathos of Milton's twenty-third sonnet, where
the blind poet dreams of the face of his dead wife, a face he had never
seen. Milton's honesty of imagination allows him only a minimal sur-
mise. The face comes "veil'd," and the poem ends with an interrupted
embrace and the fall back into the impoverished, hungry self: "I wak'd,
she fled, and day brought back my night." Like the dreamer in the son-
net, Anna mourns not only lost love but also the loss of the very capacity
to love, the token of diminished power signified in the felt blindness of
the eye. Miller's concession to the tragic limits of desire comes not in a
final line of waking to darkness but rather in the simple placement of the
paragraph. She places it at the opening of the chapter in which we meet
Leo and so brackets the central episode of gain with the sure presentiment
of loss. And the loss, like Milton's, is "compounded." By loving Leo,
Anna loses not only him but also a way of being in the world that had
been deeply her own, a unique "capacity itself to see."

Anna's "shameful" associations return immediately after Brian's
phone call, when Anna moves automatically to wash the dishes and
squirts out "the thick white soap, viscous as come." The clean thing is
dirty again, and shame will win the day. Anna here falls out of the world
of free association and sexual pleasure and into one of imposed interpre-
tation, its action confined largely to public rooms.

At notary Brower's office Anna enjoys her most stunning "free" as-
sociation. Brower is all law – notary, "deputy police, and now fire mar-
shall too." He is also all dirt; unshaven, "black crescents" under his nails,
in a house full of cats and "dark stink." Dirt and the law; this initial en-
counter with sworn authority, the first big scene in the book, locates the
will toward transgression in the very site of prohibition. Brower hectors

Anna about her divorce and thereby keeps her from her child in the car, who nearly breaks her mouth with crying. The law creates what is unclean by outlawing it, all the while indulging in a massive projection of its own "sense of shame."

As Brower rifles though his drawers for his official seal, Anna tries not to listen to his "stupid words. Finally he extracted an immaculate nickel device from the flotsam in the fourth drawer down. For a moment, it looked oddly like a speculum to me." Here the instrument of care gets confused with one belonging to the system that disciplines and punishes. In *The Good Mother,* the woman's body and her sexuality are continually probed, scrutinized, regulated by the law. Anna's association is scarcely a free one; given the world in which she lives, the conflation of male tools is inevitable.

When Anna calls up the speculum, she instigates the novel's insistent concern with the politics of looking. *Speculum* means "to look," or "mirror." When a male doctor introduces a concave mirror into the body of a woman, the procedure might seem to suggest an interest in the other, in difference. But Luce Irigaray has shown that looking into the "mystery" of the woman has typically afforded the male the opportunity to look at, to speculate on, himself. She reads the Western philosophical tradition as a vast enterprise of "specularization," one based on the necessity of postulating, as Toril Moi puts it, "a subject that is capable of *reflecting* on its own being." In *Sexual/Textual Politics* (1985), Moi argues that the male turns the mirror of speculation against the female and upon himself. "The philosopher's *speculations* are fundamentally narcissistic. Disguised as reflections on the general condition of man's Being, the philosopher's thinking depends for its effect on its specularity (its self-reflexivity); that which exceeds this reflexive circularity is that which is 'unthinkable.'" Woman stands outside this circuit of speculation and so defines the possibility of it. The sex that "touches herself" has not been given room within the tradition to speculate on her own shape. In this argument, the very tool we call "thought" also remains the province of the male.

These are heady speculations, and the very existence of thinkers like Irigaray reminds us that they constitute an allegory rather than a diagnosis of gender relations. To think like this is to enter the tradition of speculation from which one claims to be outcast; there is no new language in which women can find a way toward thought. *The Good Mother* is neither an essentialist or an exceptionalist text; it does not imagine women as determined by the natural any more than it assumes that they can escape the realm of the cultural. The novel attempts to deploy a myth that comprehends the space in which we are all unfree. "For me," Miller says, "the book is about the sense – the false sense – that we are essentially in charge of our destiny."

Miller consistently exposes the illusoriness of any offered free-
dom. Even Anna's free associations prove overdetermined by the fate of
a female body in her social world. Her sexual awakening indentures her
to a rigorous standard of performance. Her extravagance consists of
obsessive or coded acts. As the last scene demonstrates ("At the next T,
I turned right"), Anna becomes, like the animals she handles, a rat in
a maze.

Anna mistakes her story for a "drama of disentanglement," and the
maze she hopes to escape is that of the family. Although it may seem a
mere digression into childhood memory, Chapter Two proves the essen-
tial unit of her story. It establishes the law of the family, its crushing "lar-
gesse." The key to Anna's passivity lies in her hatred of her mother, and
the key to her mother's absence is that she belongs to a man – not her
husband, but her father. In the scene in which Anna's grandfather dis-
misses father David's claim to be a self-made man, his wife makes no
move and does not look up. The adolescent Anna watches the moment
with a welling "hate." Anna goes on to repeat her mother's story; she too
loses a daughter; either mother or daughter or both are always lost to a
man. Anna will justify the time with Leo by saying, "It was as though
we were in a family." And, near the novel's end, she will admit that "I
yearn again myself to be in a family." She confesses here to have learned
nothing; more important, to the radical human inability to imagine a
home free of the fiction of family love. Whereas in this first novel Miller
engages in a critique of Anna's position, in her second she moves toward
identification with it. *Family Pictures* (1990) presents family life as the
"great adventure," a horizon beyond which the author seems unwilling
to imagine.

The gap between Anna's fantasy and her experience reflects the tenac-
ity of the ideology of the family compared with its destructive persis-
tence in her life as a social form. Anna does explore "a kind of
boundariless Eden" in her life with Leo, and before that, in her "pas-
sionate experiment" with Molly. But she has no precepts by which to
theorize the lesson of her own example. The scope and persistence of the
fantasy of an alternative become a measure of the forces it resists. Anna
can only imagine substitution, a recreation of family on her own fanta-
sized terms; and so her story, for all its revisionary energy, remains a ver-
sion of Family Romance.

Two figures learn to spurn the family's largesse: Anna's maternal
grandmother and her daughter Babe. Babe "existed in a no man's land,
nobody's child, nobody's mother." She gets pregnant and is nobody's
wife. Babe's story establishes the inconceivability of motherhood with-
out a legal mate. When Anna asks whether Babe is ever going to have her
baby, her mother answers, "Of course not, dear. Aunt Babe's never even

been *married*." A man must mediate the fact of birth; pregnancy here is a social rather than a biological event, and so Babe endures a "lonely labor" and gives up her child. Years later, the drunk Babe drowns in the family lake. She is the unfamilied person, the daughter lost from the start. But Babe does save her mother's life. In the year of her own daughter loss, Anna hears from her grandmother that "There was a period of my life where I used to wake up each morning and wish I'd died." The period lasted "ten or fifteen years." Then Babe was born. "She was mine, I felt. The only one that was." Yet the mother cannot save what she is saved by. Their bond has been a silent one; speaking out is not a mother's place. Her one outcry comes too late, in the rowboat sent to retrieve Babe's ashes. The grandmother spots Babe's Pappagallo shoes where she had kicked them off before her dive and begins to scream in "steady bursts of sound." But "My baby, my baby" can rescue no one; it only names what has been lost.

In the novel's most dramatic scene, this bereft mother chooses not to lose another daughter. Anna has come to ask her grandfather for money to pay for the trial. In a device used strategically throughout the novel, Miller makes this an echoing scene, a repetition of the earlier interview at Thanksgiving when the grandfather offers Anna money for Molly's care. These echoing scenes (another set: as the grandfather dismisses David, Leo will dismiss Anna and her "work") establish Miller's as an art of second chances, of the freedom to be found within the pattern of fate. Yet the chance offered, perhaps, is only a compulsion to repeat.

Anna asks for money, and what she gets are questions. Her grandfather makes her pay. As they sit on the porch, Anna sees her grandmother "standing in the center of the living room, her head tilted up like a blind woman's." Then she moves to the doorway.

> She looked from one of us to the other, then spoke quickly to my grandfather. "Here now," she said, as though he were a naughty boy. And then her mouth worked a moment. Then, "Stop this," she said.
>
> "You do not need to concern yourself with this, my dear." His voice had changed. It still had the same self-important sternness, but the edge, the mockery were gone.
>
> "I'm talking to you, Frank," she said as though he'd said nothing. "Do you hear me?" Her bony hands were at my eye level. They gripped the door frame, and I watched the thickened nails whiten around their edges as they squeezed. I had never heard my grandparents so much as disagree. I felt a child's terror, a wish to disappear.
>
> "This is between Anna and me, my dear," he said.

She waited a moment, pushed her lips together, then had nothing to say. After a long silence she whispered, "No."

"Yes," he said, gently. "Anna has asked *me* for help." He too spoke as if to a child; and it struck me that neither of them had a tone, a vocabulary, for conflict with the other, and so each borrowed from his relations with children, those with whom you could be assertive, or condescending, to disagree.

"Then hadn't you better help her?" she said, shrilly.

"That's for us to arrange." His tone was final, dismissive.

Anna cannot believe her ears and eyes; like her grandmother, she has lived silent and blind. Surely, she thinks, her grandmother has "no choice but to withdraw." Anna tries to let her off the hook. The response deserves to be quoted at length.

"Thank you, Gram," I said.

It was as though I'd waked her. Her head swung towards me. She brought me into focus with her sharp eyes. Then she said, "You could ask *me*."

I looked at her blankly for a minute.

"I have money, too. My own money," she said. "You could ask *me* for money."

"Eleanor," my grandfather began.

"It's my money," she said to him, over my head. Then again, to me: "You could ask me."

"That's not what your money is for, Eleanor," he said.

"It's my money," she said.

"You're not to spend your money on the family, Eleanor. That's not the way we do it." His voice had a nervous quality I'd never heard in it.

"It's my money," she said. She kept her eyes on me. "You could ask me," she said. My grandfather's voice was suddenly stern. "Now Anna's not going to do that," he said. "Anna's asked me and that's that."

"She could ask me, too," my grandmother said. She looked at me again, her eyes pleading. "You could ask me, Anna."

My grandfather stood up, stepped towards her. As he spoke to her, his hand reached up to touch her shoulder in some final assertion or claim. She was, after all, his wife. "Anna has asked me, Eleanor," he said, and his strong male hand, the back of it furred lightly with white hair, gripped the frail bones under her blouse.

She yanked herself back from him. "But you're not *giving* it to her!" she shrieked.

Open-mouthed, frightened, and at a loss, the grandfather writes a check.

I have called this an echoing scene, and it is, yet nothing in the novel really prepares us for it. Like Anna, we are its incredulous spectators. Suddenly, as if awakened ("It was as though I'd waked her"), the silent woman finds her voice. The grandmother of memory had said nothing, or little: "While all the other cousins and aunts and uncles talked volubly, garrulously, Gram's sentences were three or four words long." Here, she transforms taciturnity into eloquence: "You could ask me." The four-word sentence gets repeated four times. The grandmother keeps talking, repeating, until she breaks the resistance down. Her speech falls upon the ear like a visitation from another world. Stunned, and grateful, we turn away from the moment chastened by the awareness that at last we have seen a woman fight on a woman's behalf.

The climax of *The Good Mother* thus occurs outside of its plotted limits, a vision of self-transcendence never naturalized into the world into which the action falls. It is like the moment in "The Short Happy Life of Francis Macomber" wherein Macomber says – in response to his wife's bitter question "Isn't it sort of late?" – "Not for me." No other moment like this occurs in early Hemingway; otherwise, it *is* too late. But by giving us the moment, he acknowledges that we want it, that it could happen, that he knows he has not given it. It is not the exception that proves the rule. It is the author's admission that he hates the rule, and that he needs our help in devising another way to play.

Miller closes her novel with its opening, in the most unhappy echo of all. In the first paragraph, a mother watches her daughter go before her, open a door. In the last, a mother searches for her daughter through halls "long and dark." They find each other. "Her hands rose to my face, stroked it, patted it, as though this were part of her way of seeing me, as though she were blind." A mother loses and finds a daughter, but the reunion is troubled and partial, the love only part-time. What culture offers Molly, what nature now seems to demand, is not happiness but blindness, "mastery over her sorrow." Mother and daughter each take up their task, a lifelong one. Molly has given the game a name; it is the story of "Looking for me."

When Freud writes in his essay "Femininity" that "a man's love and a woman's love are a phase apart," he points to the essential injustice at the heart of heterosexual family love. Compared with a man's, a woman's life must involve "extra tasks." He is not asked to give up his mother. "A boy's mother is the first object of his love, and she remains so during the formation of his Oedipus complex, and, in essence, all through his life." An adult male heterosexual love still allows for the love of a woman. Every finding is a re-finding. A girl's mother is also the first object of *her* love, but an adult female heterosexual love requires that she replace her

first love with a man. Every finding is a reminder of a losing. Love for a woman in such a world *is* loss. Could not the origin of envy – of anger – lie here, as much as in the perceived absence of a penis?

The Good Mother tells the story of the lost mother. It answers the myth of Oedipus with another myth, no less tragic, no less culture-bound. Myths are not about changing the world, and some may fault Miller for providing yet again another strategy for containment. But at least it is a woman's story, a commensurate vision of loss.

It is perhaps a lovely irony that the most filial of our poets has given the myth its swiftest summary in English. He does so in a simile about the incomparability of paradise:

> Not that fair field
> Of Enna, where Proserpin gath'ring flow'rs
> Herself a fairer Flow'r by gloomy Dis
> Was gather'd, which cost Ceres all that pain
> To seek her through the world . . .
> might with this Paradise
> Of Eden strive . . .

Milton sees Eden as an improvement on Enna, just as his story is an improved retelling of an earlier story. Proserpine's act duplicates Eve's; this first description of paradise anticipates its fall. So the story of the fate of the world turns upon the fate of a daughter. It is not simply the story of the miraculous or obedient son. Milton's trinity lacks a mother, and his sacred complex did not allow him to see that within the myth he had summoned up lay the rudiments of the daughter's story. For the history he tells – in the simile, and in its epic poem – is of the abduction of the exposed daughter by an abrupting male power. Her father has agreed that she be carried off. The mother's task is to seek her through the world. When she finds her, it is too late. The daughter has already eaten of the forbidden fruit, and the price of appetite must be paid. (Anna may dream of "forbidden foods," but Molly eats them.) As the man takes the girl, so Proserpine takes the pomegranate, but only the daughter is punished for having desire. The refound love can only be part-time. All the rest is mourning, the unyielding seasons of pain.

ETHAN MORDDEN

The literatures of difference – our stories about women, blacks, gays, and other groups of "others" – explore the tension between what is born and what is made. The current wisdom has it that the created world supersedes the given world. The usual terms of opposition are *nature* and *culture,* but the opposition is really a disingenuous one, as the second term – *culture* – is assumed before argument begins to subsume the first. Nothing is ever really just born; everything is always already made. We wish to believe this because we believe we can alter what is made. Humans make culture and so can unmake it. Culture is light. Nature, on the other hand, is heavy, and appeals to the "nature" of things typically allow us to rationalize oppressive cultural arrangements. The two terms *homosexual* and *gay* embody the tension I describe. The first belongs to nature, the second to culture. In *The Homosexualization of America,* Dennis Altman argues that "To be gay is to adopt a certain identity whose starting point is the physical and emotional attraction to one's sex. Thus gayness is a particular social form of homosexuality, while homosexuality is best understood as a universal component of human sexuality." In this account, "gay" is an adopted, learned behavior – a *choice,* finally; whereas "homosexual" is a found, ubiquitous proclivity – an *inheritance,* initially. In the first volume of his *Tales from Gay Manhattan,* Ethan Mordden casts the tension this way, as he stares at Hepburn impersonator Harvey Jonas:

> He was tall, not good-looking, and strikingly weightlifted; another year or two of iron and he could have entered a contest. The contrast between his physique and his performance was like a standoff between homosexuality as a feeling and gay as a style, the clipped hunk look warring with the camp. Half of him was more homo than gay, the other half more gay than homo. He was *homogay.*

Contrast; standoff; war; half versus half; these tropes of opposition prove more than a match for the clumsy neologism (*homogay*) that would efface them. For Mordden, the point of telling stories is not to find a synthesis for these antitheses, but to expose the way in which the tension becomes the beautiful and terrible engine that drives life on his island.

To put it another way: In a gay couple that I know, one man insists that he is homosexual; the other, that he is gay. The first man believes that he was born as he is; the second, that he began to love and live with men at a certain moment in his adult life. Such debates can occur, in part, because the prevailing myth about nonstraight lives centers on a moment of

choice: the decision to come out. The decline of the coming-out novel is a welcome development, as for straight readers it can make the meaning of homosexuality reducible to such a choice. If, for some gay men, there is no closet ever inhabited, and therefore no one to come out to, for most in Mordden's world the hegemony of the closet – as a notion, or an experience – remains a key crux for the gay imagination, one starting point in the debate within couples and individuals over the origin and structure of identity.

In *Epistemology of the Closet,* Eve Kosofsky Sedgwick reminds us that one big difference between gayness and most other kinds of difference is that gayness is a difference one can hide – especially from oneself. However exaggerated her notions about "panic," she does establish gayness as a difference continually at play; in the myth of the closet, the door can always be reentered. Mordden argues in *Buddies* that "black and Jewish separateness is inevitable; visual, aural, historical. Gays don't *have* to be gay." The body here is an underdetermined text; it does not legislate options the way it can for blacks, for women. The myth of the closet correspondingly puts extreme emphasis on the activities of concealment and display. It argues that the presence or absence of gay identity has everything to do with looking and being seen. The tyrannical trope of the visible enters gay life under the sign of the closet. The price paid by those in the sway of such a trope is very high, and it is Mordden's intention to calculate it.

The full title of Mordden's first collection of stories is *I've a Feeling We're Not in Kansas Anymore: Tales from Gay Manhattan.* The book, published in 1985, is the initial volume in a trilogy about life in gay New York. (*Buddies* followed in 1987, *Everybody Loves You* in 1988.) The stories in this volume are set in the mid-seventies, before the time of "mortal peril." This last phrase constitutes Mordden's only reference in the book to the rise of AIDS, a specter he elides because it can facilely be interpreted as the "revenge of nature" on culture, an unseen hand that cruelly resolves the terms of the debate. ("Revenge of nature" is the label given to AIDS by the Cardinal of Rio de Janeiro.) Mordden thus belongs to the generation of writers that includes Andrew Holleran, Larry Kramer, and Robert Ferro, a generation that has written liberation texts about that one decade – post-Stonewall and pre-AIDS – when gay life was least distorted by oppression or crisis.

Mordden begins with "Interview with a Drag Queen." It is his most challenging and original story, one bent upon confounding "the difference between" such oppositions as active/passive, pleasure/spectacle, even straight/gay. It is bent on confounding every opposition except one, the opposition of "beauty" – it is the drag queen's word – to everything

it is not. "Beauty" proves the book's irreducible term, one that mocks any movement toward a "free market" of love.

The story possesses a double frame: Mordden at his desk, writing the story; Mordden in the shabby walkup eleven years earlier, interviewing the aging drag queen. The story *she* tells is of a Miss Titania, and of an even earlier day, before Stonewall, when Miss Titania had to discipline a "certain trade" at her club, The Heat Rack. A big galoot named Carl has been swindling the johns, and Miss Titania knocks him out with a mickey, ties him up to a bed on his stomach, and proceeds to give "the most spectacular rim job since Scheherazade." The voice here is audacious, even incantatory, and admits through the comparison that storytelling has everything to do with ravishment.

> "Miss Titania spreads Carl's legs wider and wider as she strokes his thighs. She must calm him down, it's true. And then he's quiet. He knows he must be sweetened, and that is the secret that queens and trade share. You couldn't hear a sound in the place as Miss Titania soothed Carl's hole with her tongue and slowly worked it open, and Carl's groaning like a wild beast who doesn't care what anyone knows about him. I truly believe that is the most beautiful sound in the world. Don't you?
> "No."

Mordden's "No" – his is the voice that answers the question – registers his resistance to a "world in which beauty passes the laws." He resists not only Miss Titania's tyranny over her court but also her more profound commitment to a world in which the values and pleasures are visual. Like the patrons of The Heat Rack, we are asked to watch and be moved by a spectacle; part of the point of beginning like this is that the way into the gay world even for the straight reader is through the scenic attractions of sex.

The drag queen finds the scene staged with Carl "beautiful," just as she herself has "lived for beauty." At The Heat Rack she made her choice "Between love and beauty" and chose the latter "because I imagined that those who know love can never have it." She complains to Mordden's "Stonewall Cowboy" that in the present "No one lives for beauty. Everything is . . . *meaning*. There's always a message now. What's the good of a message when a pretty picture tells you everything you need to know?" She is a creature intent on her own reflection and recounts "her saga into a great mirror" that stands just over Mordden's left shoulder. The self here is the thing mirrored, and it seeks confirmation of its identity through its resemblance to other selves. Miss Titania stages with

Carl a beautiful performance, and the drag queen's retelling of it is a triumph of style as well. That he finds it compelling, against all his sober objections to it, is what Mordden can't stand.

Mordden repeatedly dramatizes his uneasiness with the drag queen's rhetoric. Just as her narrative has built to an especially pungent moment – "And his ass is so lovely as she parts it to inhale the stink of him" – Mordden breaks away from the story to the scene of writing it. "I would rehearse dialogue in my window, but how does one look saying this? Because truth is not beauty. Is *not*." In rejecting Keats's willed equation of these two terms Mordden argues that beauty is the enemy of all deep and abiding structures – of "meaning," "truth," "love." Mordden wants to align himself with these structures rather than with the ravishing power of beauty. "I, too, like a pretty picture," he admits at the end. "But I think the meaning matters more." He may think this, but his story shows rather how difficult it is to avoid the seductions of the eye.

Mordden completes the interview without realizing that the drag queen *is* Miss Titania. He looks up from his writing desk, and his window finally tells him that it was so, "eleven years later; it took that long for me to believe my ears. My eyes I trust by the moment." His not noticing is the tale's best argument against living for beauty; Miss Titania's only remaining claim on it lies in the words of her story. When she says that "Beauty is the death of the drag queen," she momentarily transcends the logic of her choice and admits that trusting in the eye is finally trusting in death, in a world that is born, and vanishes. Beauty is the fact that stands for everything given, everything that cannot be altered by an act of imagination or by words. If we must, as the Yeats of "Adam's Curse" says and the drag queen knows, "Labor to be beautiful," there is still the recalcitrant fact of what Mordden later calls one's "born form." Despite all the emphasis here on arraying and conditioning the body, you either have it or you don't; as we shall see, the ultimate appeal of the object resides in its most unique personal imprint, the face. In Mordden's world, desire involves an unconditional surrender to beauty, to "looks." This is not a moral failing but an emotional and political disaster, as it not only proves fatal to love but also aligns gay desire with the natural rather than the cultural order. Mordden hates this and structures his book against it. He asks us to put more trust in our ears and tries to reveal his characters as less people of the eye than of the word.

Mordden introduces the word *difference* into his depiction of gay life. The word necessarily means something different in his text than in mine. As a white, straight, middle-class male, I am positioned at an all-too-safe remove from those depictions of "difference" that, in this chapter, I am trying to engage. However much I attempt to imagine Mordden's, or Miller's, or Walker's worlds, I can do so only from my own subject po-

sition, one already advantaged by the categorizing terms that identify other positions as a variation upon it. I begin with the drag queen because Mordden does, but for me to so begin also puts maximum emphasis upon my act of looking, upon the voyeurism implicit in any look into – on the part of readers "like" me – gay life. Mordden structures his opening as an invitation and a challenge; he offers visitors the sexual and "spectacular," and he does so in a way that encourages them to recoil from the objectifying force of their expectations. If *I've a Feeling* deals with the morality of looking, it does so by way of arousing in the reader an awkward awareness of the politics of his or her standpoint. It also has the honesty and courage to keep alive the image and pursuit of pleasure for a reader who may have lost it in the sexual politics of anger.

Mordden's first tale takes place in an entirely gay world. The second and third deal with crossing over and crossing back. The crossings are sudden, or offstage; what interests Mordden are the arguments they provoke. In "The Straight," essentialist Dennis Savage argues that "All straight stories are the same" and that "straight is straight and they never cross that line." As the nominalist, Alex dismisses the significance of a mere "act" and insists instead on the saying of a word. Narrator Mordden shifts between these two positions, insisting one day that "if it makes love to men, it's gay," on the other that, sleep with whom he may, "he doesn't seem straight and he doesn't seem gay." The argument is over Joe Dolan, "A lover who won't bear the word *gay*."

Joe has lived with Karen, now sleeps with Alex. His story appears to be about the remaking of Joe, of life as self-fashioning:

> his months at the gym had styled him smartly, and he could pass. He had lost his nondescript straight's fleshiness; he was cut and basted. His pants were tight, his hands heavy, his nipples offensive. At the tenth floor one night, Dennis Savage and I overheard two kids discussing some avatar when suddenly we realized that they were referring to Joe, dancing shirtless with Alex. We watched the crowd watching them, knew that Joe was crossing over. . . .

But Joe refuses to *say* what the men around him see. Joe's story might seem to be about the self-policing aspect of gay culture, its insistence that its members pay the price of coming out. Alex certainly stands for this function. When Joe wants to stop at the word *buddies,* Alex explodes at him. "We're *not* buddies! *We are not.* . . . We're *lovers.* We're men who fuck together. Your cock in my ass. Lovers, Joe. Say the word 'gay.' Say 'lovers'!" Joe weeps, Alex rants, but Joe never says the word. In the course of this public argument the word gets lined up with so many trifling and desperate synonyms – *filth-beast-buddy-queen-man* – that when

the narrator finally ends by saying "Welcome to gay," the invitation is to
a scene of excruciating contradiction. We have here a good case of what
Sedgwick calls "paradigm-clash." This love cannot/will not speak its
name because it cannot agree, even within a self-identified and cohesive
minority, on what it is. Mordden's story ends, then, not with the codi-
fication but the deconstruction of a word.

Joe's story is followed by Mac McNally's, "The Mute Boy." Mac can-
not speak, so there is no emphasis on saying. We get the self seen, visual
rather than verbal forms of identification. Mac falls in love by first seeing
lover Nick in a porn magazine, and Mordden helps him make the con-
nection. The liaison lasts, and Nick "adds another trope" to Mordden's
"catalogue: the fuck machine plugged into a good gig." When Nick
walks out to join a new lover in California, Mac resettles in his native
Wisconsin. A letter arrives with a second photograph, of Mac, and his
wedding to Patricia. The story ends with the sight of a third photograph,
of Nick, in another magazine. "He's so hot," a joking man says, "he
could make a straight turn gay."

Mac reverses Joe's motion; from straight to gay, from gay to straight.
Both stories deal with an unlooked-for turn. In fact, *trope* and *turn* are the
key words in the language I've quoted. These two stories see the turn
toward or away from gay as a kind of troping, a putting on or off of a
metaphor, another way of saying or seeing the self. Every metaphor is
divided into an object of comparison and a thing to which the object is
compared, but which comes first, the tenor or the vehicle? These stories
deal with the mystery and possibility of turning, about the difficulty of
establishing a hierarchy of essences or references in a world composed of
a continual play of similitude and difference. If it is impossible to assign
a natural priority to either side of an achieved trope, it is just as possible
that "straight" and "gay" are more like two parts of a metaphor than
halves of a binary opposition, locked in a mutually constituting dance of
seduction, a perpetual collapse of tenor into vehicle.

Mordden's text turns, then, upon the proliferation and confounding of
oppositions. If the second and third stories slyly elide the distinction be-
tween straight and gay – all the while insisting on the importance of say-
ing the word – in the fourth, argument between competing accounts of
the nonstraight self is intensified. Although Mordden's sequence does
contain stories of coming out and crossing back, it finally focuses little
attention on the relation between the homosexual and heterosexual
worlds. The intensity of focus on his world can be taken as a kind of
argument: The tensions *between men* are less fraught than the tensions
within them.

"The Homogay" returns to a set of oppositions implicit in "Interview
with the Drag Queen," the opposition between homosexual and gay, be-

tween the born and the made. "Beauty" again proves the buzz word, the endowment – or is it an acquisition? – around which argument gets structured. The status and origin of beauty are the anxiety that teases story into form.

Harvey Jonas is Mordden's reluctantly acknowledged "self-character," the person he wishes he weren't but probably is. They share "secrets," a word the story repeats three times. Harvey is the only character who resurfaces from Mordden's past. In childhood Harvey had relentlessly picked on Mordden; he was the "bully" who "had to double as the sissy." He did so because Mordden repressed his own doubleness; he chose the role of victim and left Harvey to play the part of the town's "champion queer." Harvey is the only character who greets Mordden with "I know you," and the only one to give him his full name – "It's Bud Mordden, isn't it?" Above all, both men – and this story completes itself in their "grownup years" – are "popular but loveless." Harvey admits this and makes it the meaning of his life. Bud merely implies it by remaining throughout the book in the role of spectator or auditor and by refusing to "speak" of his "love life" with either character or reader. He does not posit himself as a penis. Scattered and fugitive rather than unitary and visible, "Mordden" the character remains a listener, a stray, a gatherer of tales. He thus evades the impulse in both the gay and straight male worlds to organize the self around singleness – the phallus, the "I," the eye. The ear is receptive rather than speculative and penetrating, and it is through the ear that Mordden's crucial experience typically comes to him.

Harvey recounts a life about a failed re-making, about parts of the self that can't be changed. The story turns upon a scene of unveiling in which Harvey literally strips himself in order to find what will suffice. Harvey tells us that the scene is "about how to hold a lover," and he stages it in private for Bud, for his reluctant benefit.

Harvey deconstructs the myth of gay love the way Joe Dolan's story does the word *gay*. What does not suffice, he asserts, are technique, wit, or size. He purchases the authority to say this by demonstrating all three. The demonstration culminates with Bud's witnessing "the most spectacular member I've ever seen." One of the most crude myths about gay culture is the hegemony of "size," and although Harvey has seen men "weep for joy" at the prospect of it, "they don't stay." "No, there is only one way to hold a lover," he continues, and with an intensity of artistic peformance worthy of the drag queen:

there is only one way to hold a lover: by having a handsome face. You may have noticed that I do not. Not partly or nearly. Not *possibly*. And once one isn't handsome, one never will be. Everyone

talks about power, but everyone wants beauty. It's sad, because you can acquire power but you can't acquire beauty. Do you know why everyone wants beauty? Because beauty is the only thing in the world that isn't a lie.

Everything else is created, cultural – a fiction, and therefore a "lie." But beauty – beauty cannot be made or acquired, and everything in Harvey's experience tells him that this desperately, terribly matters.

As so often occurs in these tales, the narrator's reaction completes their meaning. Despite his dissent from her argument, Bud had found the drag queen "honest." Harvey has simply recast her story, and perhaps at greater risk. But at the completion of Harvey's strip/speech, Bud finds himself no longer afraid of Harvey and refuses to forgive him. Instead he visits upon this character his most severe and dismissive judgment. He renounces Harvey's theory of beauty for a theory of truth. "You want hot truth?" Mordden asks the reader. "That scene was about the ruin promoted by childhood calamities. About how something goes wrong in infancy and nothing feels right thereafter. About being haunted by nameless worries." Equally deterministic and even more reductive than Harvey's, Mordden's theory about him betrays the residue of a lingering and unexpressed anger.

He admits there is something withheld: "I promised not to expose the secrets of Harvey Jonas. But he owes me satisfaction: for my bicycle pump, for what happened at the swings, and mainly for some other matter that I'd rather not mention just now." Throughout this story the narrator withholds and the character gives. Harvey's story rehearses for Bud his own campaign to found his appeal on truth rather than on beauty. *I've a Feeling* can be read as a defense against a matter Mordden would "rather not mention" – the career of his unloved face.

Unloved rather than unlovely; I have chosen the adjective to remind us that as the cliché has it, beauty lies less in the face of the beloved than in the eye of the beholder. The eye constructs the world; it does not merely see it, and what it constructs, appreciates, and values gets structured by the ways in which it has been taught to see. Beauty is not a unitary essence belonging to bodies across all cultures. What *counts* as beauty is always a cultural affair, and the standards vary wildly from place to place. Far from being the thing "you can't acquire," beauty consists of a highly unstable and arbitrary set of norms. To find oneself unbeautiful is to surrender, then, as surely to culture as to nature. Susan K. Harris reads Harvey Jonas's story as a reaction to an externally enforced self-hate: "is the homosexual preoccupation with beauty a sign of his search for the cultural validation of the 'I'? – of the need to see himself as beautiful

rather than, as the culture has taught him to see himself, as ugly, distorted, grotesque – un/true?" Mordden's book explores the irony of a subculture that has *mistaken* beauty for a natural fact. If the will to assert a normative gay beauty expresses, then, a political urge toward self-assertion and self-worth, Mordden also reveals it as a move that backfires, one that intensifies the traditional insistence upon the objectification of the other.

Once Harvey Jonas has spoken, the heart goes out of Mordden's book. We may learn to forgo beauty in the other, but can we ever "forgive" (and this is what Bud refuses Harvey) its felt absence in the self? Stories like Harvey's are among the most honest we have about the cruel "command of attraction" in human life.

The subsequent stories resolve into episodes. In the preface, Mordden writes that "One's life breaks into episodes, chapters of a picaresque adventure." Here, at the start, he seems relaxed with *episode* as a synonym for *story*. As the book proceeds, the gap between these two terms widens and comes to take on an almost moral force. The interminable "Case of the Dangerous Man" focuses upon Carlo, and Carlo is called the most "episodic" of Mordden's friends because he is the most attractive, of a "typeless" beauty. But Carlo and his lovers "lacked a theme." Episodes are for the beautiful, and they are trivial; stories are for the nonbeautiful, and they are "sad." This may be, for Mordden, the ultimate poverty of beauty; its action shapes no tales. If the word *vocation* gets used twice, and in the book's two weakest stories, it is because the more Mordden turns in them to the mere episodic career of beauty, the less he feels he deserves the title of "storyteller."

The problem can be summed up another way: Fire Island and Little Kiwi. The first is a locale toward which the action increasingly shifts, and it is a place where beauty can pass all the laws, a dream of perpetual vacation and youth. The second is a character who refuses to play the love game and whose innocent "incomprehension" becomes a perspective too jealously guarded. Witness Little Kiwi's response to this encounter on the beach:

> Ahead of us we saw a tall, dark-haired, very well-built, and extremely handsome man of about thirty-five stalk down the beach toward a young, fair man in the surf up to his thighs. As the older man neared him he turned and they stared at each other for a long moment. Everything else around us seemed to stop, too. The older man very gently stroked the youth's chest. The youth returned the gesture, but not willingly – uneasily, maybe, in a beautiful alarm, never taking his eyes from the man's own. They went on trading

these compliments in a kind of reverie, hypnotized by the setting,
by their utter disregard for the received inhibitions of Western Civ-
ilization, and perhaps by their own grandeur as archetypes. . . .

After seeing this, Little Kiwi puts down his head and weeps. His fear and
chagrin are perhaps best meant to stand in for those of the embarrassed
reader, but if we have come this far our initiation has been sufficiently
complete. Kiwi's shock is rather an index of Mordden's uncertainty over
his remaining material, which he must jazz up by pretending to an anx-
iety over its scandalousness. The story ends with Kiwi asleep in Mord-
den's lap as he ebbs by the ocean of life, an eternal suckling who wants
merging without difference. But Mordden has already given us this, in
the supposedly shocking encounter. I have interrupted the passage in
midsentence, and the full sentence reads: "They went on trading these
compliments in a kind of reverie, hypnotized by the setting, by their ut-
ter disregard for the received inhibitions of Western Civilization, and
perhaps their own grandeur as archetypes, like unto like." *Like unto like*.
By his own admission, Mordden's shocking moment contains no simil-
itude in dissimilitude, no resolved opposition, no transgressing of a gap.
There is nothing to be shocked by here except the suddenness of it, and
even that is obviated by the buried metaphor of reflection: The other is
an image each man already happens to possess, as mirror gazes only
upon mirror.

After the first four strong stories, then, *I've a Feeling* loses its nerve.
It stops dealing with the "yoking of contradictions" that Sedgwick dis-
cerns in gay culture and shifts instead to a fantasy of buddyhood that is
Mordden's version of Family Romance. The fantasy culminates in the
penultimate story, "A Christmas Carol," where the bereft narrator, alone
for the holidays in Manhattan, gets picked up by a close friend and his
"fag hag," brought home, and plunged into the center of a drama that
makes Mordden the hero of the friend's unanticipated and painless com-
ing out. Two fantasies converge here: that one can come out to someone
else's parents, and that the narrator's sexual preference is merely, as he
calls it, "the luck of the draw." The natural order is denied even as it is
affirmed; one can adopt a surrogate origin but must surrender to the
dealer of one's erotic hand.

Mordden ends these tales of his city with a long story meant to reprise
and redeem the whole. We have read about people trapped in obsolete or
killing stories and now, at the end, there is the promise of revision. In
"The Disappearance of Roger Ryder," Mordden returns to the recalci-
trance of beauty to see whether he can wring from it a more liberating tale.

Roger meets a stranger on the beach. The stranger offers him escape
from his "born form." *You can change your looks*. For three months, Roger

Ryder will know "the invulnerability of absolute beauty." Roger resists, accepts. All summer long he materializes like a god, choosing and taking whom he will. He also gets his first TV part, as himself. He also falls in love with Little Roger, another actor on his soap. But he cannot get free of his disguises, cannot come out and be seen and loved as himself. He can approach the man he loves only in one of his concocted faces, and the more Little Roger responds, the more the unseen Roger Ryder feels betrayed. He has perfected a knowledge of the old cliché – "You only love me for my looks."

So Mordden here attempts a resolution of thematic tension through Faustian allegory. A pact with beauty is a pact with the devil, because beauty is always something borrowed, a tyrannical diversion from one's abiding "truth" or "meaning." But beauty and the natural order for which Mordden's people have made it stand cannot be wished away by this fantasy of surfeit. At his story's end, Roger finds himself still "run by the fascism of looks," and all Mordden has been able to offer him – or us – as antidote to it is the foregone cliché that he should have refused to enter the game, a gay moralist's version of "Just Say No."

One of the most celebrated gay novels of the seventies is Andrew Holleran's *Dancer from the Dance*. The title comes from Yeats's poem of antinomies. "Among School Children" ends in a great crescendo of resolved oppositions, as the gap between body and soul, subject and object, form and content gets suspended by the poet's moving rhetorical questions. Ethan Mordden founds his book on these antinomies, especially, in Yeats's phrase, the "beauty born of its own despair." But he can imagine no way to resolve the problem of born form. He cannot close the gap between the ear and the eye. "The name of a thing is strategic," he says, subject to maneuver, negotiation, revision. But the look of a thing is chronic, a condition for which we have found no cure. "At a point," he writes, "you must face the other eyes." "As if no one dared face himself": This is Dennis's savage gloss on gay culture.

Face is a verb as well as a noun, and gay life, as Mordden imagines it, ought to be an activity of facing. Not outward but inward: The moment of truth need not be the display of one's beauty to another but the acknowledgment of one's identity before oneself.

In the first paragraph of "Drag Queen," the narrator sits before a window that gives him his reflection back, "as if I were working before a mirror." He begins with the fact of the face. At the start, his fantasy assumes that "I am my characters, and can put on any of their faces at will." As he moves through his book, he comes up against the irreducible uniqueness of the human face, its insusceptibility to substitution. Mordden begins with a belief that his characters are like him and that beauty – difference – does not matter. He learns otherwise. In the last

paragraph of "Drag Queen," the mirror has become a window again, and Mordden finds himself "staring straight into" it, "to the disgust of my neighbor." The neighbor is a woman, and she is a figure for the outsider. But she is also a figure who knows all too well Mordden's peculiar kind of sorrow, for "To be woman born," as Yeats also reminds us, is to be similarly vulnerable to the fascism of looks. Through the figure of the woman, who is also a figure for the reader, Mordden images a confrontation between "differences" that are not as different as they think. Gay culture, in Mordden's version of it, makes explicit the activity of the larger culture, by pushing its values and assumptions to a self-questioning extreme. We are all people of the eye. The woman's disgust, then, is not at what she sees, but at being seen, at having to face Mordden, to meet his eyes. Mordden's synonym for *fiction* is *reflection*. In the past, when he wrote only nonfiction, he admits that "I had no reflection." Facing the larger world, the world beyond his island of beloved men, Mordden offers all seeming outsiders the chance to face him and to face themselves: The window out is also the window in, and a window is always also a mirror.

ALICE WALKER

Alice Walker is a woman of letters: letters as the components of words; letters as directed epistolary messages; letters as the received terms of tradition. When she thinks of tradition, she likens it to a spark, or a seed, and then hits upon the simile that best conveys just what anonymous mothers hand on to daughters – it is "like a sealed letter they could not plainly read." Walker lives by the word, not the Logos; it isn't ultimate truth that interests her but language's practical power. Her second novel opens with the complete definition of a word. The definitive imperative in her third is Celie's parting admonition to Nettie: "Write." Walker's work dramatizes the power of letters to change a woman's place.

The possession of letters allows for the play of desire. The release of desire through the body can be forwarded through its articulation in words. Shug helps Celie enjoy her "button" by giving her a name for it. Knowledge leads to pleasure in Walker, and through the experience of pleasure one locates, confirms, and enlarges the possibility of an adaptive self.

The problem is that in Walker's world, men have appropriated both language and desire. Walker puts this on display in the opening pages of *Meridian* (1976) through the episode of the "dead lady." Her identity has been reduced to the three role words scrawled in red paint on the displaying husband's wagon: "Obedient Daughter," "Devoted Wife,"

"Adoring Mother." Her story comes from her refusal to be contained by
the words, as the fourth legend reveals: "Gone Wrong." The two words
immediately convey the history of a fulfilled and forbidden desire. For
those who don't know the convention, the husband's flier explains that
his wife had "gone outside the home to seek her 'pleasuring,' while still
expecting him to foot the bills." She met her fit punishment in death,
and Henry now lives by showing her body and retailing her story.

The body can be shown because it mummified after Henry shot
Marilene and her lover and "Throwed 'em both into Salt Lake." "The
oddest thing about her dried-up body, according to Henry's flier, and the
one that – though it only reflected her sinfulness – bothered him the
most, was that its exposure to salt had caused it to darken." Viewers con-
cerned about "his wife's race" should be convinced of her whiteness by
"the straightness and reddish color of her hair." Meridian's first act is to
march a group of black children through Henry's wagon, despite the or-
dinance that their "day for seeing her ain't till Thursday."

This little story within the novel hinges on three of Walker's key con-
cerns: language, desire, race. Race might seem the most salient of the
three. *Meridian* is a novel about the civil rights movement, and Walker's
career has inevitably been dramatized as the story of a black writer in
America. But I think the treatment of the "dead lady's" color here sug-
gests the way in which race often diffuses itself as a theme in Walker's
writing. We know that gender strife has occurred here; we know that the
man has co-opted the woman's "True Story." We do not know whether
she is black or white, and the tone and sequence of the narration encour-
age a reader to see the ambiguity as humorous, even irrelevant. Of course
that white husbands worry about such things matters a great deal, as
does the town's prevention of equal access to the show.

Du Bois argued nearly ninety years ago that "The problem of the
twentieth century is the problem of the color line." In 1970 Walker wrote
that "My major advice to young black artists would be that they shut
themselves up somewhere away from all debates about who they are and
what color they are and just turn out paintings and poems and stories and
novels. Of course," she adds, "the kind of artist we are required to be
cannot do this. Our people are waiting." Insofar as race or cultural and
ethnic "difference" continues to rationalize the exploitative relation be-
tween the First and Third Worlds, Du Bois has been proven right. But
the argument that every black writer must foreground Du Bois's truth or
her own blackness is hostile not only to the activity of writing but also
to the souls of black folk. Early in her career Walker admits to the ex-
haustion of having always to attend to life on the color line. Nothing is
furthered, I imagine she would agree, by holding writers accountable to
some essence of "blackness," as the debate on the black canon among

Joyce A. Joyce, Henry Louis Gates, and Houston A. Baker Jr. (*NLH* Winter 1987) attests. Every writer operates under the sign of some readily essentialized identity to which the value of his or her writing can be reduced. But the most promising departures in African-American criticism today – work by Baker, Gates, McDowell, Spillers, Willis – view blackness as a cultural legacy rather than as a natural fact, a trope that has helped to organize, not enforce, a tradition.

Within this tradition, Walker's career proves remarkable for having won for itself, through its vision and its style, the power to direct attention away from the "nature" of race. She does this, in part, by directing attention toward the "nature" of gender. "Black people come in both sexes," she wrote in 1979, and, a few years earlier: "It seems to me that black writing has suffered because even black critics have assumed that a book that deals with the relationships between members of a black family – or between a man and a woman – is less important than one that has white people as primary antagonists." Walker's most revelatory work has as much to do with being female as being black, and the oppressions against which she revolts are patriarchal as well as racial. As Bernard Bell argues in *The Afro-American Novel,* Walker's major work to date, *The Color Purple* (1983), is "more concerned with the politics of sex and self than the politics of class and race."

One telling precursor here is Eldridge Cleaver. Like Walker, Cleaver equates power with the mastery of language, a mastery that also illuminates and liberates desire. *Soul on Ice* (1968) begins with an account of the release of physical anger in rape. It moves toward the fulfillment of imaginative strength through style. What has alienated Cleaver, he comes to realize, is gender as well as race, the split between the male and female and the pathos of existence in a gendered body. Sex is the "Primeval Mitosis," the division of divisions. We all suffer from it, and the quest for fusion becomes at once a shared universal (Cleaver is relentlessly heterosexual) and the "dynamic of history." But the white male has refused to participate in the pathos of gender by distracting attention toward race. In America the white male fear of racial mixing, Cleaver comes to see, is a way of finessing the issue of sexual adequacy, because, at the bottom of his resistance to miscegenation is not the fear that the white woman's purity will be defiled but that his own merely human potency will stand revealed. "Race fears are weapons in the struggle between the Omnipotent Administrator and the Supermasculine Menial for control of sexual sovereignty." The prevailing system of sexual access expresses the anxiety of the patriarch before the menial: "I will have sexual freedom. . . . I will have access to the white woman and I will have access to the black woman. The black woman will have access to you – but she will also have access to me. I forbid you access to the white woman.

The white woman will have access to me, the Omnipotent Administrator, but I deny her access to you, you the Supermasculine Menial." Rape is Cleaver's rebellion against this logic; lynching has provided the traditional enforcement of it. Cleaver comes to see that for the black man to take on the project of rape is to act out a fantasy rooted in white alienation and anxiety. This discovery allows him at the end of *Soul on Ice* to recover and express his respect and desire for his black "sisters." Cleaver writes rather than rapes his way free and reveals along the way that in America a racial politics is also always a sexual politics.

Walker's work proves a tissue of commingled and surprising influences: Behind Cleaver stand, of course, the slave narratives. Few books advance a more intelligent analysis of the sexual politics of race in America than *Incidents in the Life of a Slave Girl* (1861). Harriet Jacobs depicts a world in which master–slave relationships are structured as if they were familial, a world in which everyone except the master is reduced by his sexual practice to the status of a child. Dr. Flint attempts to exploit a daughter's sentiments in his letter to the escaped Linda Brent: "Think what is offered you, Linda – a home and freedom! Let the past be forgotten. If I have been harsh with you at times, your willfulness drove me to it. You know I exact obedience from my own children, and I consider you as yet a child." It is precisely the collapse of slavery into the metaphor of the family that gives it its pernicious force, and it is not for nothing that Jacobs refers to it as the "patriarchal institution." But Jacobs's critique goes even further, to reveal the ways in which family itself can become a kind of slavery, a system in which women in particular become trapped in role words and unfulfilled desire. The argument between Aggie and Linda's grandmother makes the terrible point that the "natural affection that children feel for a parent" also operates to stand in the way of the imperative of freedom. Aggie tells the grandmother that tears are not the appropriate response to an escaped child:

> "Is dat what you's crying fur?" she exclaimed. "Git down on your knees and bress de Lord! I don't know whar my poor chillern is, and I nebber 'spect to know. You don't know whar poor Linda's gone to; but you do know whar her brudder is. He's in free parts; and dat's de right place."

Linda must painfully discover that the language of fatherhood and motherhood, especially as deployed by her grandmother (she would rather see Linda "dead" than pregnant by a white man), is also the language that keeps slavery in place.

Jacobs's narrative reveals the corrupting effect of the "father's" abuse on every member of the social system. Slavery allows above all the

indulgence of male power, and Linda's story resolves into her fight against the master's sexual advances. Slavery thus formalizes the cultural assumption that women are "traffic" and forces even the white mistress to assume a station on her husband's rapacious circuit of desire. Everyone is brutalized: the master, by the insatiability of his will to power; the master's wife, by her desperate identification with the aggressor (in the narrative's most astonishing scene, Mrs. Flint bends over Linda as she sleeps and "whispered in my ear, as though it was her husband who was speaking to me"); the slave woman, by the violence of the continuous assault; the slave man, by his marginalization and exclusion from the circuit of desire. *Incidents* proves a crucial text for readers of Walker's fiction and especially *The Color Purple* because it recovers the context within which the anger and brutality of her black male characters can seem like more than arbitrary cruelty.

The line from Jacobs to contemporary black women writers is there to trace. Linda Brent's is a prototypical black woman's story: She escapes by staying in the neighborhood. Her seven years in the garret express the conflict between her loyalties as a mother and her need for freedom. She is free but imprisoned; her children are visible but out of reach. Liberation cannot be distinguished from an enduring and almost self-chosen captivity. Women in Alice Walker's and Gloria Naylor's worlds often find themselves in a similar fix; Celie inherits and lives on in the house of her oppression, and Linda's garret expands, only slightly, into the cramped quarters and alleys of Brewster Place. Naylor's women, like Walker's, are rejected daughters who have been pushed into dead ends for wanting too much.

Naylor and Walker also share a continuing project: the search for "good men." Walker's most fully imagined male character is the hero of her first novel, Grange Copeland. He is allowed to change and grow and "be touched," as Walker says, "by love of something beyond himself." The subsequent works trace a diminishing capacity to create such characters, despite the felt importance of male–female relations. Naylor's work nearly inverts this pattern. In her first book, the male annihilates the female in a crude assertion of phallic power. He has "an erection to validate." In her third, *Mama Day* (1988), the male dies on the woman's behalf. *Linden Hills* (1985), Naylor's pivotal book, ends with the man and woman going down together in an auto-da-fé. Naylor searches throughout for an adaptive destruction, for a way of diverting male aggression into life force. She finally imagines an adequate male, but he must lose his life – as so many fictional heroines have always been asked to do – in order to prove his love.

Naylor's early work reveals the ways in which influence can work within as well as across literary generations. The father–daughter sto-

ries in *The Women of Brewster Place* (1983) – especially Ben's failure to protect Elvira from the white man's seduction – take much of their inspiration from Walker's *In Love and Trouble* (1973). The question posed by Butch to Mattie about her father is also Walker's question: "What he savin' you up for – his self?" The "Trouble" in Walker's stories is that her women are caught up in the script of a daughter's love. "All along," Walker wrote in 1973, "I wanted to explore the relationship between parents and children, specifically between daughters and their fathers." Fathers hardly serve in Walker's work as "Inspiriting Influences." The phrase is Michael Awkward's and expresses his sense that African-American women writers have set up "a cooperative system of textual sharing." If we think back to Jacobs's garret, then Awkward's claim suggests that the spaces female characters come to inhabit reflect the sense of possibility their female authors feel before the tradition itself. If Baker and Gates have identified the black male writer's stance toward tradition as a competitive blues "signifying," then Walker and Naylor prefer subletting, or house sitting. They temporarily inhabit a space domesticated by an earlier female voice, like Jacobs's garret. This model is an enticing one, and most critics agree with Awkward, for instance, that in reading *The Color Purple* "it is most fruitful to concentrate primarily on *maternal* influences." Literary relationships among black women play themselves out, then, the argument has it, within a co-op rather than a nightclub or a wrestling match.

In denying Walker's anxiety of influence, we also narrow her tradition to writers who are black and female. In 1985 Hortense Spillers wrote that black women writers "engage no allegiance to a hierarchy of dynastic meanings that unfolds in linear succession and according to our customary sense of 'influence.' " Spillers is nearly alone in questioning the model of this tradition as an unanxious sisterhood. More important, she asserts that "We have yet to place this community of writers in perspective with writing communities that run parallel to it – black American men's," for instance. I hope to show that if Walker's fiction explores the destructiveness of the father–daughter bond, her use of sources that send up the work reveal her as a daughter willing and able to locate enabling literary fathers as well as mothers.

"The Child Who Favored Daughter," from *In Love and Trouble,* is Walker's most powerful early story. It consists of a core story and its repetition. The father in the story once had a sister named "Daughter" whom he loved "with his whole heart." She gave her love freely, even to "the lord of his own bondage." Broken by the collapse of this affair, Daughter returns home to madness and suicide. The women in her brother's life subsequently face a "sullen barrier of distrust and hateful mockery." When he learns years later of his daughter's affair with a white

man, he beats her and begs her to "deny the letter" he has found. She
refuses, and in an emotion "burning with unnameable desire," he kills
her by cutting off her breasts.

The story begins with a poem about the exclusiveness of a daugh-
ter's love:

> "That my daughter should
> fancy herself in love
> with *any* man!
> How can this be?"

In this crude act of wish fulfillment, a father assigns to a daughter an
indifference that is a register of his own anxiety. What the poem really
sings of is the possessiveness of a father's love. The repetition of the word
daughter as both a generic and a proper noun suggests that to this man, all
women are daughters. (The wife in this man's life gets only one sentence,
in the course of which she is beaten and driven to suicide.) The only love
"father" knows is forbidden, regressive, homebound. Walker's vision
here argues that for men, love is incest, the primal form of desire.

Walker makes it clear that desire is at the bottom of this father's anger.
He is aroused when he visits his beaten daughter in the shed: "the damp
black hair trailing loose along the dirt floor excites him and the terror she
has felt in the night is nothing to what she reads now in his widestretched
eyes." The form his mutilation of her takes is to cut away the arousing
flesh. Fathers sexually desire their daughters. Walker enacts this on the
first page of *The Color Purple*. It takes no great imagination to believe it.
More interesting is Walker's skill at showing how fathers and daughters
collaborate in maintaining this incestuous bond. Walker's work deals
with heroines who are not merely victimized, but self-enslaved.

If the father's choice of a love object is regressive, the daughter's choice
of a substitute is reactive. What makes this a "black" story is that Daugh-
ter and the daughter have each taken a "white lover." These women pur-
sue their desire in ways guaranteed to "gall" the black man who loves
them. For the woman, going outside the "race" becomes a way of as-
serting a sexual independence that she will not renounce. For the man,
staying within the race becomes a way of containing a sexual desire he
cannot acknowledge. In the entire course of the story, the father is quoted
as speaking to the daughter only once: " 'White man's slut!' " He ratio-
nalizes his rage as the justified anger of the oppressed. But Walker por-
trays it as a rationalization, a screen for more powerful feelings. If the
father expresses his anger as if it were based on a felt rejection of his race,
it is even more deeply based on a betrayal of his desire. As in *Absalom,
Absalom!*, the introduction of the dreaded miscegenation affords the de-
siring male a reason to punish, as does Henry Sutpen, the object that has
aroused his incestuous love. Walker's point, like Cleaver's, is that "race"

can be used by black as well as white men as a way of masking or acting out sexual drives and fears.

Through letters Walker's women try to free themselves from the force of their original desire. The power to separate flows from the ability to communicate; letters and language bring a fatal knowledge, a fall away from the father. "She knows he has read the letter." This is the first sentence in "The Child Who Favored Daughter." If the daughter's body is the focus of the father's desire, the "Words of the letter" are the focus of his rage. "It is rainsoaked, but he can make out 'I love you' written in a firm hand across the blue face of the letter. He hates the very paper of the letter and crumples it in his fist." The father has somehow found – stolen? – his daughter's letter. How it has come to him matters less than that it is his; fathers are men made out of words, and the language belongs to them. So the third sentence of the story reminds us: *"Father, judge, giver of life."* The daughter approaches the father (she is walking toward him) through names, names that convey his power to originate and punish. Her transgression has been to write about her desire, and the deepest wish is that she will eat her words: "she is his daughter, and not Daughter, his first love, if she will deny the letter. Deny the letter; the paper eaten and the ink drunk, the words never wrung from the air." By refusing to ingest her words – to swallow her voice – this unnamed woman renounces the role of daughter and dies asserting not only the claims of desire but also the need to articulate it.

The body is a text that Walker's women learn to express and to read. Without words the body can remain locked within the fantasy of the father's desire. When women come to tell their stories, they are often about castration, about a state removed from the power to express. They live in danger of being cut off, like Louvinie the slave woman in *Meridian,* who has her tongue lopped off after telling too powerful a story, one "bursting . . . with delight." Being cut off from words means being cut off from sex. The woman in " 'Really, Doesn't Crime Pay?' " cannot be "moved" by a man until one has acknowledged her verbal power. Mordecai reads Myrna's story and likes it. "After that, a miracle happened. Under Mordecai's fingers my body opened like a flower and carefully bloomed." Myrna comes as a writer. And what she has written about is a double castration, about "The One-Legged Woman" who loses a leg and then a husband who "can no longer make love to her." When Mordecai later steals Myrna's story and prints it as his own, he forces her back within the terms of the story she has written. She now lies "unresisting on" her husband's "bed like a drowned body washed to shore." In stealing Myrna's words, Mordecai also extinguishes her desire.

Most of Walker's women are, like Meridian, "suspicious of pleasure." Truman sees her at the end as "Lazarus," and her novel chronicles a sort of ongoing burial, one that consists of frigidity rather than of death.

"While not enjoying it at all, she had had sex as often as her lover wanted it." Walker narrates Meridian's frustration with Truman in almost clinical detail. "Her gaze fell on his penis. It seemed to her extremely large and oddly curving, as if distorted by its own arrogant weight. When she took it in her hand Truman shivered, his face contorted. His face moved her. She guided him into her and they fucked (she consciously thought of it as that), they fucked, it seemed, for hours, and over and over again she nearly reached a climax only to lose it. Finally, when she was weary enough to scream, Truman came and quickly fell asleep." Meridian never comes. Her only "ecstasy" is alone, with the "warm, strong light in bed" or through the "warm explosions" her blood makes in her body at the Indian burial mounds. Not coming becomes for Meridian an almost political response, a refusal to participate in the world of pleasure as long as her people are deprived of their civil rights.

The Color Purple argues that orgasm is a political act, an experience that frees a woman from one realm of sexual politics so that she can enter another. Frigidity is our rather awkward word for a woman's inability to leave her father and become "one flesh" with another. This is why Shug calls Celie, who has never had an orgasm, a "virgin": It is the word applied by the culture to women who remain the intact possession of the male parent. "It was men who invented virginity not women," Mr. Compson says, and it is Caddie who has ceased to value it because she has discovered orgasmic desire. ("I die for him over and over again.") Walker redefines frigidity as virginity to emphasize that the change in a woman's status ought not to be measured by the mere fact of male penetration but much more by the capacity for female response:

> You never enjoy it at all? she ast, puzzle. Not even with your children daddy?
> Never, I say.
> Why Miss Celie, she say, you still a virgin.

Celie will come with Shug and go on to learn that the fulfillment of desire can lie literally within a woman's hands. Even Myrna begins her story with an autoerotic moment of sending her hands "seeking up my shirt front." But the promise of a wholly self-contained sexuality never "flowers" for her. In fact, Walker's later work advances a stubbornly heterosexual vision that accommodates lesbian or masturbatory fulfillment as alternatives to the difficult project of fulfilling sexual desire with a man. Walker's early characters have not yet grasped the paradox of heterosexual orgasm: It is an experience with a man that frees one of the need for the Man. To "come" with a man is to "leave" the father, to break the thralldom of that first attachment. Celie can't come, in part,

because her first experience of sex is of incestuous rape, an act of abuse that asserts the father's rather than the daughter's claim to her body. Walker writes so frankly about orgasm because it is one of the most economical and empowering steps beyond daughterhood, an achievement of pleasure that is also a liberation of self.

Immediately after Shug calls Celie a virgin, she gives her new words for the spaces and uses of her body.

> Listen, she say, right down there in your pussy is a little button that gits real hot when you do you know what with somebody. It git hotter and hotter and then it melt. That the good part. But other parts good too, she say. Lot of sucking go on, here and there, she say. Lot of finger and tongue work.
>
> Button? Finger and *tongue?* My face hot enough to melt itself.

What melts Celie here is embarrassment, not pleasure. Her resistance is not only to having sex but also to knowing about it, giving it words. It is precisely a question of finger and tongue. They create both pleasure and language. *The Color Purple* traces Celie's discovery of the many uses of the hand and the mouth.

Celie's story begins with a sudden blow. She comes to consciousness through the body and discovers, as Walker did in her own life, "how alone woman is, because of her body." Walker modifies Emerson's dictum: "It is very unhappy, but too late to be helped, the discovery that we have been raped. That discovery is called the Fall of Woman." Rape is the originating act, the beginning of Walker's book and Celie's story. It hurts her into language. "I am fourteen years old. I am I have always been a good girl." In the wake of the rape, Celie has become not only self-expressing but also self-revising. The "I am" shows her will toward exactitude, getting the tenses right. But the fall into sex carries with it no consoling knowledge: "First he put his thing up gainst my hip and sort of wiggle it around. Then he grab hold my titties. Then he push his thing inside my pussy. When that hurt, I cry." Pa's "thing" is mystified for a lack of a name, as are the bouts of pregnancy that somehow then befall Celie. "When I start to hurt and then my stomach start moving and then that little baby come out my pussy chewing on it fist you could have knock me over with a feather." Celie experiences her body as an alien space, the site of her father's desire and her mother's anger. Abrupt and concrete, her sentences yearn toward a verbal and emotional vocabulary that can convert sensation into emotion, that can deliver Celie into the possibility of feeling rather than watching her life.

The opening two letters of *The Color Purple* can be read as restaging Trueblood's dream from Chapter 2 of *Invisible Man* (1952). Trueblood, a

black sharecropper, recounts the story in his own words, to the narrator and the white man for whom he acts as a chauffeur, Mr. Norton. Ellison positions the dream much in the way Walker does the rape of Celie, as an ur-story, an originating fantasy out of which the novel that follows seems to spring.

It is so cold in Trueblood's cabin that the family of three sleeps together, "Me on one side and the ole lady on the other and the gal in the middle." Trueblood thinks about his daughter's new boyfriend and then hears her say, " 'Daddy,' soft and low in her sleep." He gets to thinking about living with an old girlfriend along the river, and the sound of the river boats, and the way the sound came close up like seeing a wagon full of watermelons "split wide open a-layin' all spread out and cool and sweet." His daughter squirms and throws her arm across his neck. He turns his back "to move away" and slips into a dream. It is a dream of "fat meat," and a "white lady," and running "through a dark tunnel." Trueblood wakes to find his daughter "scratchin' and tremblin' and shakin' and cryin' " beneath him. He now tries "to move without movin." He pulls away, but "she didn't want me to go then." Wife Kate wakes up and brains him with an ax. Trueblood runs away and comes back to find both women pregnant. Now white folks "gimme more help than they ever give any other colored man." "What I don't understand is how I done the worse thing a man can do in his own family and 'stead of things gittin' bad, they got better."

Ellison structures his story for a white listener; Mr. Norton is its audience, and Trueblood's melodrama gets put forward, in part, as a burlesque of that listener's stereotyping expectations. Celie writes to no audience but God and so tends to diminish rather than heighten the violence of her story. Still, the two stories can be compared. In both, there is the same triad of father, mother, and girl child. There is the same seduction of proximity, the fatal home space. In both, initiation equals betrayal. Both are masterpieces of dialect, spoken by eloquent but uncomprehending voices. And Trueblood and Celie each present themselves as victims of incestuous desire. It befalls them, like a force from without.

Ellison's point may be that men are also alone because of their bodies, that they are no more the subjects of their desire than are women, and that fathers and daughters are functions of reciprocal yearnings that they neither understand nor control. Walker borrows the story but drops the reciprocity. Celie never answers "Pa" in any way. She is innocent, deprived of all desire. And it turns out that the sex was not forbidden, just forced. The romance of incest will diminish into the ugliness of rape; Celie discovers that "Pa is not our Pa," and the story she is caught in loses the dimensions of family romance.

Of course this *is* the family romance. Walker has invented a story in which the father is not the father, in which the daughter gets her fairy-tale wish – that another man is her true begetter. Celie embarks on a search for self that lets her reconceive that self as not-a-daughter. The whole cathexis on "Pa" dissolves when she reads Nettie's letter about "Samuel's story," and thereafter she never again writes to God.

Celie reacts to the crucial letter from Nettie as if it were a negation, a loss:

> Dear God,
> That's it, say Shug. Pack your stuff. You coming back to Tennessee with me.
> But I feels daze.
> My daddy lynch. My mama crazy. All my little half-brothers and sisters no kin to me. My children not my sister and brother. Pa not pa.
> You must be sleep.

This is Celie's shortest and most "spontaneous" letter. As in *Clarissa,* the climax of the story is marked by the breakdown of epistolary style. Letters become "Papers," fragments, outcries. But Celie's story moves toward unmasking rather than defeat. She quickly composes herself and confronts her "father":

> Nettie in Africa, I say. A missionary. She wrote to me that you ain't our real Pa.
> Well, he say. So now you know.

Clarissa's story ends in rape and its fatal consequences; Celie's begins in rape and moves toward empowering knowledge. What she comes to know is that there is no secret, no gnosis, no hidden knowledge or power on which a father is founded. The power is secrecy itself, and Pa's stands as a metaphor for the power lodged in any parent, which is simply to remain mysterious, hidden, unknown. Were we ever to "know" a parent, he or she would retain no more power than does Pa, the man who merely pretends to the role. Families are founded on secrets, and the power they have over us is less some irresistible blood tie than the leveraged ignorance of all we do not know.

The Color Purple substitutes affiliation for filiation (to use Edward Said's terms), a sibling community based on the unanxious exchange of words rather than blood ties reinforced by secrets. Human bonds become a matter of reciprocal belief, not a function of natural inheritance. Celie and Nettie maintain a sisterhood out of sheer faith, whether or not written messages get delivered. As Celie says to Nettie in her longest and

most eloquent letter: "How can you be dead if I still feel you?" The very structure of the book, divided as it is between the styles of two quite different correspondents, suggests the possibility of exchange despite the obstacles thrown up against it. A correspondence waiting to be read: This is Walker's major metaphor for tradition itself. When Mr. _____ interrupts Celie's correspondence by stealing it, "the fate of individual letters parallels," as Linda Kauffman argues, "the fate of a lost Afro-American history." Walker refigures that history back into being. If Walker images the social world as a conflict between men and women in the novel, her openness to earlier acts of literary correspondence suggests that she hopes to resolve that conflict, on the level of influence, in her writing of the novel. Walker's stance toward literary tradition in *The Color Purple* – toward texts written by men as well as by women – provides perhaps the best argument for her emerging vision of family romance.

Walker's homage to the work of Hurston, Harper, Jacobs, and other women writers is open and unquestionable. Her willingness to use and acknowledge such sources has led critics like Gates to argue that *The Color Purple* "points to a bold new model for a self-defined, or internally defined, notion of tradition, one black and female." In this view, Walker's work becomes a "joyous proclamation of antecedent and descendent texts" – hence the link forward, for instance, to Gloria Naylor. More politically significant, I have been trying to argue, are Walker's refigurations of the African-American male tradition. Mary Helen Washington has said that Walker's most obvious debt as a writer is to Richard Wright: Both authors deal with the rural South, the fate of anger, violence, the macabre. Gates points out that Celie's decision to become a dead tree ("I make myself wood") inverts the case of Hurston's Janie, who thinks of "her life like a great tree in leaf" and who discovers ecstasy "stretched on her back beneath" it. But doesn't the fantasy also hail from Chesnutt's *The Conjure Woman,* wherein Po' Sandy says, and out of a desire to deaden and hide himself like Celie's, " 'I wisht I wuz a tree.' " The point is not to score points off of Gates, who has done as much as anyone to recover the entire black tradition, but to expand the emphasis to include its male side, one with which Walker achieves a relation that re-forms the sexual tensions and politics her novel deplores.

Nowhere is this more clear than in Walker's choice of a title. The color "purple" can be read as deriving from the story "Bona and Paul" in Toomer's *Cane* (1923). (Toomer as source should be no surprise; Walker has written that "*Cane* and *Their Eyes Were Watching God* are probably my favorite books by black American writers.") "Bona and Paul" ends with an apotheosis of color, and purple is the central one. This is Paul speaking to the "uniformed black man":

"I came back to tell you, to shake your hand, and tell you that you are wrong. That something beautiful is going to happen. That the Gardens are purple like a bed of roses would be at dusk. That I came into the Gardens, into life in the Gardens with one whom I did not know. That I danced with her, and did not know her. That I felt passion, contempt and passion for her whom I did not know. That I thought of her. That my thoughts were matches thrown into a dark window. And all the while the Gardens were purple like a bed of roses would be at dusk. I came back to tell you, brother, that white faces are petals of roses. That dark faces are petals of dusk. That I am going out and gather petals. That I am going out and know her whom I brought here with me to these Gardens which are purple like a bed of roses would be at dusk."

Paul then shakes the black man's hand and looks up to see that his date, Bona, is "gone."

Why purple? Because it is the blend of Paul's own rosy-black and the pink-white faces that haunt him throughout the story, because it is the noble color through which Paul and Toomer can fantasize about the merging of all colors and the differences based on them in a new American "race." This is the "something beautiful" that is going to happen. It will be a world in which black men can stop dressing up, like the doorman, in livery. The story hedges this wish with ironies – while Paul imparts his vision, his date wanders off, and the fantasy segues into the Kabnis section, which calls for a descent into rather than a transcendence of black identity. Color is throughout *Cane* Toomer's major figure for "difference," as when Paul feels suddenly "apart from the people around him." "Suddenly he knew that people saw, not attractiveness in his dark skin, but difference." Toomer embeds Paul's fantasy in a book in which the narrative voices and characters betray an obsession with the existence of colors and how they vary. (*Cane*'s first line reads: "Her skin is like dusk. . . .") Is Toomer arguing that in a world of many colors, equality can be founded not on an ideal of abstract homogeneity but on the fact of concrete and infinite differences? That purple ought to be the index of a living spectrum in which colors are not dissolved? The repeated fantasies of blended color, of the effacement of difference, make this unclear and leave both the story and *Cane* itself an anguished cry from a self powerfully imprisoned within the visible.

Walker treats purple not as a figure for difference or the collapse of it. Shug presents it rather as a figure for passion, or what it inspires: response. And respond is what we are obliged to do: "I think it pisses God off if you walk by the color purple in a field somewhere and don't notice it." Purple gets assigned outward, onto creation, away from the body

and any concern with its many possible hues. By refiguring purple as the color of fulfilled pleasure rather than resolved or unresolvable difference, Walker argues that for the characters in her tradition the matter of one's color need not preempt or determine the pursuit of one's happiness.

Walker treats the black male writers in her tradition not as repressive fathers but as enabling siblings. Cleaver, Ellison, Chesnutt, Toomer – with each it is a case of "Show me how to do like you," as Stevie Wonder croons in the novel's epigraph. The anger of black men about the treatment of male characters in *The Color Purple* is something about which they can best speak. But with a book that has been accused of fostering so much division, it is useful to count the ways in which it has also tried to overcome it. The ending of the novel certainly attempts this and betrays Walker's ambivalence about the family in an unmistakable way.

Like Sue Miller and Ethan Mordden, Walker does not imagine a world free from the embrace of the family, despite the power of its ties to damage and subdue. In the last fifty pages of the novel, Walker condenses the passing of the years at an ever-increasing rate. She ends *The Color Purple* in an orgy of reconciliation. The ingathering feels as sudden as does Albert's softened heart ("I have love and I have been love"). But however awkwardly the final pages are set up, they do themselves display a sudden access of style.

The challenge here is to reunite Nettie and Celie with their everextending family without relying on the traditional glue of hierarchy or guilt. In Walker's sense of an ending, no one hurries home. Those who approach "walk real slow up the walk to the house." Those who wait, wait just as patiently. Celie tells it this way:

> I try to speak, nothing come. Try to git up, almost fall. Shug reach down and give me a helping hand. Albert press me on the arm.
> When Nettie's foot come down on the porch I almost die. I stand swaying, tween Albert and Shug. Nettie stand swaying tween Samuel and I reckon it must be Adam. Then us both start to moan and cry. Us totter toward one nother like us use to do when us was babies. Then us feel so weak when us touch, us knock each other down. But what us care? Us sit and lay there on the porch inside each other's arms.
> After while, she say *Celie*.
> I say *Nettie*.
> Little bit more time pass.

Walker has so arranged her fictive world that the primal reunion will not be between parent and child but between sisters. The moment of return

occurs among equals. No one need make the first move, like the erring son who bethinks himself to "arise and go to my father." So the reunion is halting, tentative. Walker carefully notates the blocking because this reunion is above all a redemption of touch. If being manhandled starts the book, being woman-embraced ends it, as it has already fulfilled it. Letters are no longer needed, because desire is being brought home, and the salutation that addresses God and everything ends with an end, not a comma but a period. What follows is not a letter but Celie's answered prayer, a fulfilled wish sent not out but up, one ending in "Amen."

Walker earns her ending on the level of the sentence, especially the fourth from the last. Celie is wondering how the various sets of grand-children now see the story's aging adults:

> And I see they think me and Nettie and Shug and Albert and Sam-uel and Harpo and Sofia and Jack and Odessa real old and don't know much what going on.

What the grandchildren think doesn't matter; it's how Celie says this that matters. The eloquence that Celie has found the power to claim amounts to giving each figure in the photograph, as she could not with Mr. _____, its living name. All sorts of lines could be drawn be-tween these proper nouns, and the lines would make an impressive and confused family tree. But Walker commits the names to Celie's unpunc-tuated parataxis: They float together in a mere series, all on one syntactic line. In this horizontal vision of relation, Walker sees only *next to,* not above or below. Everybody seems a sibling. If this sentence and the story of which it is a part argue that the generations ought to collapse into a generation – the family into a brotherhood and sisterhood – Walker has earned the right to the fantasy by converting her literary fathers and mothers into brothers and sisters who contribute without rancor to the resonance of this work of art.

SURVIVAL

Gregory Orr

Louise Glück

Michael Herr

"Who Killed Poetry?" Joseph Epstein demands in the August 1988 issue of *Commentary*. "Death to the Death of Poetry" Donald Hall answers back, in *Harper's,* a year later. Epstein: "However much contemporary poetry may be honored, it is, outside a very small circle, scarcely read." Hall: "More people read poetry now in the United States than ever did before." The rhetoric of decline and defense inflects most talk about contemporary poetry. From the tone of such debates, one might infer that the very survival of a form is at stake. When in 1987 it was heard that the *Los Angeles Times* would discontinue reviewing books of poems, Jonathan Yardley of the *Washington Post* sent up the hue and cry. A cultural turning point had been reached; the audience, through the newspaper, had found a way to express its profound uninterest. To the defense again, Hall opened *The Best American Poetry 1989* with this reminder: "The editor of the *Los Angeles Times Book Review* merely announced that his paper would review fewer books; instead, the Review would print a whole poem in a box every week, with a note on the poet. In the two years since instituting this policy, the *Los Angeles Times Book Review* has continued to review poetry – more than the *New York Times Book Review* has done – and in addition has printed an ongoing anthology of contemporary American verse. The *Los Angeles Times* probably pays more attention to poets than any other newspaper in the country." If news filtered back, however, it was likely to be Yardley's news; those concerned probably still remember the case as one in which a major paper threw in the towel.

Epstein and Hall concern themselves less with what is being written than who is listening. Since Wordsworth, at least, poetry has suffered an anxiety about audience expressed as an anxiety about form. Wordsworth begins the 1800 Preface to *Lyrical Ballads* by worrying over reception. His intentions had been formal – to find a new language, or renew an old one, "the real language of men." But his concerns now prove rhetorical: "a greater number have been pleased than I ventured to hope I should please." He will not write a "systematic defence" of his new style, he announces, because that would require, first, "a full account of the present state of the public taste in this country." Yet he goes on to provide a good deal of both, and he begins with taste. Everything it is possible to do in poetry depends, in the logic of this argument, on the poet's sense of his public. In writing, an "Author" makes a "formal engagement" with a "Reader," and each era will excite its own "very different expectations." Wordsworth goes on to admit that his poems have a "purpose," one that is rhetorical. They attempt nothing less than the renovation of the power of his audience to attend. And this restoration is required because of a specific historical crisis:

> For a multitude of causes, unknown to former times, are now act-
> ing with a combined force to blunt the discriminating powers of the
> mind, and, unfitting it for all voluntary exertion, to reduce it to a
> state of almost savage torpor. The most effective of these causes are
> the great national events which are daily taking place, and the in-
> creasing accumulation of men in cities, where the uniformity of
> their occupations produces a craving for extra-ordinary incident,
> which the rapid communication of intelligence hourly gratifies.

The ambient culture of Wordsworth's London seems to operate in ways
not unlike Epstein's New York; sensory deprivation competes with sen-
sory overload. In stimulating a "degrading thirst after outrageous stim-
ulation," our urbanity (so the argument would go) depresses the power
of the mind to have its "affections strengthened and purified" by an en-
counter with the formal difficulties of poetry.

There is something recurrent about the attempt to link poetry's crises
of form with a crisis of culture. Eliot did the best job of this in our cen-
tury, elevating what he later called a "personal . . . grouse against life"
into a myth of encompassing waste. His critical essays bolstered the
myth with their pseudo-sociological etiology of decline. Something
there is in poetry that loves a crisis, and every Hall will, finally, concur
with his Epstein. The defense collapses in *Poetry and Ambition* (1988):
"We write and publish the McPoem – *ten billion served.*" The metaphor
of junk food conveys Hall's fear that readers form not an audience but a
mass, and that they wouldn't know good form if they were served it. His
susceptibility to the rhetoric of decline indicates that poetry is a genre
through which post-Enlightenment culture questions whether it remains
still serious, still committed to the sacred truths. As the only surviving
genre besides drama that is classically based, poetry enjoys a great lati-
tude for wandering from the purity of origins. The history of talk about
it proves one of continual decline, renovation, return.

Numbers can imply only the quantity of current interest. *Poet's Market*
(1987) lists more than 1,500 publishers of poetry in the United States. *A
Directory of American Poets and Fiction Writers* (1987) gives information for
3,918 poets. *Contemporary Poets* (Fourth Edition) "contains material about
some thousand living poets from all over the world who write in En-
glish." The volume indexes some 7,600 book titles. According to the Na-
tional Center for the Arts, 42 million Americans write poems or stories.
According to James L.W. West III in *American Authors and the Literary
Marketplace Since 1900* (1988), "as recently as 1979, the median American
author . . . earned approximately $4,775 annually from writing." For all
of the books written, published, and read, "It is a sad fact about our cul-
ture," as Auden wrote in the opening sentence of *The Dyer's Hand* (1962),

"that a poet can earn much more money writing or talking about his art than he can by practicing it."

Since the sixties three systems of support have come to the aid of poetry in America: little magazines; small, independent, and university presses; and creative writing programs. Jarvis Thurson estimates that when he and Mona Van Duyn founded *Perspective* in 1947, "there were extant probably less than fifteen quality magazines with some national readership." Dustbooks's annual directory of little magazines now lists more than 1,000 titles. Henry Taylor notes that "Even major libraries are unable to subscribe to more than a fraction of the available poetry magazines." These publications provide an outlet for thousands of poems a year. In *Vital Signs: Contemporary American Poetry from the University Presses* (1989), Ronald Wallace reports that "While few New York presses will now read any poets at all, university presses read from 500 to 1500 manuscripts annually, publishing about sixty." Trade publishing peaked at 100 poetry books a year in 1972; by the late eighties, the total had slipped to around 50. The Yale Younger Poets Prize was first awarded in 1919. Wesleyan began publishing poetry in 1950, and Pittsburgh followed in 1968. By 1990 more than 20 university presses were carrying a poetry series. Along with publishers like Ecco and BOA, such presses now carry the burden of single-volume publishing. In 1960, only five programs competed with the Iowa Writer's Workshop in offering advanced degrees for works of fiction and poetry. The current *AWP Official Guide to Writing Programs* (1990) lists descriptions for 328 writing programs in the United States and Canada. These programs not only produce many of the poets who go on to fill the pages of the magazines big and little but, perhaps more important, they provide a steady income, along with the lucrative circuit of campus-based poetry readings, for most of the American poets now worthy of the name.

The sense that poetry makes nothing happen may have less to do with its failure to reach an audience than with its apparent success. Fully institutionalized in the universities and the publishing markets, poetry has ensured its survival as a literary form. What is at stake, rather, is its status as a form among forms. If the cultural authority of poetry has not been lost, it must certainly henceforth be *shared*. Movies, music, advertising, food, television, sports, architecture, fashion – the list of diversions offered by the ambient culture is so long and rich that the decision to enjoy any one of them can feel like a decision against high culture. It is an implicit argument of this book that an American mind thinking can no longer commit itself to a preordained hierarchy of attentions – especially one based in some tacit prizing of one genre, gender, or race.

More than any other literary genre, poetry has taken as its project the innovation and conservation of form. If the ambient culture diverts

attention from this project, a more serious challenge to it comes from the great national events, as Wordsworth has it, that are daily taking place. Explicit anxieties about the efficacy of form become a measure of how a generation feels about surviving the deformations of history. History is rape, so "Leda and the Swan" argues, but the rape is contained and even beatified by Yeats within the sonnet form. Poets who came of age in the sixties, the period of naked poetries and open forms, were asked to absorb the belief that what matters is the shape of a poem. History conceived its rape, and the war came. The question poets who kept writing were likely to ask was whether form itself was not a kind of affront to the memory of those who had been survived. The answer, here given by two poets, is that the survival of loss depends upon the survival of form.

I have chosen to conclude this book by writing about two poets and a journalist. The two poets, Gregory Orr (b. 1947) and Louise Glück (b. 1943), began writing in the sixties but scarcely touch the subject of the war. The journalist, Michael Herr (b. 1940), served as a correspondent in Vietnam and published *Dispatches* in 1977. However disparate their subjects, the three careers take up the same question, and it is about the efficacy and cost of survival, its relation to the consolations of form. The question gets urgently posed because each writer has outlived the loss of a key contemporary. This dead brother or sister or friend becomes the speaker's implicit audience, one for whom the form is performed. Here is someone who will not stop listening. And the need to remember and testify is met by a sense that it must be expressed through a war-torn form, one that records, through a uniquely stylized personal language, the burden of a generational fate.

GREGORY ORR

At the age of twelve Gregory Orr killed his youngest brother in a hunting accident.

> A father and his four sons
> run down a slope toward
> a deer they just killed.
> The father and two sons carry
> rifles. They laugh, jostle,
> and chatter together.
> A gun goes off,
> and the youngest brother
> falls to the ground.
> A boy with a rifle
> stands beside him, screaming.

This poem, from *Gathering the Bones Together* (1975), is dedicated to Peter and is the first in which the poet tells this story. It is utterly accurate about the events of that November day and responds to something like a request for transparency, one issued by Peter himself. In the full dedication, Gregory had answered his brother's implicit call for a clearing of the air:

> FOR PETER ORR
> When all the rooms of the house
> fill with smoke, it's not enough
> to say an angel is sleeping on the chimney.

This stands as an apology for having previously displaced Peter's story into figurative language. Taken to task here is the indirection of a poem from Orr's first book, *Burning the Empty Nests* (1973), wherein the guilty survivor had imaged the heaviness of his spirit through this trope:

> All the rooms of the house fill with smoke,
> because an angel is sleeping on the chimney.

Peter's impatience – Tell my story – has become the poet's. What began as a process of obsessive and displaced mourning has become one of carefully mastered repetition. In the course of telling it Orr has learned that this is not the only story he has to tell and that his vision does not issue from the shock of a single fall.

The first poems were opaque:

Darkness surrounds the dead tree. Gathering around it,
we set a torch to the trunk.
High in the branches sits an old man
made of wax. He wears a garland of wounds;
each one glows like a white leaf with its own light.
Flames rise toward him, and as they touch his feet
he explodes, scattering insects made of black glass.
A moth lands on the toe of my boot.
Picking it up, I discover a map on its wings.

Even in the midst of this flurry of images, the poet knows what he is
doing: He is discovering the possibility of a career. He will follow the
map wherever it leads. What it is of is not yet clear; the content of Orr's
vision metamorphoses too quickly to glimpse. Perhaps the content is
metamorphosis itself, a mind beset by images that ceaselessly beget one
another in an obscure litany of grief. There is something chancy in the
way these figures shift into one another, the way someone standing be-
side you suddenly falls. The imagination here is metonymic and seems to
depart from a sense of how one thing leads to the next. Proximity is fate.

To persist with this first book is to learn something, however, about
the logic of metaphor. Orr's images gradually acquire the status of com-
plex arguments. We begin with the figures that will recur: the tree, the
wound, the thing with wings, the possibility of glass. From the tree of
mind and memory images must be smoked out or shaken down. They
flow from a wound worn almost as a badge, or "garland," on a body
prematurely aged by grief. Wings test unsuccessfully the hope of light-
ening the pain. So the nostalgia becomes the hardness and transparency
of glass, a radiance purchased at the price of flesh or feeling. But writing
leads to an ingathering of responsibility, and so to a darkening rather
than a purgation of self:

> He was not transparent, far from it.
> He was growing darker,
> becoming a sky
> at night
> without stars.

As the poet's project comes to weigh more heavily upon him, it contracts
into the image of the stone:

> The stone struggled to love the wound,
> but its whole body shuddered with loathing.
> The stone tore at the wound,

which grew to a red door
through which the stone entered its own body.
It saw a clearing where a white tree grew.
Instead of leaves, there were children
trapped inside glass teardrops.

Through the image of the stone, Orr explores the limits of a poetry that
can feel its hurts only by obscuring them. These poems are allegories of
the growth of the poet's mind as it wavers between extreme defenses
against loss. They remain largely self-explicating, closed off from imme-
diate response. Orr's second book moves beyond the opacity of stone and
the transparency of glass toward images of a self that traps the light:

On the side of a bleak hill
we build our hut; windowless,
but filled with light.

There is a growing conviction here that the poet can, with love, learn to
nourish and sequester the power of illumination. He tries in the volume
to slow and order the pacing of his troping through simile. *Like* becomes
the active word, and if there is some loss of power in seeing the poet's
comparisons held up to the light, there is also a steady increase in our
knowledge of his subject.

In *The Red House* (1980) the poet passes even beyond simile, but not
without a backward tribute to the originating power beyond his earliest
mode, the shape-changing wound that sought so many disguises:

Song: Early Death of the Mother

The last tear turns
to glass on her cheek.
It isn't ice because,
squeezed in the boy's hot
fist, it doesn't thaw.
It's a tooth with nothing
to gnaw; then a magical
thorn: prick yourself
with it, thrust it in soil:
an entire briary
kingdom is born.

This appears to be that "same poem" that the poet imagines he will be
"accused" of repeating once he crosses into the other world. Its title in-

dicates, however, that more than one loss is now being acknowledged as having troubled the poet into vision. The poet's mother died in Haiti two years after Peter was killed. The poem displays a new tone of control; the elaborate syntax of the last sentence bespeaks a shaping rather than a haunted mind. Wounds here are things self-nourished and self-administered. What had begun as an almost self-propelling phantasmagoria modulates into a disciplined breviary of the imagination. As loss supervenes loss in the poet's thawing memory, Peter's death recedes as the founding fact of the career.

What we are witnessing is a liberation of the mind from the dictates of fantasy and into the chastity of sheer story. The metonymic sensibility, so alive to the poetry in sequence, gradually matures into a narrative imagination. Incident can now speak for itself. These new stories – about catching turtles, burning weeds, dreaming of horses – can trail off into silence, like Wordsworthian memories of early childhood. The sense of a self as constituted by a single crime diffuses out into a cherished ambivalence about the whole of one's "Fair seed-time":

> *The Weeds*
> On the lawn, beside the red house
> she taught me to slice deep
> circles around dandelions
> with the sharp point of my trowel
> so when I pulled them
> the taproots came up too.
>
> She wore a blue dungaree jacket,
> her braided hair
> tied in a paisley bandanna.
> We crouched there near each other,
> mother and son, digging in silence
> in the dusk of late summer.

This is offered without quite being understood, and that is its power. In the quiet fullness of this moment mother and son occupy, the only time in Orr's poetry, a working present together. The nakedness of this memory is arresting. The poet is coming to trust in the story of the self as worth telling, even in his ignorance of what the story means. Of course the isolation of this memory is not, finally, adventitious. The poem's central situation – the one maternal lesson the poet remembers – embodies the conviction elsewhere acted upon in *The Red House* that we had better bring up whole what we bring up from below. The mother in-

structs the son in the integrity of rooted things, alerts him against partial acts of recovery, and thus against the return of the repressed.

Orr's poetry had followed Wordsworth's in another sense: The image into which the early images gather is that of a grown man haunting the grave of a lost boy.

> A child died, and a child
> was born inside me.

Perhaps because these lines from the unpublished "For Peter" point out too starkly the theme of continuity within rupture, the poet chose not to include them in his final collection. Wordsworth, on summer evenings, often visited the grave of the boy of Winander, and we know from early manuscripts that Wordsworth imagined the boy to be himself. His procedure is to displace the act of mourning for his own lost childhood by imagining the deaths of others. Orr has worked in the opposite direction, toward the recognition that his most inclusive theme is not the death of another but one that befalls everyone in time. The red house poems become elegies for the child that dies, and is reborn through memory, in all of us.

Orr's fascination with an originating fall is reflected in his many renderings of the three poem groups in *The Red House*. Earlier versions of the manuscript saw it ordered chronologically. It had begun with "Morning Song" and the new poetry of childhood (the section called "The Red House"), moved to the poetry of the wound ("A Buoyant Song"), and concluded with the world of the present ("Walking"). In the final version we start with the world of "Friday Lunchbreak," where grinning butchers in "spattered white smocks" move past the poet's window as if in step with a thoughtless and universal call to slaughter. This poem was originally grouped with one called "Memorial Day," which began with the lines: "When I think of my friends who enlisted / and fought in the Asian war." Orr reworked "Memorial Day" for nearly ten years until finally publishing it in 1986 in *We Must Make a Kingdom of It*. He is not yet ready to connect the personal with the historical and so creates in *The Red House* patterns that resonate with the universal or the archetypal. In the volume's final ordering of poems, we begin with the aftermath of fall, move to the poems of childhood, and conclude with the poems of adult life in Virginia. To apply Blake's terms to Orr, we begin with Experience, return to the memory of Innocence, and end with Organized Innocence, the mature man conferring order and value as best he can. It is as if the book starts with the early Orr – the poet of phantasmagoria and the macabre – so as to sever this vision from the emerging

new one. The early fears will henceforth have to contend with the sanity of poems like "Morning Song," which remains, by virtue of its sensitivity to the problem of beginnings, the book's true psychological point of departure.

"Morning Song" begins in all innocence, and still what follows, through the tightening noose of alliteration, is a darkening way:

> Sun on his face wakes him.
> The boy makes his way down
> through the spidery dark
> of stairs to his breakfast
> of cereal in a blue bowl.
> He carries to the barn
> a pie plate heaped
> with vegetable scraps
> for the three-legged deer.
> As a fawn it stood still
> and alone in high hay
> while the red tractor
> spiraled steadily inward,
> mowing its precise swaths.
> "I lived" is the song
> the boy hears as the deer
> hobbles toward him.
> In the barn's huge gloom
> light falls through cracks
> the way swordblades
> pierce a magician's box.

What we are up against here is the uncanniness of the everyday. No sooner than found paradise is lost. Not for long are we warm, unsponsored, free. The poem repeatedly traces a spiraling inward to a limiting point. The bed becomes a bowl, the field a trap, the barn a coffin. Intimations of mortality shadow the growing boy; death is not brought into the world on one November day.

The poem's triumph is to issue in an image that lightens the burden of its guilty knowledge. The metaphor of the magician's box transforms the barn/coffin into a container made in order to be escaped, and becomes the vehicle for a sort of wry transcendence. The poet moves toward insight the way a spectator enters the box, by exposing himself to being pierced by a power that leaves no visible wound. Something is being said about the power of the imagination to reach even the seemingly entombed.

Orr once dreamt that he would spend his life "gathering the bones to-
gether." In his third book he wants more, insists in "Some Harvests" that
his earth be as much a garden as a grave:

> I plant the lower slopes
> of this mountain, where the dead
> are buried. No one
> else will eat what grows here.
>
> Tonight I sit at field's edge,
> under the black wall
> of the woods, listening
> to new shoots push aside the bones.

Filled with "emblems of return," *The Red House* offers the harvest of
memory, the imaginative movement up and back, as our best defense
against being tapped gently into the earth. It gathers its promise of sur-
vival everywhere, as in the girl once seen at the picnic:

> Under bare feet, warmth of pine
> needles as we climb
> in bathing suits up a path
> to the tower; icy damp
> of its stairs. We never
> touch, we'll never meet
> again, but as we lean
> together on the balcony, I
> glimpse eternity beneath
> her pale green suit:
> small breasts, pink nipples.

The early awakening of sexuality and its later flourishing (as in "Swamp
Songs") is now an explicit theme. Orr is becoming a poet of heat as well
as light. In "Walking" (and walking is Orr's metaphor for proceeding
with hope), we can venture out together into the cold because our bed is
"still warm." If childhood begins with a fading of the warmth, adult-
hood moves toward a recovery of the lost hearth:

> I crawl along the vegetable rows,
> looking for some last thing
> to harvest. October dusk,
> the suddenly-cold ground
> sucks heat down through

> my hands and knees.
> At last I tear loose
> and go back inside,
> saving the remnant fire.

The poet ventures out in order to return to his new-found hearth. This "remnant" has been preserved through a literal process of husbanding; the poet returns habitually to that windowless house he continues to build with his wife. This book is filled with a sense that whatever is best of the past is rekindled in the present discipline of married life.

The possibility of shared warmth has been rekindled also by the discipline of poetry. In "The Orange Is the Only Light," a poem eventually excluded from this collection but reworked in future volumes, the poet admits the temptation to bury himself, sometimes, in a poetry that illuminates only itself. Orr borrows the title from the painter Egon Schiele and sustains an extended comparison between their experiences in jail:

> I'm twenty eight-now. I've outlived Schiele;
> I live a careful life, and slowly
> I'm trying to trust the people I love.
>
> But sometimes the terror returns.
> I'm locked in that cell again;
> A poem becomes the orange
> that gives the only light, and all
> the rest is lucky or unlucky accident.

I think Orr rejects this vision of poetry as a mysterious sphere because it fails to satisfy his desire for a less self-enclosed pain. Poetry must become a vehicle through which hurts can be felt and shared (the magician's box) rather than obscured (the light-trapping orange). This is the burden of the much more generous self-judgment Orr achieves in "On the Lawn at Ira's," where he and his friend enjoy a running argument about free will:

> Your father walked out when you were thirteen
> and everything you'd done since you called
> an act and measure of your will.
> At twelve, I killed a brother by accident,
> my mother died soon after: my whole life
> I sense as a lugged burden
> of the invisible and unforgiving dead.
>
> Now we're sitting on a summer lawn in Maine.
> The sun's out; it's the same argument

but I see it another way: you never
let the early hurt be felt and so
it governs you; I now admit I'm mostly
happy, even feel blessed among so many
friends.

This book arrives at whatever happiness it achieves through a remark-
able willingness to abandon the arts of self-defense we call "poetry." For-
giveness is the goal, and the poet even has the strength to extend such
possibilities to his troubled family. Not to the mother, for all her intui-
tive encouragement about digging deep. The task of freeing her from
brooding seems a future one. She remains a prisoner of self-generated
images of confinement, as in the curtains she makes for the boy's room:

She carves a woodblock print
and stamps with purple ink
a border for the linen curtains
she made for my room:
a row of Chinese wind-dragons,
each curled in a box,
biting its own tail.

It is to the father that the poet extends, in the strongest poem in *The Red
House,* the chance to walk with him a distance into the light:

A Story Sassetta Paints

FOR MY FATHER

In the background, a saint walks a path
through mountains and a centaur-haunted
forest. In the foreground he's arrived.
He greets a hermit at a cave's mouth.
They've dropped their cudgels
in the stony road, and as they hug
their two haloes are one.

That's all. Let's say they're men,
not saints: what's taking place
is a wished-for, believable miracle
which must suffice.
When the one enters the gloomy cave
he cannot emerge, nor can
the other, making his way
through the world's woods, ever arrive.

In an earlier version, the last line had read "ever return." Stanley Kunitz read the draft and questioned whether the poet did not mean, rather, "ever arrive." The poet finally settled for the less consoling verb. This would be a major revision for any poet, but it is *the* major revision for Gregory Orr. *Arrive* points toward a perpetually receding destination; *return* suggests that what matters has already taken place. Arrival here is defined as return – we don't need the manuscript evidence to see that the one place imagined in the poem is the site of embrace. What further arrival can be expected when, as the poem attests, "what's taking place" is enough? Of course what's taking place is a surmise, a wish momentarily coming into focus as a fact. That's why *arrive* is finally more appropriate than *return* – it reminds us that the fiction which the poem projects still awaits its literal enactment. Only in the moment of surmise does the poet step aside from the dictates of the painting to imagine the embrace as fulfilling some mysterious human need. It is a supreme example of the poem of the mind in the act of finding what will suffice, strong precisely because the poem's central illusion is broken in the act of being entertained.

Why does this fiction become a sufficient destiny? The dedication to the father suggests that the poem fulfills the fantasies of a prodigal son. Perhaps this utter convergence of selves takes its impulse from the other event, next to the shooting of Peter, that underlies Orr's early work. Two days after he had accidentally killed his brother, Gregory was told (he remembers the story as coming from his mother) that his father had, at about the age of twelve, accidentally killed a friend with a rifle. The young Gregory's own act might have made him feel guilty, but its exposure as an inherited repetition was more likely to raise his self-consciousness to the level of a poet's. He was compelled to accept his place in a pattern of coincidence that seemed like a sort of election. His father's refusal to talk about their shared stories (his abiding in the gloomy cave) became, in the poet's words, a "spur" to his task. What has given the career its special dignity and pathos is that it has been secretly dedicated to atonement for the sins of two generations. That project seems nearly complete. The son could have found few images more redemptive of that first intersection of his fate with the father's than this second, in which what they share is not guilt but light, cudgels dropped in the stony road.

I wrote the foregoing paragraphs on Gregory Orr in 1979, while he was publishing his third book. Now, fourteen years later, they seem full of extraordinary hope. Younger then, we were friends in the same department of English, heading toward the tenure wars. He was promoted in 1980. Two daughters were born to the Orrs in the next decade, and the

poet brought out three more books: *Stanley Kunitz: An Introduction to the Poetry* in 1985, *We Must Make a Kingdom of It* in 1986, and, in 1988, his *New and Selected Poems*.

The hope seems extraordinary because Orr's more recent poems do not, for the most part, display the confidence won in *The Red House*. The domestic sublime does deepen; there are strong poems about making and loving children. But along with this access of personal happiness there runs a current of doubt in the new father's professional role. Not in his status as a professor and, by 1990, director of the Creative Writing Program at the University of Virginia. Not, even, in the value of his performance as a writer. The doubt is over the standing of poetry, its place and purpose in American life.

By the time Orr publishes his *New and Selected Poems* in 1988, he feels "caught in history." The words come from a prose poem about his experiences in Southern jails. He had gone south in 1965 to work in voter registration and had been arrested at a demonstration in Jackson, Mississippi. After his release he was picked up on Route 80 east of Selma and jailed a second time, in solitary confinement. The first poem to deal with this episode is "Solitary Confinement" and leads off Orr's fourth book of poems. The expanded retelling in the prose poem appears two years later. Both poems were quarried from "The Orange Is the Only Light," the long poem in six parts that Orr wrote during the period of *The Red House* but decided not to publish.

By choosing to publish these two accounts of his most dramatic encounter with public power, Orr admits that history is a prison from which he cannot escape. "Solitary Confinement" ends with the poet transported out the jail window by way of a Keats book they "let me keep."

> Imagination is good wood; by midnight
> I'll be as high as that mockingbird
> in the magnolia across the moonlit road.

The very title of "On a Highway East of Selma, Alabama, July 1965" suggests the inescapable presence of time and place. "That adolescent I was twenty years ago" is in jail still. "For eight days he cowered in his solitary cell, stinking of dirt and fear. He's cowering there still, waiting for me to come back and release him by turning his terror into art. But consciously or not, he made his choice and he's caught in history." Imagination can no longer, at age forty, accomplish the Keatsian "already with thee" move out the jail window. To turn terror into art may be to forget a sequence of events in which the self needs to stay caught. It is as if, after working his way through the roles of son, brother, husband, and father,

the poet has come up against the inescapable public role of *citizen*. The
key figure from the poems of the eighties is Hector, the only hero in the
poem of force accorded a domestic life. Orr's treatment of the story fo-
cuses on the "scene where Hector, reluctant / leaves for his last battle."
Any reader of the *Iliad* remembers the scene as out of the order of the
poem, a glimpse of the private happiness that war destroys while pre-
tending to defend. Hector's reluctance makes him human and unheroic,
and yet his story demands that he give up his life for his city.

The conflict between the domestic and the civic self is new in Orr's
work, and one he has not begun to resolve. While he admits that "His-
tory is the only river," he reminds his wife that "the two of us hope to
swim across its swift current." The conflict breeds an uncertainty about
answerable forms. Orr works hard during the eighties to balance the po-
etic and the prosaic; the prose poems that crowd into his volumes express
his uneasiness with language broken into lines. Orr's work had always
been most confident in its images and uncertain in its rhythms, and the
turn toward prose signals a diminishing interest in his habitual iambic
cadences. The prose poems also carry the bulk of his historical narra-
tive – Orr locates most of them in cities – and so shadow the efforts of
the lyrics to extend the reach of his personal legend.

The work done since 1980 conveys a pervasive sense of being cut off.
The poems are full of pieces of things; images of the "fragment" abound.
The cover photo on *New and Selected Poems* shows a heart, an arm, a
child's arm hanging from a piece of lumber. (They are candles displayed
outside a New York shop.) A fifth-grade teacher pulls his glass eye from
its socket. Men here are trying to work their way back, like "Homer's
crew." Dismemberment and exile express the poet's fear that he has lost
a sure sense of his place:

> Ovid's stuck among the barbarians;
> he's trying to write his way back
> to Rome . . .

The poet here tries unwriting the *Amores* in order to win back the favor
of his civilized audience. As the poem ends, a hail begins to splatter
"around him: ripe / fruit young girls drop from the cliffs." A figure
for creative and erotic isolation, Ovid wants to return to the site of his
early fame. At the end of his fourth book of poetry, in 1986, Orr won-
ders whether he doesn't prefer to stand outside the city gates, with the
barbarians.

The work since *The Red House* is an unillusioned poetry, strong in pro-
portion to its doubts about itself. The poet wishes to speak a "vulgar"
tongue. The word occurs twice in a sheaf of poems Orr wrote and chose

not to publish in the early eighties. Poetry ought to forgo the beautifi-
cations of art, or so Orr argues in these lines:

> Of course, I'm crude,
> so was Archilochus –
> first of our line, first
> we know by name.
> You think
> I'm vulgar – he makes me
> sound like Sunday school.

Orr here admits that the vulgarization of poetry is from the start one of
its dominant subjects. No longer does he want to deliver

> lyric time – that moment
> you've all been waiting for
> when you're lifted up out of your life
> and it lies below you like some
> dumb landscape.

The muse turns out to be a strumpet; "get her off that pedestal." What
she wants is rough love:

> she was a mean muse
> and that's a fact. Burning Bush
> they called her – hair that red,
> hands and eyes that cold.

Orr recognized that he had not transformed this quarrel with himself
into poetry ("The quality of ore kept diminishing," he puns in one poem)
and so kept these lines from print.

The poems that do see the page continue to imagine a new, more vul-
gar role for the tongue. Leery of the "turning . . . into art," Orr wants
to taste as much as to phrase. He mistrusts mediation, even of senses like
eyesight and touch. These are the last lines from the 1988 volume:

> Not eyes
> discover it, nor even fingers
> touching and probing mud, but
> mouth and tongue – to taste
> this world on lips
> where, for that instant, the world lives.

"There's a pink tongue / that thinks for itself" in these poems, a desire to incorporate rather than to articulate. Even the "black kid" in Selma gets tested by "the taste of metal, the feel of pin against his tongue." In this moment of maximum political tension, the poem remains uneasily erotic. The published and unpublished work records a passage into "the sexual / dark" coincident with the central event in the poet's life in these years, the birth of his first daughter in 1980.

If one poem sums up the anxieties and achievements of these years, it is "For My Daughter." The history of its revisions records the poet's effort to find a form that can express and also exceed the personal. The poem assumes its final title in its fourth version, in *New and Selected Poems:*

> *For My Daughter*
>
> I.
> This morning holds intact the skeletal
> radiance of a dandelion's globe,
> bones of delight a light wind
> blows apart.
> The winged seeds lift:
> a song whose burden is the earth,
> lost to us even as we walk upon it.
>
> 2.
> Desire conceived you: Power
> that binds to recombine,
> that makes – from dust
> and bright-furred beasts –
> a risen god, an upright ape.
>
> 3.
> Love's shrine is strewn with skulls
> but where else worship you
> through whom we enter the kingdom
> of flesh a second time?

The poem was first published as a broadside in 1982:

> SEPTEMBER MORNING
> for my unborn child
>
> I
> In photographs I've seen your likeness
> floating in the amniotic night.

Soon you will end your first life, push
through and come up gasping on our shore.

2
This morning, grief holds intact
the skeletal radiance of a dandelion's
globe – bones of delight a light wind
blows apart:
 the winged seeds lift:
a song whose burden is the earth –
lost to us even as we walk upon it.

3
In the green valley, desire conceived
you: desire that binds to recombine,
that makes from dust and bright-furred
beasts: a risen god, an upright ape.

Aphrodite's shrine is strewn with skulls
but where else to worship you
through whom we enter the kingdom
of flesh a second time?
Your birth redeems the fallen leaf.

A later manuscript version of the poem changes the epigraph to "for an
unborn child," crosses out the first stanza (as in the final version), and
ends with "Your birth redeems the fallen leaf." A third version of the
poem is printed in *We Must Make a Kingdom of It*. There the poem is
called "The Fifth Month." Except for variations in punctuation and line
breaks, the words of this poem correspond to those of the fourth and fi-
nal version.

The momentum here is toward the formalization of the personal. We
lose the original opening stanza, in which a clear connection is made
between the expectant father and the unborn child. *Grief* drops out of
the poem; this is not the power that holds the dandelion together. That
word belongs to the unassuageable early Orr. The disastrous syntax
of the original stanza 2 gets corrected; the two colons are reduced to
one, and the dash drops out. The final poem opens with a strong sen-
tence that stops after the word *apart*. Differences are being articulated
rather than casually equated. In "September Morning," the word *desire*
had been used twice, in part to fill out the syllables in a line. By cutting
the unnecessary repetition, Orr also changes the meaning of his poem.
"For My Daughter" emphasizes not the repetitiveness of desire but its

"Power" to bring together and make new. By shortening the line lengths
in the second section of the final version, Orr not only achieves a sym-
metry between the first and fifth lines but also refrains from aligning the
line breaks with the melodramatic device of a dash. He also drops the
final epigrammatic line, since, before reaching it, the poem has three
times argued the paradox and necessity of gain through loss.

The confidence with which Orr tightens and shortens this poem ar-
gues that by 1988, he had begun to recover the sublimating power of the
best work in *The Red House*. The appeal of "September Morning," as
originally "conceived," lies in its openness and awkwardness. It is a
poem of assertive connections and sentimental claims. As the poem
changes for the better under the poet's hand, it becomes an allegory of its
own making. The power that brings the man and woman together –
"that binds to recombine" – acts like the power that allows the poet to
return upon his poem. Here the logic of desire and the motion of the
imagination figure each other forth; sex and art create from sources and
through patterns that are comparable. Through his process of revision,
Orr rediscovers poetry as not only an adequate but also an enabling
form, one that can compound the history of humankind (from ape to
god) with one man's story. It is important that all this happens, as the
poet admits in his final choice of title, by way of a poem about having a
daughter. The guilty survivor accepts his status as a maker; this is his
work, human work. The poet now stands in a new primary relation: not
next to a brother he cannot protect, but before a child whom, with luck,
he will. Only the history of the future, both public and private, and not
the haunted past, can reveal the shape of that story.

LOUISE GLUCK

Modern poetry began as an attack on the personal. Eliot called for
an "extinction of personality." This became the announced program,
whatever the erring practice. The generation that followed reacted
against this and claimed as its most visible distinction a poetry of con-
fession. The pendulum come round again, we have in 1990 the
L=A=N=G=U=A=G=E poets, with their call to the freeplay of
phonemes. Whether one labels the binaries mythic or Adamic (Pearce),
classic or romantic (Hulme), symbolist or indeterminate (Perloff),
American poetry and poetics swing between the repression and advocacy
of the personal.

The poets of my generation whom I read with pleasure – Orr, Glück,
Hass, Ryan, Gallagher, Olds, and others – imagine the continuity of the
self as the substance of things hoped for. These lines express the hope:

> I have walked through many lives,
> some of them my own,
> and I am not who I was,
> though some principle of being
> abides, from which I struggle
> not to stray.

These poets move toward a moment of self-recognition, one that depends on a "freedom of speech" that suspends many of the defenses of style. The quoted phrase is Eliot's and comes from his 1940 lecture on Yeats. "In beginning to speak as a particular man he is beginning to speak for man," Eliot says of Yeats in mid-career. The trend is "not fully evidenced until the volume of 1914, in the violent and terrible epistle dedicatory of *Responsibilities,* with the great lines

> *Pardon that for a barren passion's sake*
> *Although I have come close on forty-nine . . .*

And the naming of his age is significant. More than half a lifetime to arrive at this freedom of speech. It is a triumph." The freedom Yeats finds in this poem is to write about himself as if he were a person among historical persons, to use words like *mine.* There can be for him thereafter no final retreat into the displacements of form. As the leading poet-mentor of the generation of the sixties argues: "The readers of a poem perceive it as a verbal structure, about which they are free to speculate; whereas the poet himself is irrevocably bound to the existential source."

Stanley Kunitz is the author of that sentence, along with the lines about straying and abiding. Kunitz confirmed three options for the young who encountered him. Besides the direct acts of sponsorship he performed as a teacher at Columbia (starting in 1963) and director of the Yale Younger Poets award (1969–77), he provided a model of writing as dramatic self-revision, organized the revisions around episodes of familial loss, and subjected this personal "legend" to the exposures of a public life dedicated to education. In Kunitz, Orr found the quest for the "father's face"; from Kunitz, Glück learned much about the "language of the wound." She dedicated her first book to him; Orr published an entire book about him. The specific acts of homage, the transposition of images and themes, matter less, however, than the lesson carried in the poet's stance. In the conduct of his life and work, Kunitz established that poetry in our time could survive through the generosity and integrity of specific persons and so preserved belief in the possibility of having a career.

One thing we can learn to value in the poetry of Orr and Glück is the movement through the event of each poem. The individual verbal

structures provide a momentary stay against the confusions of the existential source. Glück has made it plain that her books unfold a drama of self-consumption. "Each book I've written has culminated in a conscious diagnostic act, a swearing off." She locates in her work a "compulsion to change, a compulsion not, perhaps, actually chosen. I see in this gesture the child I was, unwilling to speak if to speak meant to repeat myself." These words conclude "Education of the Poet," a lecture Glück gave at the Guggenheim Museum in January 1989. Glück's reluctance to repeat measures the insistence of the concerns that abide. Like Stanley Kunitz, she is not yet done with her changes, and, like Gregory Orr, she is caught on a spot of earth, one where a sibling lies buried:

> ### Lost Love
>
> My sister spent a whole life in the earth.
> She was born, she died.
> In between,
> not one alert look, not one sentence.
>
> She did what babies do,
> she cried. But she didn't want to be fed.
> Still, my mother held her, trying to change
> first fate, then history.
>
> Something did change: when my sister died,
> my mother's heart became
> very cold, very rigid,
> like a tiny pendant of iron.
>
> Then it seemed to me my sister's body
> was a magnet. I could feel it draw
> my mother's heart into the earth,
> so it would grow.

This poem appears in *Ararat,* published in 1990. "Lost Love" finally tells Glück's story, and with a freedom of speech that has taken five books to arrive.

In "Death and Absence," a brief essay Glück composed for the anthology *The Generation of 2000* (1984), she tells us this about her two sisters:

> I have always been, in one way or another, obsessed with sisters, the dead and the living both. The dead sister died before I was born. Her death was not my experience, but her absence was. Her death let me be born. I saw myself as her substitute, which produced in me a profound obligation toward my mother, and a frantic desire to remedy her every distress. I took it all personally: every

shadow that crossed her face proved my insufficiency. Not proved, maybe, but suggested, as the birth of my younger sister suggested yet more concretely. I wanted to be child enough. At the same time, I took on the guilty responsibility of the survivor.

Striking here is Glück's tone of knowingness, about what she calls her "subject matter." She is one of her generation's most penetrating self-commentators, eloquent especially about what writing has taught her. Her attentiveness to the "latent significance" of her poetry owes something to the seven years of psychoanalysis she began in the fall of her senior year of high school. "Analysis taught me to think," she says. The analysis was undertaken as a response to persistent anorexia, a refusal to eat that she interprets as the "intent . . . to construct, in the only way possible when means are so limited, a plausible self." The anorexia arose in part from an ambition to define herself "in opposition," especially to a parent: "Even then, dying seemed a pathetic metaphor for establishing a separation between myself and my mother." At eighteen, instead of going to college, Glück tells us, she embarked on psychoanalysis and enrolled in her first poetry workshop at Columbia.

After such knowledge, what forgiveness? Glück's relentless insight into her reasons for writing may have come later rather than sooner, but it does reveal a mind potentially suspicious of figuration. Glück admits that "from the beginning I preferred the simplest vocabulary." The urge toward simplification, laying bare, the diagnostic: These were not so much resources as inhibitions, a way of framing experience that would leave it unavailable to poetry. The way forward was myth. For such a sensibility, myth allows confrontation rather than evasion, an embodiment and enactment of feelings that have already been all-too-well intellectualized, understood. Glück begins with an excess of insight into the personal that must be caught up – lost – in myth if her hurts are to be felt.

The poems foregrounded by such a reading are not openly personal. *The House on Marshland* (1975) registers a pervasive horror of spring. "It is spring! We are going to die!" one poem chants. Another complains of "spring" and "its routine / message of survival." A reading of "For My Mother" –

> It was better when we were
> together in one body.
> Thirty years. Screened
> through the green glass
> of your eye, moonlight

filtered into my bones
as we lay
in the big bed, in the dark,
waiting for my father.
Thirty years. He closed
your eyelids with
two kisses. And then spring
came and withdrew from me
the absolute
knowledge of the unborn,
leaving the brick stoop
where you stand, shading
your eyes, but it is
night, the moon
is stationed in the beech tree,
round and white among
the small tin markers of the stars:
Thirty years. A marsh
grows up around the house.
Schools of spores circulate
behind the shades, drift through
gauze flutterings of vegetation.

– locates Glück's hatred of spring in the timing of her individual birth. She came out then, into the images of moon, pond, tree, and stars that litter these poems. In the mother's bed, she could receive the father's kisses. Winter kept her warm, feeding her little life through the mother's filter. The line break in "And then spring / came" expresses the hovering on the brink of possibility that usually proves a loss in Glück; her spring is not Williams's awakening but Eliot's cruel exposure to the seasons of desire. Spring withdraws the forbidden and even carnal knowledge of the father, the sense that in the prenatal state she and her parents were not quite three, and propels Glück into an innocence from which it will take her as many years to recover – thirty? – as it did her mother to bring her to birth.

In "For My Mother" Glück argues that spring objectified the triangle merely latent in the womb and so ejected the daughter into a marshland of unfulfillable desire. The most powerful thing mourned here is the emotion of requited incest. The unbearable, unwatchable – the primal scene – is not conception but birth. "Pomegranate" tells a different story, a deeper story. It uses the myth of Persephone to complicate the vision in "For My Mother" of the trauma of origins:

First he gave me
his heart. It was
red fruit containing
many seeds, the skin
leathery, unlikely.
I preferred
to starve, bearing
out my training.
Then he said Behold
how the world looks, minding
your mother. I
peered under his arm:
What had she done
with color & odor?
Whereupon he said Now *there*
is a woman who loves
with a vengeance, adding
Consider she is in her element:
the trees turning to her, whole
villages going under
although in hell
the bushes are still
burning with pomegranates.
At which
he cut one open & began
to suck. When he looked up at last
it was to say My dear
you are your own
woman, finally, but examine
this grief your mother
parades over our heads
remembering
that she is one to whom
these depths were not offered.

The myth of Persephone is one in which the daughter actively collaborates in her fall. She eats the offered fruit. Individual will is seen as helping to create, for better or for worse, the world in which it lives. Its choices bring on the seasons – in Frost's words, "that other fall we call the fall." It makes spring. In Glück's "To Autumn," the speaker claims, a bit smugly, that "Only I / do not collaborate" with spring. "Pomegranate" tells a different story, one in which the daughter is not the victim but the co-author of her fall.

"Pomegranate" leaves Persephone on the brink of choice. We do not see her take the fruit. But we know that she will. By the poem's end, the abducted daughter has exhausted her will to resist seductive speech. This is a poem in which someone speaks. Hades does so three times: Behold – Consider – My dear. Glück's poems rarely include other voices. Here the power of irruptive voice propels the daughter toward an unprecedented expression of appetite and independence of being. As in the complementary "Abishag," she falls not only for the power of sex but also for the power of "sounds."

This Persephone falls for poetry. The choice to leave the mother, to eat the fruit, to be joined to the man – all this is subsumed under the awful daring of a moment's surrender to "unlikely" words. "Unlikely" expresses not only the dividing pathos of gender (how different must be a man's heart) but also the quality of his speech. "I had a strong desire to speak": so says Glück about her early years. Here the young woman overhears a speaker comfortable with the unlikeliness of poetry. Hades ventures the insinuating alliteration in "minding / your mother," and the world takes on the unlikely aspect of a chastened and obedient child. By rehabilitating a cliché he also realigns a mother's love with anger typical of a male parent – vengeance is mine, sayeth the mother. The metaphor buried in "parades" turns Ceres's grief into display. He literally suspends Persephone's doom by deploying his participles *(minding* and *remembering)*, like her own *(containing, bearing, adding)*, at the ends of lines. The isolation of the final participle in a line of its own argues that this will be an activity never ended, the daughter's future work. The manipulating imperatives enforce a perspective while seeming merely to offer a look. Such irresistible verbal assurance points toward an unlikely conclusion about a mother's love – that it kills rather than gives life. Hades's sinister turns of speech give the myth a shape that rationalizes the daughter's acceptance of food at his hand.

The poem reverses primal recognitions. The man gives "suck," while the mother starves not only her daughter but the entire world. The mother is seen as the withholder of food. This is a highly condensed insight into the logic of anorexia, one suggesting that a mother's love can be, for some daughters, a gift that famishes the craving:

In mid-adolescence, I developed a symptom perfectly congenial to the demands of my spirit. I had great resources of will and no self. Then, as now, my thought tended to define itself in opposition; in those days, what remained characteristic was the single characteristic. I couldn't say what I was, what I wanted, in any day to day, practical way. What I could say was *no:* the way I saw to separate myself, to establish a self with clear boundaries, was to oppose my-

self to the declared desire of others, utilizing their wills to give shape to my own. This conflict played itself out most fiercely with my mother. And, insofar as I could tell, my mother only wavered when I began to refuse food, when I claimed, through implicit threat, ownership of my body, which was her great accomplishment. My mother loved her children, but the only sign of love I was equipped to recognize was terror.

Can there be any better commentary on this poem? "Pomegranate" dramatizes the need to resist a mother's love, an anger at the demand that it be reciprocated. Hades offers the daughter something to eat, but what he offers above all is the power of speech that will make her take it. In the poem one kind of appetite or ambition usurps another; the choice is not of food, but words. Persephone can take nothing, want nothing, from the mother.

Glück's work proceeds from the terrible conclusion that what nurtured her as a body will not nurture her as a poet. Ten of the thirty-five poems in *The House on Marshland* turn upon the word *body* and the scandal of having one. It is capable of only minimal forms of articulation, "the formless / grief of the body, whose language is hunger." Glück everywhere expresses her fury that sex and eating are somehow adequate to fill the needs of this formless thing. She dedicates herself to another kind of hunger, the "need to perfect" through unlikely words.

A fantasy basic to Glück's work is of a man (death, language, the father) who will save her from the gift of life (Ceres, the body, hunger):

> When the stern god
> approached me with his gift
> my fear enchanted him
> so that he ran more quickly
> through the wet grass, as he insisted,
> to praise me. I saw captivity
> in praise; against the lyre,
> I begged my father in the sea
> to save me. When
> the god arrived, I was nowhere,
> I was in a tree forever. Reader,
> pity Apollo: at the water's edge,
> I turned from him, I summoned
> my invisible father — as
> I stiffened in the god's arms,
> of his encompassing love

> my father made
> no other sign from the water.

In "Mythic Fragment," the female child refuses the gift of sex – which typically comes as a rape – and elects to remain the daughter of her father through transformation into the "nowhere" of a rooted form.

The Oedipal myth dramatizes a competition for attention. Glück deploys the myth, like Sue Miller, in order to expose its inadequacy as an account of a woman's life, and as a cover for a more insistent story. At its most abstract, the myth does express the wish for an exclusive love. But the anger at the mother in Glück's poems argues that she, and not the father, is the object of unrequited desire. As she admits in "Dedication to Hunger," "the girl child . . . loved him second." Beneath the competition between a mother and a daughter for a father's love lies one between a sister and a sister for a mother's.

Glück's books can be read as the account of a figure gradually coming into view. It is the figure of the lost sister, descending back to earth, crossing over into speech. The five books seem to focus elsewhere, on other losses: *Firstborn* (1968), on the poet's own birth; *The House on Marshland*, the imminent birth of her son; *Descending Figure* (1980), on the terror of becoming a mother; *The Triumph of Achilles* (1985), the loss of her house to fire, the end of an affair, and the resumption of the "journey" of career and marriage; *Ararat*, the father's death. Where, here, is the sister? Everywhere, I would argue, or anywhere, at least, that we find this poetry's pervasive emotion, which is not so much loss as stunned wonder at having survived.

At first, the sister is only a trace. She leaves her biggest mark in the title: *Firstborn*. While this title refers to Glück's older sister, nothing in the poems that follow directly does so. It is easy to take the speaker as the firstborn. Or to apply the term to the imagined birth of a son. (Glück's one child, Noah, was born when she was thirty.) Or to see it as a name given to the early poems. On page six, we hear of a "younger sister." On page eight, of a "second child." A sister is mentioned twice again, but she is clearly alive. The only direct allusion to the "firstborn" proves ambiguous, a snapshot of the father "pushing forty / And lyrical / Above his firstborn's empty face." If we do not ask – "Who is this?" – it is because the buried allegory of the book has not troubled us with the question.

What we can notice is the unrelieved mourning for something lost, as in "The Racer's Widow." "From the first," Glück has written, "I wanted to talk about death; also from the first I had an instinctive identification with the abandoned, the widowed, with all figures left behind." So, in *Firstborn*, the poet becomes a figure of precocious grief, with the largest sympathy reserved for herself:

> Birth, not death, is the hard loss.
> I know. I also left a skin there.

If these lines from "Cottonmouth Country" express an anger at separation, they do not admit its place, except perhaps through the image of the bartered skin, in the larger drama of replacement.

In "The Pond," from the second book, the sister floats closer to the surface.

> Under the ringed moon I can make out
> your face swimming among minnows and the small
> echoing stars. In the night air
> the surface of the pond is metal.
>
> Within, your eyes are open. They contain
> a memory I recognize, as though
> we had been children together.

The "as though" at once allows and undercuts recognition, just as the pond water admits and repels the light. In a later poem in the same book, the title "Gemini" raises the spectre of linked siblings, with the attendant doubling or annihilation of self. But the poem's opening lines displace siblinghood into one of Glück's most persistent tropes, an unwelcome pregnancy:

> There is a soul in me
> It is asking
> to be given its body

These words seem to issue from an expectant mother. Yet what gets born in the poem is a memory, not a new child:

> So the past put forth
> a house filled with
> asters & white lilac
>
> a child
> in her cotton dress

Whether Glück here recalls her own childhood or that of her dead sister is unclear. More remarkable is the way in which this turn into the past, along with the poem's opening lines, confounds the responsibilities of memory and motherhood. A son will get born in the course of Glück's life, and the process gets registered in the poems. But the soul that is

asking to be given its body here may be quite another one, one long since dead, a sister imagined as a twin and therefore threatening to the poet's uniqueness of being.

The title poem in *Descending Figure* at last brings the sister, by name, into the light. But only as an imaginary figure:

> Long ago, at this hour, my mother stood
> at the lawn's edge, holding my little sister.
> Everyone was gone; I was playing
> in the dark street with my other sister,
> whom death had made so lonely.

The poem allows only the sureness of "twilight" things. It does amass the central players, the mother and the three girl children. It does make clear that another sister – not the speaker – is being held. And it admits, as "Gemini" had only obliquely, that the middle sister's task will be memorial. She will play with and sing to the "other sister," as she imagines in the closing section of the poem. These intimations of relationship remain private, elusive; they tell us little except that someone has been lost. Unsupportable here is the arbitrariness of survival, the obligation left with the living, as Hamlet urges Horatio, to "tell my story."

This is the burden of "The Triumph of Achilles," a poem about the loss in war of a brother in arms:

> In the story of Patroclus
> no one survives, not even Achilles
> who was nearly a god.
> Patroclus resembled him; they wore
> the same armor.
>
> Always in these friendships
> one serves the other, one is less than the other:
> the hierarchy
> is always apparent, though the legends
> cannot be trusted –
> their source is the survivor,
> the one who has been abandoned.
>
> What were the Greek ships on fire
> compared to this loss?
>
> In his tent, Achilles
> grieved with his whole being
> and the gods saw

> he was a man already dead, a victim
> of the part that loved,
> the part that was mortal.

Achilles triumphs by refusing to become more than "nearly a god." His mortality gets the poem's last word. And the burden of mortality is less death than survival. This is the true punishment, that we fasten our love on people who then die. Out of the death come legends, stories that cannot be trusted because their source is the survivor, the one who has been abandoned. Why "cannot be trusted"? Because the overriding emotion is not grief that the beloved has lost a life but anger at being left behind on one's own. The survivor is *abandoned.* The word implies victimization, and the emotion felt while reading Homer, while reading this poem, is for Achilles, for the poet. The sister's loss of her own life, Patroclus's loss of his – these are not where the accents fall.

Elegies are always laments for the survivor. *Always,* as the poem twice repeats. It is a law. Survival is Louise Glück's comprehensive term for human life in a universe of death.

As a book, *The Triumph of Achilles* makes a mortal turn, takes off its armor. It may seem otherwise. A recurring figure here is petrification, a body becoming a stopped form, like a tree. Glück attends to story arrested in the moment it becomes myth: Sisyphus at the mountain top; David lifting his hand; Moses reaching for the coal. Yet these poems afford a countervailing movement in which the speaker decides to "retract / the myth" and remind us that such stories often entail a second act, one in which "the gods sank to human shape with longing." David finally falls for Bathsheba; the poise of closure keeps breaking down. Glück surrounds herself with gods and heroes to test the efficacy of their stories as vehicles for her own and finds that "All my life / I have worshiped the wrong gods." They give no shelter from "Eros," the one who leaves her "swaying and quivering." Apotheosis provides no quarter, for Glück sees that "the process that creates / the writhing, stationary tree is torment" and has "understood / it will make no forms but twisted forms." If *Descending Figure* had ended with a vision of the birth of god out of the pathos of human division and desire, *The Triumph of Achilles* recovers this projection and reserves its love for figures that can die.

"In April of 1980," Glück writes, "my house was destroyed by fire." The following summer she wrote "Mock Orange," and then, very rapidly, twelve more poems. These became *The Triumph of Achilles.* She began to fear for her life; "such fluency meant I was going to die." Writing and starving herself had always been linked, for Glück, with the "need to perfect," with death. As she says about her initial ambitions for *Triumph,* "I wanted to locate poems in a now that would never recur." In

perfecting that need, she came to feel a contrary one. "For the first time in my life, I wanted not to write; for the first time, I wanted survival above all else." It is the fear for her life rather than the wish for her death that is welcome and that marks a turn. As she wrote her way into her fourth book, she determined that "What had to be cultivated, beyond a necessary neutrality, was the willingness to be identified with others. Not with the single other, the elect, but with a human community." For all of its "scorn" of sex, then, *Triumph* admits and dramatizes its power. She will run the "Marathon" of love. If the key word in *The House on Marshland* was *body*, and, *In Descending Figure, form*, then the one for *Triumph* is *life*. It is the book's most insistently repeated and concluding word. The last poem is spoken from the vantage point not of the resistant woman but that of the desiring man, a man well aware of the woman's will to displace. She seems to seek a "passage out of this life." We stand off with him and watch the resistance that wants, also, to be touched, broken down. "The basic dispute, the source of all the others," as Calvin Bedient argues, "is over the value of pleasure, hence of life itself." If the dispute is not resolved at the end, it is at least staged, given a voice and a gender through which the poet can lay bare her will to withhold. The identifications in *The Triumph of Achilles* open the way for *Ararat* and its freedom of speech.

Because of her sister's death, Louise Glück lost her mother too. It drew her heart away. So she feels; she survived for this. This is the story told in "Lost Love," the ninth poem in *Ararat*. But to number poems, or to speak of poems at all in a volume so integrated, is perhaps an impertinence. *Ararat* reads as one poem held together by a single act of attention. A book about the punctuation of our lives, *Ararat* prizes the marks that divide up time "to make time pass." The poems are built of strong and assertive sentences; many lines here are end-stopped with periods. Yet the first poem ends with a dash and so expresses Glück's reluctance to break this whole into parts. "A breath, a caesura": this is all we are offered "on earth," and nearly all that the poet will offer as interruption to this book's continuous motion of mind.

Glück has never before failed to end a poem with a period or an unpunctuated space. She likes closure. "She's always trying to make something whole, something beautiful, an image / capable of life apart from her." So she writes of a friend in "Celestial Music," the most open set of lines in this book. The last line in the poem goes like this: "The love of form is a love of endings." Glück overrides the endings of her forms in *Ararat* in order to explore another kind of love. Never quite stopping and therefore never quite starting, the reader is asked to develop instead a feeling for being in the middle, to enjoy a passage into life.

This structure is purchased with some loss of power. Ruminative and explanatory, *Ararat* displays little of the "ferocity" with which Glück has said she serves her poems. It forgoes the mythic concentration of *Triumph*, the vatic intensity of *Marshland*. No one could call this, as Bedient does *Descending Figure*, "an attack of purity." The openness here draws attention away from the perfections of any "one form." Glück explores instead the nature of being "human," the central word in the volume's epigraph. As George Orwell elsewhere reminds us, she admits to being broken up by life:

> The essence of being human is that one does not seek perfection, that one is sometimes willing to commit sins for the sake of loyalty, that one does not push asceticism to the point where it makes friendly intercourse impossible, and that one is prepared in the end to be defeated and broken up by life, which is the inevitable price of fastening one's love upon other human individuals.

But whom to love? On the trip to Ararat, only pairs got to go. Which two would be picked to survive? Two siblings? Parent and child? Husband and wife? There had to be sex; each kind had to make more kinds. So the question was, for Noah, not a hard one. Glück thinks it still an open question, or wonders, though with an increasing calmness of mind, whether the wrong two have happened onto the ark. In *Ararat,* she tries to make room, in the "new life" of those who have survived, for more than two.

Ararat demystifies Glück's myth of family and revalues the poet's role within this revealed structure. The core story deals with the aftermath of the father's death, the widowhood of the surviving women. The key players are the same: father, mother, the poet, the dead and the living sister. The concern, for the first time, is more with the living sister than with the dead:

> My sister and I
> never became allies,
> never turned on our parents.
> We had
> other obsessions: for example,
> we both felt there were
> too many of us
> to survive.

Glück hasn't stopped pairing off; twoness remains her subject. But by multiplying the crucial pairings and submitting to a place in each of

them, she positions herself within an expanding whole. Of her blonde
and younger sister she can say:

> We were like day and night,
> one act of creation.
> I couldn't separate
> the two halves,
> one child from the other.

Competition with a dead sister here shifts to implication with a living
one. One plus one makes two, a doubling, a tension. But two halves
make, simply, one. As the book advances further into the surviving
structure of which she is a part, Glück reimagines her story as less about
having lost a sister than about having gained one, and her task as learning
not how to mourn but rather how to love.

This revaluation culminates in "Paradise," a poem in which the
speaker casts herself as an origin, not a remnant.

> Like Adam,
> I was the firstborn.
> Believe me, you never heal,
> you never forget the ache in your side,
> the place where something was taken away
> to make another person.

This astonishing identification not only reverses the poet's gender but
also repositions her within her family's sibling order. Firstborn. The title
of the first book gets taken back. Glück here allows that her experience
of a sister who lived had primacy over a fantasy about one who did not.
A lifetime of facing the younger sibling has taught her what it feels like
to be first. And the feeling is generative. Adam gives his rib not to make
a sister but a wife. Eve redresses an erotic and spiritual loneliness. De-
spite Glück's emphasis on creation as loss here, the myth cannot be
deployed without invoking also the generosity and courage of the first-
born's will to sacrifice and make way for "another person."

Ararat begins with a disclaimer. "No one could write a novel about this
family: / too many similar characters. Besides, they're all women; / there
was only one hero." Yet Ararat goes on to give us a represented action
with characters about whom we are made to care. The story begins with
a sequence about widows, the familiar theme of survival. Then follow
poems about the lost sister. In the title poem, Glück discovers a recurring
fate across two generations of sisters: her mother and her aunt, herself
and her living sister. The heart of the book then follows, poems about

the two still-living daughters. A few poems of marriage and its alternatives lead into those in which Glück further explores her likeness to her mother. Poems follow about the living sisters and the children they have made. The book then returns to the father, and a memory of him when last seen alive. The beautiful "Celestial Music" imagines a world of friendship and stillness apart from family. The book ends with a last judgment on the poet and her place in the line.

Ararat unfolds as a story of seeing how people in a family do "the same thing," or do things "in the same way." Glück refines the differences, alert to the ways opposites collapse into samenesses or the "similar" veers off toward the antagonistic. The tensions that drive a family apart also hold it together, like the tensions of a poem. If the career has been founded on a sense of the poet's distance and difference from her mother, then the crucial move here is to recognize their "terminal resemblance," one so profound as to suggest a continual collapse of offspring into source, vehicle into tenor.

The survivor of the first four books sees herself more clearly as a maker in the fifth. What comes from her counts for as much as what comes to her. This is especially true for love, for "the way / my mother loved me." A mother for almost twenty years herself, Glück determines in "Brown Circle" that she, like her mother, has come to her child with a magnifying glass and burnt a brown circle of grass around the flower. "I must learn / to forgive my mother, / now that I'm helpless / to spare my son." Helpless in the face of trying to love him, she means, "the way I meant to love him." In the end, Glück is like her mother in simply trying to be one herself. The cure for being a child is becoming a parent; "What matter," as Yeats says, "if I live it all once more." He too uses the verb *forgive,* and he too understands that the only delivery from "the crime of death and birth" is to repeat it.

Louise Glück ends *Ararat* where she begins, by repeating. The first line of the opening and closing poem is the same. "Long ago, I was wounded." Except that "First Memory," the last poem in the book, adds two words:

Long ago, I was wounded. I lived

The poem goes on. But does it have to? These two added syllables say, perhaps, everything. "I lived." The consequence of the first sentence, in "Parados," was that "I learned / to exist." In "First Memory," the consequence is living rather than subsisting, and it follows unbroken from the stated fact of the wound. The wound *is* the bow. Saying this, showing this, the poem gathers strength to make its remarkable conclusion:

from the beginning of time,
in childhood, I thought
that pain meant
I was not loved.
It meant I loved.

"The Wound" in *Firstborn* turns out, as love for others is, to have been self-inflicted. It is not a question of deprivation or guilt, but of excess and risk. This insight owes everything, as always in Glück's poetry, to the form in which it occurs. It occurs as a repetition that is also a revision. Glück agrees at last to repeat herself, to live in time. *Ararat* in its ending circles back not only to the beginning of its structure as a book but to the beginning of the career, to show that its end – or this enabling middle – lies buried there. The structural gambit of the book enforces its psychological argument. The meaning of its poems, like the meaning of any life lived in a family, proves shifting and interdependent, not fixed and apart. Any single poem by Glück here provokes in the reader, because of the powerfully revisionary imagination working through all of them, the desire and pursuit of the whole. When we read a career like this, one so resolutely defended and yet so dedicated to knowing what it can, we are asked to take on the kind of nature envisioned in the volume's epigraph, from Plato: "human nature was originally one and we were a whole, and the desire and pursuit of the whole is called love."

MICHAEL HERR

The violent chaos of war is always "sharply structured" by the stories we bring to it. Only the constructions of the imagination allow us, perhaps, to persist in so wounding an undertaking. Paul Fussell has shown how literary our experience and understanding of war will inevitably be. As he argues in *The Great War and Modern Memory,* wars invent myths of themselves and generate controlling new ones. War refers, remembers, revises: "The act of fighting a war becomes something like an unwitting act of conservative memory, and even of elegy." Desert Storm, some say, was fought to "erase" Vietnam; if the idea is obscene, it reminds us that war compulsively *alludes.*

It is therefore perhaps not surprising that the first thing mentioned by the protagonist of *The Quiet American* is a book. Pyle may not know it, but Greene does – that Vietnam, like all wars, was destined to be mediated. Vietnam was to present, in duration and intensity, a profound challenge to the American literary imagination. As John Del Vecchio argues, the "equilibrium" that was Vietnam was "sharply structured – a

state, perhaps, which invited destruction." Did it also invite answerable creation? C. D. B. Bryan speculated as early as 1984 that there had already grown up a "Generic Vietnam War Narrative." The cultural response to the war – in movies, poetry, history, memoir, and fiction – has been generous, and undelayed; no one could argue that this has been the Unwritten War. I will limit myself here to prose responses to the war, in journalism and fiction, and to a particular instance – Michael Herr's *Dispatches* (1977) – with a structure sharp enough to destroy and recreate the old stories.

Vietnam found itself, in the writing of it, caught in a style match between what could be called innocent and informed accounts. Innocent accounts assume that the war was unprecedented in its horror, squalor, and moral betrayal. A key example – a weak book but, since Oliver Stone's movie, a looming cultural icon – is Ron Kovic's *Born on the Fourth of July*. This extended howl comes upon the fact that war hurts – that soldiers get wounded. Its only arresting gambit is to write the wounding scene twice, and to conclude that it has been "for nothing." But the book has already made its sense of waste terribly clear, and so the repetition does not make us re-see. A more informed vision of repetition – a sense of his station in a line of wounds – might have delivered Kovic from his sense of unique grievance and converted his story into a form-giving expression of grief. (This is to take nothing away from Kovic's actual experience of suffering and sacrifice, for which we can honor him.) At this late date, one simply cannot write well about war – any war – in innocence of the best war writing.

The informed account returns not only upon tradition but also upon itself and so questions the methods and styles by which it can proceed. Tim O'Brien has cornered the market on the self-interrogating Vietnam book. By all rights he is *the* Vietnam writer, having produced three strong prose works (and garnered a Pulitzer Prize) out of the war. Like Kovic, O'Brien was a combatant. But he is convincing when arguing the irrevelance of this fact in any claim to authority in accounts of the war. "Can the foot soldier teach anything important about war, merely for having been there? I think not. He can tell war stories." In the quantity and quality of his work, O'Brien argues for well-told stories as the least the war deserves. Left to itself, to mere accounting, the war has no shape: "Things happened, things came to an end. There was no sense of developing drama." In the gathering discipline and shapeliness of his work – from magical realism to autobiography to speculative short stories – O'Brien makes the case that in returning upon his materials and the inheritance of war stories, Vietnam can be given a shape that conveys its destructive force. The reflexivity of all war – its obsessive quotation of the past – becomes in *The Things They Carried* a masterful self-

reflexivity, a continual refiguring of earlier work in order to show us "How to Tell a True War Story."

Telling war stories is "not a game. It's a form." For a war story to work, it must conform not to truth but to the imperatives of "sense-making," as Philip Beidler calls it. O'Brien admits that in war stories, "Absolute occurrence is irrelevant. A thing may happen and be a total lie; another thing may not happen and be truer than the truth." The recurring accent in *The Things They Carried* on the words *true* and *belief* registers O'Brien's sense of war as constructed. What arrests O'Brien, wakes him from sleep – raises incident to the level of a story – is its twist or trope, not Lemon blown into a tree by a booby trap: "But what wakes me up twenty years later is Dave Jensen singing 'Lemon Tree' as we threw down the parts." The story in which this happens graphs Lemon's death five times and makes through reiteration its largest point, that war stories insist upon and perhaps consist largely of their desperate vying for the truth, an almost endless rhetoric of retelling. As O'Brien says, "You can tell a true war story if you just keep on telling it." Stories are things soldiers carry, a thing to bring back, a gift, an excess, and so they must have, if they are not to be mere burden and baggage, they must have – in the title word of the shortest story in O'Brien's book – they must have "Style."

The informed account that was to prevail in Vietnam stories was Conrad's, the voice that can say "this also has been one of the dark places of the earth." This is the first sentence uttered by Marlowe in *Heart of Darkness*. *Also* is the word that counts here, the admission that such places are many, perpetual, that they add up. Marlowe's is a voice filled and tired with knowledge, yet one open to the shock of discovery. *Heart of Darkness* fuses its vision of repetition with the horror of a unique moment of colonial exploitation and so finds, like the tale that frames the central tale, a structure to contain its disruptions. The form will prove a resilient one: the troubled memoir of the survivor who has outlived the charismatic hero. This structure allows for displacement and distance, an elegy for somebody else. And yet the splitting or doubling of the central character – the profound identification between the teller and his fascinating subject – allows as well for a self-elegy, a mourning for possibilities in the speaker that also have not survived the "horror" of his war.

Marlowe/Kurtz – Fowler/Pyle – Herr/Flynn: The line of descent is a compelling one. Graham Greene rewrites *Heart of Darkness* down to the point of leaving the surviving man facing the alarming charms of the hero's Intended. *The Quiet American* may be the greatest novel written about America in Vietnam, despite the fact that it antedates the arrival of U.S. ground troops there by ten years. Its greatness lies, in part, in Greene's confounding the stories of "War and Love." A few pages from

the end, Fowler says that "I can't worry much about people in history." But he has himself already entered history, and for personal reasons. He arranges Pyle's death in order to recover Phuong and then discovers that history and the personal cannot again be separated. He learns that one has to take sides "If one is to remain human." Pyle takes sides from the start, and with the best of "motives," yet he remains so "armored by his good intentions and his ignorance" that he is destroyed by what he tries to save. The novel does not recommend "taking sides" but allows us instead to measure the cost and difficulty of doing so – or of not doing so. In renewing Marlowe's Congo vision, Greene thus prophecies the future as well. He creates the best case against an American "innocence" ("Innocence always calls mutely for protection when we would be so much wiser to guard ourselves against it") that would have appalled Conrad and that proved to be, as surely as anything, the downfall of our nation in Vietnam. This innocence can be defined as an absence of awareness or irony about one's narrative stance, Pyle's uncritical belief in the power and originality of his Vietnam war story.

In 1979, Michael Herr adapted the plot and tone of *Heart of Darkness* for the screenplay of *Apocalypse Now.* But he had already paid Conrad homage in the war-torn form of *Dispatches,* the book by an American that most successfully takes on not only Vietnam but also the traditions that had already fully imagined it. Herr's book works not simply because it is outraged but because it remembers. If the theme of salvaged love drops out, the narrator-hero structure remains. Herr centers his book squarely in the problem of survival, in the sense that his Vietnam is about the gain in loss of living on.

In *Dispatches,* Herr tells an "old story." His is the story of a "survivor" who spent his war watching it. He worries over the morality of looking, his status as a paid observer. Herr spent more than a year in Vietnam; witnessed the siege of Khe Sanh and the destruction of the old capital, Hue; logged most of his time with Marines. *Esquire* had hired his services with no particular deadline or assignment; just "cover" the war. "Talk about impersonating an identity, about locking into a role, about irony: I went to cover the war and the war covered me; an old story, unless of course you've never heard it." The most dramatic moment in his first chapter comes when Herr amplifies the meaning of the verb *cover* – when he slides over to the wrong end of the story. "We covered each other," he says about life with the grunts, "an exchange of services that worked all right until one night when I slid over to the wrong end of the story, propped up behind some sandbags at an airstrip in Can Tho with a .30-caliber automatic in my hands, firing cover for a four-man reaction team trying to get back in." "Breathing In" ends with Herr picking up a gun. His drama of detachment temporarily ends: "I wasn't

a reporter, I was a shooter." In the morning after the firefight, Herr sees the empty clips lying around his feet and cannot "remember ever feeling so tired, so changed, so happy."

The clarity of these emotions proves unique in *Dispatches,* a transport unavailable to Herr when looking at pain. Herr never suffers a serious wound, although he will panic badly on one occasion. A mortar comes in, and "When we fell down on the ground the kid in front of me put his boot into my face." The kid's profuse apology sends Herr into a terror spiral: "somewhere in there I got the feeling that it was him, somehow he'd just killed me. I don't think I said anything, but I made a sound that I can remember now, a shrill blubbering pitched to carry more terror than I'd ever known existed, like the sounds they've recorded off of plants being burned, like an old woman going under for the last time." He had suffered a bloody nose. Herr's big moment of physical pain and fear proves bathetic, the wrong end of the story. His job and his story is not to shoot and be shot. His book works because he cannot do his job with a single mind.

"Put yourself in my place": Herr quotes this sentence before telling the "head-wound" story on himself, and it is the request made to him by every G.I. he meets, "the story . . . always there and . . . always the same." Being a good reporter, a journalist, means being *un*detached, standing in with, feeling for. " 'Must be pretty hard to stay detached,' a man on the plane to San Francisco said, and I said, 'Impossible.' " If this is New Journalism, it has nothing to do with Tom Wolfe's arch surveys and melodramatic syntactic gyrations. It is a claim made rather about the status and purpose of witness, one Herr makes on behalf of all those who, at whatever distance, watched and survived the war. The claim comes straight out of Wilfred Owen, and his muddy trenches: that when it comes to war, the poetry is in the pity.

Vietnam writing by combatants makes, typically, the opposite move and invests energy in the act of not feeling, in detailing the defenses that hold pain at bay. Drugs give one way out. In *Meditations in Green,* Stephen Wright's narrator not only smokes pot but identifies with the uncontested being of a plant: "Vegetable bliss." Pitch-black humor offers another way, Gustav Hasford's conversion of the war in *The Short-Timers* into a sick joke, a world made "safe for hypocrisy." Silence provides a third, as in Larry Heinemann's *Paco's Story,* where a body reduced to "bloody confetti" finds its story not only stolen by others but, anyway, "more than tongue can tell." Herr gets liberated to tell precisely by what also limits him, the precariously safe haven of the journalist's stance. He can put himself in a soldier's place because he is not already in it and so converts his book into a meditation on its persistent activity – looking – and on looking's biggest subject – pain.

Herr's earliest act of witness, one he buries midway into the book, deals with his not being able to see. He is flying with some replacements in a Chinook:

> And across from me, ten feet away, a boy tried to jump out of the straps and then jerked forward and hung there, his rifle barrel caught in the red plastic webbing of the seat back. As the chopper rose again and turned, his weight went back hard against the webbing and a dark spot the size of a baby's hand showed in the center of his fatigue jacket. And it grew – I knew what it was, but not really – it got up to his armpits and then started down his sleeves and up over his shoulders at the same time. It went all across his waist and down his legs, covering the canvas on his boots until they were dark like everything else he wore, and it was running in slow, heavy drops off his fingertips.

This scene replays one on Conrad's Congo steamer, in which Marlowe sees "Something big" appear in the air, the helmsman step "back swiftly," and the man "fall" upon Marlowe's feet. "The side of his head hit the wheel twice, and the end of what appeared a long cane clattered round and knocked over a little camp-stool. It looked as though after wrenching that thing from somebody ashore he had lost his balance in the effort." The helmsman too has been hit and killed, not by a bullet in the back but by a spear. Each narrator's literal description of the motions of the wounded body captures the terrifying sense that in such dark places we will always have the experience but miss the meaning. Given the casual notation through which these sentences unfold, each writer gets his reader to take the same, unknowing trip. Knowledge by definition is belated, too late to save or rescue. Words like *bullet* and *blood* are facts language here cannot quite summon, although it can manage the domesticating metaphor of the baby's hand. Although one hesitates to convert this passage into any kind of literary performance, the growing darkness of the blood does capture the way information will come to Herr in Vietnam, the irrevocable stain of knowledge, its inevitable spread. All that is left, as Conrad writes in the preface to *The Nigger of the Narcissus,* and as Herr repeats near the end of *Dispatches,* is an act of witness: "I didn't go through all of that not to see."

In *Dispatches,* information overload threatens the efficacy of the eye. "Levels of information were levels of dread, once it's out it won't go back in, you can't just blink it away or run the film backward out of consciousness." There was the official myth of the war, contravened by any eyewitness of it. There was its undaunted love of speed, the "traveling so

fast toward something so frightening." There was its peculiar brand of horror, with its seductive evocation of pleasure:

> It came back the same way every time, dreaded and welcome, balls and bowels turning over together, your senses working like strobes, free-falling all the way down to the essences and then flying out again in a rush to focus, like the first strong twinge of tripping after an infusion of psilocybin, reaching in at the point of calm and springing all the joy and all the dread ever known, *ever* known by *everyone* who *ever* lived, unutterable in its speeding brilliance, touching all the edges and then passing, as though it had all been controlled from outside, by a god or by the moon. And every time, you were so weary afterwards, so empty of everything but being alive that you couldn't recall any of it, except to know that it was like something else you had felt once before. It remained obscure for a long time, but after enough times the memory took shape and substance and finally revealed itself one afternoon during the breaking off of a firefight. It was the feeling you'd had when you were much, much younger and undressing a girl for the first time.

In this shocking and arousing paragraph, Herr admits that he at once hates the war and loves it, that it is the ultimate trip, that "We had no secrets about it or the ways it could make you feel." If there are no women in *Dispatches,* no Intendeds lost or found, no Phuong to thrust one into "the mess of life," it is perhaps because, as a place, Herr's Vietnam proves so utterly ravishing.

Shame and the look: If Herr connects the two, he does so by way of exposing his profession's lust for guilty pleasures. Looking, like desire, is an act that is never ended. Of dead bodies, Herr begins by imagining a moment "When you finally started seeing them." But "even when the picture was sharp and clearly defined, something wasn't clear at all, something repressed that monitored the images and withheld their essential information. It may have legitimized my fascination, letting me look for as long as I wanted; I didn't have a language for it then, but I remember now the shame I felt, like looking at first porn, all the porn in the world. I could have looked until my lamps went out and I still wouldn't have accepted the connection between a detached leg and the rest of a body, or the poses and positions that always happened, (one day I'd hear it called 'response-to-impact'), bodies wrenched too fast and violently into unbelievable contortion." The endlessness of looking, its uncanny resemblance to the rhythms of desire – this is what Herr discovers in Vietnam, and it finally has less to do with the quantity and tex-

ture of the information coming in than with the sheer and permanent logic of the act of looking itself.

"I went there behind the crude but serious belief that you had to be able to look at anything, serious because I acted on it and went, crude because I didn't know, it took the war to teach it, that you were as responsible for everything you saw as you were for everything you did." Where the distinction between seeing and doing collapses, the journalist's stance as a non–this or that vanishes as an issue. Herr's text finds no stance free from responsibility and so delivers not only a timeless treatise on the ethics of journalism but also a historically specific analysis of the implication of any onlooking American and the war in Vietnam. There is no place in which Herr's reader can, with him, stand aside.

So we come to *Dispatches* because, like Herr off to Vietnam, we want to see, to know, to be turned on – and we leave it responsible for everything we have read. The book gets us "to perform a witness act." But it does not indulge us in the "mistake of thinking that all you needed to perform a witness act were your eyes." Feeling is the thing, and if we do not move from looking to feeling, then we have refused to go to Herr's war, stayed home.

And of course "home" is the ultimately false position, the place that, after Vietnam, ceases to exist. The States are, as Herr calls San Francisco, "the other extreme of the same theater." The Vietnam books that play up the distinction between the war and home are the least convincing, like James Webb's *Fields of Fire*. After the crafted pathos of his battle scenes, the final tableau at a stateside peace rally tries and fails to make a point about dissent at home undermining the fighting abroad. But the burden of fighting as Webb has revealed it – as nearly every book about combat reveals it – is not in its purpose but in its passion, a self-justifying activity that knows less about politics than the brotherhood of pain. Men fought out of the solidarity with other men that war will always create; in any case, it was not as if they were likely to be demoralized by the peace movement, a struggle that reflected a deep domestic disquiet and that entailed its own substantial risks. Robert Stone's *Dog Soldiers* made, early on, the essential case for Vietnam as a war that was also fought at home. The aptly named Converse simply switches from one theater to another, an America as spaced out and drugged out as its Southeast Asian double. As Herr says in the last line of his book, "Vietnam Vietnam Vietnam, we've all been there."

This is not a glib act of inclusion but an admission that whether one fought the war or fought against it, the images and stories of loss were there to be looked at, felt about. Herr begins his book with a man in a room looking at a map. *"I'd lie out on my bed and look at it."* A map is an abstraction, he admits, and *"even the most detailed maps didn't reveal much*

anymore.'' What bloods the abstraction is reading, the gerund that replaces looking: *"reading them was like trying to read the faces of the Vietnamese, and that was like trying to read the wind. We knew that the uses of most information were flexible, different pieces of ground told different stories to different people. We also knew that for years now there had been no country here but the war.''* Vietnam is fungible; its everything can be converted into everything else. Herr's challenge will be to move beyond the abstract purposes of the war, to stay its endless flexibility, and to find a structure in which its hurts can be felt.

As in Orr's poems, the need for shape gathers around the task of looking at pain. And as in Glück's *Ararat,* Herr's book is careful in laying claim to pain. The continual and unresolved issue, for Herr, is that he has *chosen* harm's way: "You fucking guys," he said. "You guys are *crazy.''* This is said by an exhausted Marine who judges Herr crazy for electing to share his pain. "I realized that after all this time, the war still offered at least one thing that I had to turn my eyes from." He cannot look at the man who questions why he has chosen to look at all. Herr suffers his failure of vision or nerve precisely when made to remember that the pain he looks at is somebody else's. The Marine who "forgives" him for being a reporter may inflict more damage:

> We were on the ground when those rounds came, and a Marine nearer the trench had been splattered badly across the legs and groin. I sort of took him into the trench with me. It was so crowded I couldn't help leaning on him a little, and he kept saying, "You motherfucker, you cocksucker," until someone told him that I wasn't a grunt but a reporter. Then he started to say, very quietly, "Be careful, Mister. Please be careful."

As readers, we are placed at a double remove; our task is to watch a man watch another's pain. Herr provides an exemplum of this in a moment at Khe Sanh when a Marine walks out of a shelled triage tent.

> A Marine came out and stood by the flap for a moment, an unlighted cigarette hanging from his mouth. He had neither a flak jacket nor a helmet. He let the cigarette drop from his lips, walked a few steps to the sandbags and sat down with his legs drawn up and his head hanging down between his knees. He threw one limp arm over his head and began stroking the back of his neck, shaking his head from side to side violently, as though in agony. He wasn't wounded.

As we read into these sentences, we prepare ourselves for the uncovering of a wound. But the kind of pain we see the Marine in is not a physical

pain. He is feeling for another, someone back inside. In this chain of imaginings, the reader watches Herr watch a Marine who in turn shares the "agony" of a man or men we cannot see. In moments like this, Herr connects with the possibilities of witness and reveals that the respective distance from the point of impact does not prevent hurts from being felt.

"I couldn't look at the girl": This sentence, perhaps Herr's most terrifying, and most honest, echoes backward toward Hemingway's "Indian Camp" ("Nick didn't look at it") and forward into all the inevitable and future moments of looking away. It comes near the end of "Illumination Rounds," as Herr visits the province hospital at Can Tho:

> One of the Vietnamese nurses handed me a cold can of beer and asked me to take it down the hall where one of the Army surgeons was operating. The door of the room was ajar, and I walked right in. I probably should have looked first. A little girl was lying on the table, looking with wide dry eyes at the wall. Her left leg was gone, and a sharp piece of bone about six inches long extended from the exposed stump. The leg itself was on the floor, half wrapped in a piece of paper. The doctor was a major, and he'd been working alone. He could not have looked worse if he'd lain all night in a trough of blood. His hands were so slippery that I had to hold the can to his mouth for him and tip it up as his head went back. I couldn't look at the girl.
>
> "Is it all right?" he said quietly.
>
> "It's okay now. I expect I'll be sick as hell later on."
>
> He placed his hand on the girl's forehead and said, "Hello, little darling." He thanked me for bringing the beer. He probably thought that he was smiling, but nothing changed anywhere in his face. He'd been working this way for nearly twenty hours.

"Is it all right?" the doctor asks. He speaks out of the middle of this scene to an unwounded journalist, asks him about his pain. He takes time out to imagine what Michael Herr may be feeling. As if it mattered. As if, compared with what the girl below him must be feeling, it mattered. He turns aside from one act of pity into another, and then he turns back to the girl.

The brilliance of this scene is that Herr was able to notice this story *as a story,* to raise a casual aside into one of the most moving examples of the capacity for pity in the literature of war – a pity so far beyond the call of duty that it feels terrifying, limitlessly sublime. Meanwhile, the girl's eyes are wide. They have been permanently opened. Meanwhile, Herr looks away. But not before he has looked and made us look as well. Two kinds of vision collide here – one beyond and the other still burdened by

feeling – and they are mediated by the doctor's two sayings, his seemingly endless love.

Herr gives this little story a structure because the pain requires it if it is to be felt. As in O'Brien's Vietnam books, *story* is for Herr a privileged word. "They all had a story," the grunts did, "and in the war they were driven to tell it." This is what Herr can do. The Marines know he will survive. So he must absent himself from felicity awhile, and draw his breath in pain, *To tell my story.* "Okay, man, you go on, you go on out of here you cocksucker, but I mean it, you tell it! You tell it, man. If you don't tell it. . . ." The first story Herr retells is this one, and it proves exemplary:

> "Patrol went up the mountain. One man came back. He died before he could tell us what happened."

Herr will incorporate a number of important narrative moves from this story. Vietnam stories are short, dispatches. They are fragmentary, broken off. They refuse to moralize the tale. And they foreground their own untellability, presume that either the teller or the listener will fail to survive or connect. Herr finds this as "resonant as any war story I ever heard" and will build his style out of it.

In *Dispatches,* Herr conducts the telling by the way of three narrative units: the sentence, the story, and the chapter. These contrasting structures advance a complex argument about the ways in which the war elicited and resisted meaning-making forms.

The distinctive rhythm of Herr's prose is its breathlessness, a sentence that hurtles toward its finish while trying to carry too much, take everything in: "Sometimes the stories were so fresh that the teller was in shock, sometimes they were long and complex, sometimes the whole thing was contained in a few words on a helmet or a wall, and sometimes they were hardly stories at all but sounds and gestures packed with so much urgency that they became more dramatic than a novel, men talking in short violent bursts as though they were afraid they might not get to finish, or saying it almost out of a dream, innocent, offhand, and mighty direct, 'Oh, you know, it was just a firefight, we killed some of them and they killed some of us.' " This sentence is the cry of its occasion. The three repetitions of *sometimes* rein in its will toward proliferation, as do the closural consonants ("-ck," "-ex," "-ll," "-el") at the end of the gathering phrases. The sentence almost ends with "a novel," then pivots on "men talking," finding the means to proceed by naming the process it enacts. It dwindles into quotation and bathos. Herr hands the sentence back to the stunted eloquence of the G.I.s and shows how and why their stories need him.

If Herr's sentences bespeak a frustrated will toward inclusion and closure, his retold stories express all the entropy in the world. He does not so much retail stories as their interruptions, like the one about the Marine slated to leave Khe Sanh. "He picked up his duffel . . . and started for the airstrip. . . ." Herr here turns aside to describe the runway, and by the time he gets back to the Marine Herr's character no longer wants the unfolding story, fails to catch his plane. For all Herr knows, he never leaves. If the stories Herr tells are truncated, abrupt, and parenthetical, they find a form suitable for a war in which a digression from Tet like Khe Sanh can be mistaken in the mind of General Westmoreland as the "capstone" of the war. The fate of the isolated and besieged Marine base near the Laotian border was a story over before it started. The heaps of shredded jungle fatigues, the burned-over jungle slopes, the wire cluttered each dawn with the dead – "None of it had happened yet when Khe Sanh became lost forever as a tactical entity." This "false love object," like the whole of Vietnam itself, so distracted attention from the big story, the real story (a story that America will never know, because it mistook the sideshow for the main event), that it compelled and even came to seem to deserve coverage, which is – "Khe Sanh" is Herr's longest chapter – what he gives it. In their fidelity to the logic of positions taken, held, or abandoned, Herr's Vietnam stories reflect and expose the absurd tactics of the war.

Herr divides the whole of *Dispatches* into six chapters. The book begins with "Breathing In," the most stylish and story-ridden section, the one that ends with Herr picking up a gun. He says and knows that this is the wrong end of the story, and it is wrong because it affords premature closure, the traditional violent apotheosis of the war story. "Hell Sucks" deals with the 1968 Tet offensive, during which both the old and new capitals of South Vietnam were overrun, and makes the moves that Herr's smallest and largest stories will continue to make, killing off the story at the start. A page into the chapter, Herr tells us that "instead of losing the war in little pieces over years we lost it fast in under a week." The surprise attacks by North Vietnamese regulars and the Vietcong left America's political will deeply shaken; Johnson announced his decision not to seek a second term a few months later. With Tet, the war was effectively over and lost. What's left to do is "cover" it. The third chapter, "Khe Sanh," is at once a "diversion" from Tet and a "recollection" of Dien Bien Phu. It is the good story that gets read as always about an earlier or a bigger one. "Illumination Rounds" consists of bursts of light, Herr's set of brief dispatches. Among the most powerful of Herr's vignettes, these are stories too short to deserve the name. "Colleagues" proves a digression into the romance of biography, and the promise that the story will be not about Herr but about somebody else. "Breathing

In" finds Herr back home, a man "Out on the street" again, like Mar-
lowe returned to his ghostly London. The opening and closing titles –
"Breathing In" and "Breathing Out" – argue that all of Herr's time in
Vietnam can be reduced to a suspenseful bodily motion, the single span
of a held breath.

Herr's largest structures call into question, then, the possibility of
large structure. He imposes no narrative arc on the story of Vietnam,
except his going and coming hence. Like most who went to the war, he
is a short-timer, and the war becomes a measure of all that can be seen
and felt, both in the heart and on the page, in short time.

Herr's Vietnam proves less a shape than an echo in time. Its romance
comes from its evocation of earlier moments, the way it intersects the
rhythms and shapes of American history and popular culture. A story of
fatal repetitions and continuities, Vietnam replays the national experi-
ence as William Carlos Williams might have dreamt it if he had waited
fifty more years to write *In the American Grain:*

> Anyway, you couldn't use standard methods to date the doom;
> might as well say that Vietnam was where the Trail of Tears was
> headed all along, the turnaround point where it would touch and
> come back to form a containing perimeter; might just as well lay it
> on the proto-Gringos who found the New England woods too raw
> and empty for their peace and filled them up with their own im-
> ported devils. Maybe it was already over for us in Indochina when
> Alden Pyle's body washed up under the bridge at Dakao, his lungs
> all full of mud; maybe it caved in with Dien Bien Phu. But the first
> happened in a novel, and while the second happened on the ground
> it happened to the French, and Washington gave it no more sub-
> stance than if Graham Greene had made it up too. Straight history,
> auto-revised history, history without handles, for all the books and
> articles and white papers, all the talk and the miles of film, some-
> thing wasn't answered, it wasn't even asked. We were back-
> grounded, deep, but when the background started sliding forward
> not a single life was saved by the information. The thing had trans-
> mitted too much energy, it heated up too hot, hiding low under the
> fact-figure crossfire there was a secret history, and not a lot of peo-
> ple felt like running in there to bring it out.

Herr provides here a demonstration and justification of his method. If he
confounds history and fiction, if he looks at Vietnam with "Cinema-
scope eyes," if Vietnam makes Wingy Manone snap into his head one
minute and *Fort Apache* the next, it is because the war is being fought by
a culture in which all experience has become *mediated,* an interpenetra-

tion of movies and music and high school versions of history and raw experience so thorough that the point is no longer to sort the data out but, as Stein argues in *Lord Jim,* "In the destructive element immerse." If Herr begins by trying to preserve distinctions between the mediated and the actual, he will end by collapsing them: "Out on the street I couldn't tell the Vietnam veterans from the rock and roll veterans. The Sixties had made so many casualties, its war and its music had run power off the same circuit for so long they didn't even have to fuse." Vietnam was a war fought out of a massive and collective illusion, an innocence and ignorance constructed out of and fed by the romantic confusion of a culture that can no longer draw the line between the world and its projections of it.

So what survives? Brotherhood, perhaps, the sheer generational experience of filiation, going through time together. "There was a brotherhood working there," Herr writes in "Colleagues," and he reserves his least complicated emotions for the lost brother, Sean Flynn. Out of Flynn's story, Herr constructs a discreet elegy for a lost friend and a lost vocation, the practice and project of journalism.

We meet Flynn early on, near the beginning of "Breathing In." "Sean Flynn could look more incredibly beautiful than even his father, Errol, had thirty years before as Captain Blood, but sometimes he looked more like Artaud coming out of some heavy heart-of-darkness trip, overloaded on the information, the input! The input! He'd give off a bad sweat and sit for hours, combing his mustache through with the saw blade of his Swiss Army knife." Flynn's "Credentials" get established less through the assertion of his personal beauty than the fact of his origin in a prince of popular culture. He is a reminder, a rhyme, not of an event or person that happened in time but of one forever stellified on the screen. He is the embodiment of glamour. And the war needs it, cannot, in fact, escape it, as the wounded Page argues at the end of "Colleagues":

> "Take the glamour out of war! I mean, how the bloody hell can you do that? Go and take the glamour out of a Huey, go take the glamour out of a Sheridan. . . . Can *you* take the glamour out of a Cobra or getting stoned at China Beach? It's like taking the glamour out of an M-79, taking the glamour out of Flynn."

Through the figure of Flynn, "photographer and connoisseur of the Vietnam War," Herr discovers that, yes, "the glamour" of being a war correspondent "was possibly empty and lunatic, but there were times when it was all you had."

Herr manages and sustains Flynn's glamour by withholding him from the reader. He emerges slowly, like Kurtz, though without the menace. The glamour of both figures resides in their mystery, a sense that they

are virtually silent centers that cannot be known. It is the mystery of character itself, the opacity and otherness such figures possess in contrast to all we so awkwardly know about their narrators. Flynn's "celebrity" forces him to seek his friends "among those who never asked him to explain himself"; if he had a past "he didn't like to talk about it. Sometime during his years in Vietnam, he realized that there really were people whom he cared for and could trust, it must have been a gift he never expected to have, and it made him someone whom his father, on the best day he ever had, could have envied." If the war offers Flynn a haven from fame, the glamour can't be taken out of Flynn or Vietnam because neither can be explained, narrated, known, told. Herr evokes this glamour repeatedly, disdains to sever Flynn from his Hollywood roots:

> He was (indeed) the Son of Captain Blood, but that didn't mean much to the grunts since most of them, the young ones, had barely even heard of Errol Flynn. It was just apparent to anyone who looked at him that he was what the Marines would call "a dude who definitely had his shit together." All four of us on the ridge looked more or less as though we belonged there; the AP's John Lengle had covered every major Marine operation of the past eighteen months, Nick Wheeler of UPI had been around for two years, I'd had the better part of a year in now, we were all nearly young enough to be mistaken for grunts ourselves, but Flynn was special. We all had our movie-fed war fantasies, the Marines too, and it could be totally disorienting to have this outrageously glamorous figure intrude on them, really unhinging, like looking up to see that you've been sharing a slit trench with John Wayne or William Bendix. But you got used to that part of Flynn quickly.

The curious thing about such passages is that they withhold more than they reveal. Herr's continual search for "personal style" comes upon Flynn and delivers him up as . . . "special"? Flynn proves the figure whose appeal is invoked rather than evoked, a style so pure it is beyond Herr's to contain it.

If Flynn is not known or conveyed, his loss is survived. One day he just disappears, a fact Herr withholds from the "Colleagues" chapter and reveals only once he is back home:

> I have pictures of Flynn but none by him, he was in so deep he hardly bothered to take them after a while. Definitely off of media, Flynn; a war behind him already where he'd confronted and cleaned the wasting movie-star karma that had burned down his father. In so far as Sean had been acting out, he was a great actor.

He said that the movies just swallowed you up, so he did it on the
ground, and the ground swallowed him up (no one I ever knew
could have dug it like you, Sean), he and Dana had gone off some-
where together since April 1970, biking into Cambodia, "pre-
sumed captured," rumors and long silence, MIA to say the least.

Herr follows this passage with a paragraph that begins *There it is*. The
paragraph goes on to give the etymology of the phrase. No extended el-
egy for Flynn; Herr just turns away. The elegy has been the entire book,
the looming recognition that Vietnam means the discovery and loss of
glamour. And what is lost with Flynn and his lost war is the glamour of
journalism itself.

Dispatches traces Herr's transformation from journalist to survivor, and
his survival as a witness leads him to question the value and purpose of
journalism as a form. If he went to Vietnam as a war correspondent, he
found that "conventional journalism could no more reveal this war than
conventional firepower could win it, all it could do was take the most
profound event of the American decade and turn it into a communica-
tions pudding, taking its most obvious, undeniable history and making it
into a secret history." After "six or seven weeks in Vietnam" he has not
yet got the picture, still thinks of a certain kind "of information as a jour-
nalist's detail that could be picked up later, not something a survivor
might have to know." By the end of the war he has learned to read the
information, refrain from fatal gestures, agree to live on. Perhaps we
were "nothing more than glorified war profiteers," he ventures near the
end, "those of us who didn't get killed or wounded or otherwise fucked
up." He ventures this a page after writing down all the "nasty things"
journalists can be called, from parasites to thrill freaks to wound seekers
to war lovers. If "Colleagues" begins (it opens with an image of a World
War I correspondent in his tent) and continues as an extended essay on
journalism, it decides with some certainty that the "news media" could
never have covered the war, that they were too "reverential toward the
institutions involved," too fact-bound ever "to report meaningfully
about death." Some sort of excess was in order, a disruption of form.
This is the burden also of Bryan's *Friendly Fire,* a book that sets out to do
an exemplary act of reporting, and in which the journalist, like Herr, be-
comes his own best subject: "I never wanted to be in this book. I had
intended only to be a journalist: unbiased, dispassionate, receptive to all
sides. . . . By concentrating on one specific incident, the death of
Michael Mullen, by restricting myself to this one isolated Iowa farm
family's story, I had hoped somehow to encompass the whole. This tech-
nique, I later came to realize, was not a journalist's, but a novelist's; and
it led inevitably not only to my own participation and inclusion in the

Mullen story but also to that awful sadness and disappointment I now felt." Bryan here comes out into his narrative. Herr admits from the start that he is in it. He knows from the start that relations stop nowhere, that professional decorum is a repressive fiction, and that the way to tell the stories of Vietnam is not through distance and dispassion but through witness and survival and the transgressions of a personal style. Vietnam becomes by way of Herr's style, as it does for Greene's readers and for Bryan's, an experience that cannot simply be watched but one that draws us down into time and care and pain, that discloses us as "people in history." In doing this, Herr's book fuses, refigures, and exposes to our scrutiny the themes of his generation: nostalgia for an American innocence that never existed, the lost solidarity of "home"; celebrity and its power to elevate the dailiness of life into attention-worthy story; family romance and its band of brothers, journalism's happy few; survival and the challenge of life after youth, and how to honor those who have been lost.

If stories are the forms through which we give or restore life – "We kept the dead alive with stories," O'Brien writes – they are also an experience through which we confirm our ongoing sense of being alive. Survival is not simply the major burden of war stories but, perhaps, of all story – that we have lived to tell or hear the tale. Anyone who lives any amount of time survives the loss of people and places and things that are loved. *Survival* is another word for life after birth, and our stories keep our sense of loss alive.

Still and all, the generation of the sixties continues to experience its unique version of survival. In reading the poetry of Gregory Orr and Louise Glück or the dispatches of Michael Herr, we are asked to acknowledge the persistence of a shaping self despite the shock of early and intimate loss. The loss is embodied in the figure of a brother, sister, or friend, someone fallen, though close in age. The survivor transforms the guilt and pain into the order of words, seeks out and questions the adequacy of an elected, professional form. The story thereby told is a personal one, the career of a unique grief. Yet the act of written mourning proves exemplary as well. As they turn and remember, these writers call up the collective memory and grief of a generation that saw nearly 60,000 of its number go to a war from which they did not return. As we live on into the nineties, the memory of those dead, and of those the war destroyed without killing, is precious among the things we carry.

Conclusion: people in history

The desire to enter history has been a great dream of the twentieth century. We operate often from the belief that the human actor can and should enter public time and try to change it. Of course we are all always in public time, but our many modes of engagement and implication can be depreciated by a view of the world as essentially political. For by history we have meant politics, and the narrowing of the term has been, for some, a disaster. Politics reduces history to a power struggle and requires the human actor to enter in, if he or she is not be a passive victim, with a position, or, worse, an ideology. To equate history with politics is to encourage the hope of an earthly paradise, and the pursuit of perfection often leads to fundamentalism and tyranny. Yeats saw as early as 1939 that defining life as political also defines away the personal as marginal:

Politics

"In our time the destiny of man presents its
meaning in political terms." – THOMAS MANN

How can I, that girl standing there,
My attention fix
On Roman or on Russian
Or on Spanish politics?
Yet here's a travelled man that knows
What he talks about,
And there's a politician
That has read and thought,
And maybe what they say is true
Of war and war's alarms,
But O that I were young again
And held her in my arms.

Yeats here dramatizes the conflict between two orders of time. The closing allusion to "Western Wind" brings poetic time to bear on historical time, and poetic time prevails. The poem slants the argument in favor of poetic time, given the way it begins with the response to the girl and dismisses the fate of empires with a rhetorical question. It is instead the rise and fall of generations and desire that compels the poet here. So the struggle between the poem and its epigraph is won handily by the poem. With "But O" the poem's crabbed rhythm breaks into a trochaic chant of praise. If Yeats in aging has become a smiling public man, his heart has not grown old, and he not only remembers the desire of his youth but feels it still. Attention is incorrigible, beauty and pleasure are irresistible, and the realm of personal feeling renews not only the speaker but the poetic tradition.

The poem had been intended by Yeats to appear as the conclusion to his collected poems. Instead, "Under Ben Bulben" was given that place by Mrs. Yeats in the 1940 *Last Poems & Plays* at the suggestion of Thomas Mark. Only in 1989 did two editions, each vying to be authoritative, finally get the order right. The history of the poem is a parable for our time. The irrepressible cry of personal lament and response is displaced by the stentorian public posturing of "Under Ben Bulben," with its "Send war in our time, O Lord." Yeats's assertion of the need to complete our "partial" selves through "some sort of violence" becomes in subsequent editions of the lyric poems his final word. And so it became for the next fifty years. During that time, it was widely and passionately believed that the destiny of man presented its meaning in political terms.

Yeats wrote "Politics" in the last year of his life. He died in the dead of winter, in 1939, some seven months before Hitler's tanks broke into Poland. It was the war that drew the United States into history once and for all, and that then led to a second one – the Cold War – more psychically debilitating than the first. This afterwar permitted neither victory nor catharsis but only an anxiously repressed waiting for the end. The generation of the sixties is peculiarly of that Cold War, the first one born into the world of the bomb and one never to know a moment free – until the November 1990 headlines told it was "over" – of unprecedented suspense and dread. Now it looks as though we were not destined after all to live at the end of historical time. Now, perhaps, we can begin to live in our time.

It is the argument of this book that some of us already have done so. Yeats equates politics with war, and I have in this closing argument as well. My book has had little to say about war otherwise, because the fighting – the story – can be found mostly elsewhere. But I want to end by thinking, as I began, about Vietnam, and the ways in which the dilemmas it posed for a generation became paradigmatic of our sense of choosing, and storytelling.

In 1991 I attended my twenty-five-year high school reunion, in San Bernardino, California. The affair was held in a geodesic dome, on the grounds of the National Orange Show. Out of a class of some 1,000, only 200 turned up. With a few men I sat and talked about the night we became people in history, the night of the draft lottery, in the fall of 1969. It was the one postgraduation memory we vividly shared. My roommates and I had sat next to the radio in a dormitory at Yale, listening to the numbers being ticked off. The first 130 birthdates picked were slated for the draft, so, as the evening wore on, the noises echoing through the stairwells changed from anguish to delight. Later, people did not speak about the sounds they had made.

The lottery was a brilliant device for sorting young men into the condemned and the saved. After that night, some would have to think about the war, and some would not. My number was 235, well out of harm's way. I had already applied for conscientious objector status, basing my claim on a tenuous mix of California "religious training and belief" and a reading of Sartre and Camus. My draft board would not have to read it, after all; I was free to marry and head for graduate school. Two friends with low numbers later used my application as a template for their own.

The response to Vietnam – whether to go to the war, fight against it, or stay on the sidelines – this became the ground for a generation's sense of political choice as ineluctable. "Sooner or later . . . one has to take sides. If one is to remain human." If in our twenties we did not know this, we still in some way had to live it out. The quotation is from Graham Greene's *The Quiet American,* published in 1955. Vietnam forced side-taking upon us at an early age, and Greene's novel, despite the fact that it was written by an Englishman – and ten years before American ground troops were committed to Vietnam – anticipates like no other the resistances to and consequences of such a choice. It advances a more complex view of the tension between history and the personal than is found in Yeats's poem. The move from the poem to the novel is the one I hope I have made in writing this book, and I would like to end with a second and extended reading of Greene's account of the burden of Vietnam.

In the early 1950s, English journalist Fowler lives happily in Saigon with his Vietnamese lover, Phuong. She fixes his opium pipe in the evening and unhesitatingly shares his bed. They cannot marry because Fowler's wife back home does not believe in divorce. Into their peace comes Pyle, a young American bent on developing a "third force" that can tip the balance in the war between the Communists and the French. Pyle falls in love with Phuong, and the story unfolds.

Greene begins his novel at the story's end, with the effect of an action. Phuong has been living with Pyle for two months and returns to Fowler's apartment only because Pyle has disappeared and both she and

Fowler are anxiously waiting to hear what has happened to their Quiet American. That night Pyle will be found murdered under the Dakow bridge. With no place to go, Phuong will "come home" to stay. The book begins and ends with Fowler and Phuong upstairs alone, in personal space, as she fixes him an opium pipe. It begins and ends with the same scene, but between the two stagings of it, and within the circularity of this structure, everything has changed. The gap between the reader's initial and final take on this scene is the movement from innocence to knowledge.

"You're *engagé,* like the rest of us." This is said to Fowler by Vigot, the French policeman who investigates Pyle's murder. Fowler has devoted himself to detachment, and Vigot knows it: Armored by cynicism and opium, he spends his days staying "neutral." "I have no politics," he proudly claims. War involves the mutilation of the innocent: "That's why I won't be involved." Yet when his personal happiness is threatened, and an act can restore it, Fowler will act. As Captain Trouin says to him, "We all get involved in a moment of emotion and then we cannot get out. War and Love – they have always been compared." Fowler's story not only allows him to compare but also demands that he confound, so thorough is his plunge into engagement, the two realms.

As Fowler's unwitting double, Pyle has come to one of the "dark places of the earth" in order to change it. "Pyle believed in being involved." He is fully engaged, albeit by an imaginary Vietnam. What he knows he has gotten from books, and Fowler endeavors to strip him of his innocence: "That was my first instinct – to protect him. It never occurred to me that there was greater need to protect myself. Innocence always calls mutely for protection when we would be so much wiser to guard ourselves against it." Pyle has the kind of innocence that thinks a man is required to jeep through enemy territory in order to inform another man that he plans to steal his girl. He treats Fowler as if he were merely the opponent in a "game." Confidently astride of history, with big plans for redirecting the war, Pyle gets derailed by his inexperience of the personal, dies because he does not know, with Fowler, that "we are incapable of honour" in love.

The Quiet American unfolds as a colloquy about false withdrawal and false engagement. Fowler and Pyle will have switched positions by the novel's end, despite the inertia implied in the repetition of the opening and closing scenes. Along the way, they vigorously debate the question of political engagement. This is a novel filled with talk. The talk is mostly Fowler's; Pyle is allowed flat-footed assertions, like "You have such an awful lot of experience, Thomas," or, on the question of the bombed dead, "they died for democracy." Pyle proves no verbal match for Fowler, and it becomes increasingly clear that Fowler is arguing with

himself. Fowler thinks himself a mere existentialist, up against the big themes of Time and Death. His habit has been to preempt loss by precipitating it:

> From childhood I had never believed in permanence, and yet I had longed for it. Always I was afraid of losing happiness. This month, next year, Phuong would leave me. If not next year, in three years. Death was the only absolute value in my world. Lose life and one would lose nothing again for ever. I envied those who could believe in a God and I distrusted them. I felt they were keeping their courage up with a fable of the changeless and the permanent. Death was far more certain than God, and with death there would be no longer the daily possibility of love dying.

Fowler thinks this his personal burden, views his life as driven by the terror "of losing" love. "If only it were possible to love without injury," he muses. Yet "The hurt is in the act of possession: we are too small in mind and body to possess another person without pride or to be possessed without humiliation." The language that Fowler finds for love – words like *injury* and *possession* – covers equally well the facts of war: It is through love that Fowler will learn to fight, take a stand. He thinks himself a man unengaged, a man without politics, and yet it is precisely his most personal feelings – his love for Phuong, that beautiful synecdoche for Vietnam – that will compel him to commit an act of war.

Greene resolves the argument between Fowler and Pyle on the level of the plot. The logic of story supersedes the endless argument about being "involved." Fowler's assistant, a man he credits with "an absolute love of truth," sends him to see a friend. He is shown an empty drum labeled "Diolaction" and a mould. Fowler becomes convinced that Pyle has been fashioning bombs. In the meantime, he has written to his wife to ask for a divorce. She refuses, but he tells Phuong differently. Phuong discovers the lie and goes to Pyle. Fowler, finding himself incensed at Pyle's role in the bombings in downtown Saigon, invites Pyle to dinner. On the way, as Fowler expects, Pyle is killed. Phuong returns to Fowler, and in the final scene he reads her the telegram in which his wife agrees at last to a divorce.

In *The Quiet American,* Greene makes two key storytelling moves: He puts the narrative in Fowler's voice, and he gives it – from Fowler's point of view – a happy ending. These are Greene's choices, his commitment to a sense of things. His choices as a writer enforce certain recognitions from his reader: a sense of why an ironist does not act, and a sense that when he does act, and acts selfishly, he will not necessarily be punished. History here asks for everything and promises nothing. Action is not a

matter of guaranteed or even foreseeable outcomes – it is the fulfillment of a passion. "Here's your happy ending," Fowler says to Phuong as he hands her the telegram. It is a happy ending. Fowler's revenge leaves him doubting this happiness, but he gets away with it, and he gets what he wants. Greene's story does not mete out justice, any more than history does. But it does insist on engagement as "human," on its inevitability. Fowler says, on the last chapter's first page, "I can't worry much about people in history." But his actions give the lie to his words. He has willingly if regretfully chosen to stop Pyle, for a mixture of reasons, and so has altered, in however small a way, the course of history in a place called Vietnam.

It is tempting to say that Greene's novel does not recommend "taking sides" but allows us instead to measure the cost and difficulty of doing so. That would be partly true. But we know much more about Fowler than about Pyle: He tells the story, and his entrance into history is the more detailed, dramatic, onstage. We do not see Pyle get killed, do not see him alone with Phuong. We are not even finally certain of Pyle's involvement in the bombings. Pyle remains a shadowy figure, a rumor. Because we know Fowler and know what he thinks he is up to, the novel becomes a forceful critique of the adequacy of his position.

There is an argument here, one almost antithetical to the argument Fowler makes: We are always already in history. We can choose, like Fowler, to repress this. Then, when we decide to act, we will act in a kind of innocence, the very destructive innocence that Fowler projects onto Pyle. "Unfortunately the innocent are always involved in any conflict," Fowler muses. He speaks of himself as a man of experience and yet has proven so innocent of any consciously held political convictions that when the time for action comes he cannot connect act with consequence. He will get what he wants and feel unaccountably "sorry." As he sits at the restaurant, waiting for the Pyle he knows will not come, he admits that "I had betrayed my own principles; I had become as *engagé* as Pyle, and it seemed to me that no decision would ever be simple again." The more intensely coveted the personal life, the more it destines itself for a precipitate fall into public time. Neutrality or impartiality – in love or war – is not an enabling fiction, it is a lie.

At the reunion, in my hometown, we sat and talked about classmates killed in the war. There was only one name I knew. He had not been a close friend; there was a vague sense of loss, and no sense of judgment. Few of us had any politics with which to meet the war; our reasons for going or not going left us scattered between Fowler and Pyle. We sat at the round table with the bad food and felt, I imagine, a sense of lucky, sober survival. I had been asked to say a few words to the class, and in the middle of our talk the emcee summoned me across the floor. A wel-

come. It's good to be back. A story about dreaming about high school. And then, as my mind tumbled to the task, and the microphone echoed off the dome and couldn't be heard, I started talking about the war. I had come back looking for home, long gone, and had found the other iceberg, Vietnam. It was the one piece of history all of us could lay claim to. Not as a badge or a wound but as a memory of choice. Vietnam had come to us early, and the fact that it had required from us a decision – a personal stand on a matter of national history, and that the matter was not at all clear – had left us with a sense of the personal and the historical as indivisible. It was the one story we had been unable to avoid, and it gave us a sense of the importance of meeting such stories head on, of the need to narrate our circumstances. So I told a little story, of minimal shape and even less comfort, and then sat down.

"Here is a story": This is what Joan Didion willingly offers her reader in 1968. By 1992, in *After Henry,* she has begun to retract the offer. The fantasies and repressions of the eighties – the years in which the generation of the sixties came into its power – have debased more than America's currency. The situations Didion chooses to recount – the triumphalism of Ronald Reagan and its reliance on faith over works, the romanticized shape changing of Patty Hearst, the equation of New York City with a jogger attacked in a park – debase as well the currency of story. "The imposition of a sentimental, or false, narrative on the disparate and often random experience that constitutes the life of a city or a country means, necessarily, that much of what happens in that city or country will be rendered merely illustrative, a series of set pieces, or performance opportunities." The interpolation of the phrase *or false* makes the essential point here. In the years of working up this book of cultural criticism, Didion has lost any residual faith in the efficacy of story. "I had come to find narrative sentimental," she writes, in an essay published in 1989. The individual pieces make, in fact, the opposite point: They are models of unillusioned narrative. But Didion does refrain from plotting the parts into a whole. The result is a book that provides no standpoint – as had Didion's two earlier essay collections – from which author and reader can imagine a larger story that might work or simply and accurately *apply.*

The stories that Didion chooses to analyze in *After Henry* prove consistently sentimental: self-serving, deluded, grandiose, or unearned. They are fabrications in which "the remote narrative" only accidentally collides with "the actual life of the country." The word *narrative* dominates Didion's analysis and, under the pressure of her insistent repetitions, acquires a sinister weight: "The narrative requires . . . the narrative demanded . . . the reduction of events to narrative . . . the invented narrative." Through these insinuating locutions, a word that

might more readily be associated with order and pleasure comes to mean something like "lie."

But to say that Americans prefer to live inside sentimental narratives does not make the case that all narrative is sentimental. Didion chooses to focus on the rhetoric of politics and journalism, and much of her anger in *After Henry* is directed at the debasement of the language of her profession. Outside the comfort zone established by these rhetorics, she argues, "accidental history" will take "its course." It is the argument of my book that there exists in our time another rhetoric that can take history in. Once we called it the rhetoric of art. Whatever we now permit ourselves to call it, there does go forward in our country the making of stories that provide an adequate image of our actual life. Between credulity and cynicism we can still locate a skeptical faith – the complex of feeling Springsteen sings out of when he "doubts what he's sure of."

Certainly some of the stories I retell in this book are sentimental, and, to the extent that they are, the work at hand can be said to fail. But as readers and citizens the choice we face is not between sentimental narrative and the unsentimental truth but between the sentimental narrative and the strong one. There is no escape from the fictiveness of story, but that is not cause for cynicism or despair. Nor must we succumb to the postmodernist faith that we can survive on a literature of surfaces and irresolution and mere critique. We still need and have available to us, I believe, the enabling pattern of beginning, middle, and end with its implicit promise of purposeful and satisfying action. Such forms record the actual and image the possible; they help us remember what we have been and imagine what we might be. The best evidence I can adduce for these claims are the readings I make in this book. "That's an amazing story," an Ann Beattie character exclaims. The amazement produces pleasure, the first requisite of a strong story. Along with the pleasure comes an access of power, the promise that we can get what we want, act in and upon the world. Such stories become the shape and source of our morale; without them, we are simply people lost in history. *Story* is the word I would leave with my reader, then, because the artists studied in this book know, at their best, that in stories begin responsibilities, as their readers are free to discover in those stories the choices of a generation fully realized, words marked by a time.

Works read and cited

The following is a list of the books and articles I read in order to write this book. References have been assigned to the chapter or section in which they are cited or for which they provided background. All titles listed have been indexed.

INTRODUCTION: THE FORM OF STORY

Baskir, Lawrence, and William Strauss. *Chance and Circumstance: The Draft, the War, and the Vietnam Generation.* New York: Knopf, 1978.

Carver, Raymond. *Cathedral.* New York: Knopf, 1983.
What We Talk About When We Talk About Love. New York: Knopf, 1981.
Will You Please Be Quiet, Please? New York: McGraw-Hill, 1976.

Coffin, William Sloane. *Once to Every Man: A Memoir.* New York: Atheneum, 1977.

Cowley, Malcolm. *Exile's Return: A Literary Odyssey of the 1920s.* 1934; rev. ed. New York: Viking, 1951.
A Second Flowering: Works and Days of the Lost Generation. New York: Viking, 1973.

Curry, G. David. *Sunshine Patriots: Punishment and the Vietnam Offender.* Notre Dame, Ind.: University of Notre Dame Press, 1985.

Davidson, Sara. *Loose Change.* Garden City, N.Y.: Doubleday, 1977.

DeLillo, Don. *Great Jones Street.* Boston: Houghton Mifflin, 1973.
Libra. New York: Viking, 1988.
White Noise. New York: Viking, 1985.

Dickstein, Morris. *Gates of Eden: American Culture in the Sixties.* New York: Basic Books, 1977.

Didion, Joan. *After Henry.* New York: Simon & Schuster, 1992.
Miami. New York: Simon & Schuster, 1987.
Salvador. New York: Simon & Schuster, 1983.
Slouching Towards Bethlehem. New York: Farrar, Straus & Giroux, 1968.
The White Album. New York: Simon & Schuster, 1979.

Feldstein, Martin, ed. *The American Economy in Transition*. Chicago: University of Chicago Press, 1980.

Gitlin, Todd. *Inside Prime Time*. New York: Pantheon, 1983.

The Sixties: Years of Hope, Days of Rage. New York: Bantam, 1987.

Goodman, Paul. *Growing Up Absurd*. New York: Random House, 1960.

New Reformation. New York: Random House, 1970.

Gottlieb, Annie. *Do You Believe in Magic?: The Second Coming of the Sixties Generation*. New York: Times Books, 1987.

Hoffman, Frederick John. *The Twenties*. New York: Viking, 1955.

Hynes, Samuel. *The Auden Generation: Literature and Politics in England in the 1930s*. London: The Bodley Head, 1976.

Jacoby, Russell. *The Last Intellectuals: American Culture in the Age of Academe*. New York: Basic Books, 1987.

Jameson, Fredric. *Postmodernism, or the Cultural Logic of Late Capitalism*. Durham, N.C.: Duke University Press, 1991.

Lentricchia, Frank. *After the New Criticism*. Chicago: University of Chicago Press, 1980.

Ariel and the Police. Madison: University of Wisconsin Press, 1988.

Mailer, Norman. *Advertisements for Myself*. New York: Putnam, 1959.

The Armies of the Night. New York: NAL, 1968.

Cannibals and Christians. New York: Dial Press, 1966.

The Executioner's Song. Boston: Little, Brown, 1979.

Miami and the Siege of Chicago. New York: World, 1968.

Of a Fire on the Moon. Boston:. Little, Brown, 1970.

The Prisoner of Sex. Boston: Little, Brown, 1971.

Miller, James. *Democracy Is in the Streets: From Port Huron to the Siege of Chicago*. New York: Simon & Schuster, 1987.

O'Brien, Geoffrey. *Dream Time: Chapters from the Sixties*. New York: Viking, 1988.

O'Neill, William L. *Coming Apart: An Informal History of America in the 1960's*. Chicago: Quadrangle, 1971.

Plumly, Stanley. "Chapter and Verse." *American Poetry Review*. 1978. Volume 7, Number 1 and Number 3.

Poirier, Richard. *The Performing Self*. New York: Oxford University Press, 1971.

Pynchon, Thomas. *Gravity's Rainbow*. New York: Viking, 1973.

Vineland. Boston: Little, Brown, 1990.

Rodriguez, Richard. *Hunger of Memory: The Education of Richard Rodriguez*. Boston: Godine, 1981.

Said, Edward. *Orientalism*. New York: Pantheon, 1978.

The World, the Text, and the Critic. Cambridge, Mass.: Harvard University Press, 1983.

Sayres, Sohnya, et al., eds. *The 60s, Without Apology*. Minneapolis: University of Minnesota Press, in cooperation with *Social Text*, 1984.

Schell, Jonathan. *The Time of Illusion*. New York: Knopf, 1976.

Slater, Philip E. *The Pursuit of Loneliness*. Boston: Beacon Press, 1970.

Tanner, Tony. *City of Words: American Fiction, 1950–1970*. New York: Harper & Row, 1971.

Trilling, Diana. *Claremont Essays*. New York: Harcourt, Brace & World, 1964.
Trudeau, Garry. *The Doonesbury Chronicles*. New York: Henry Holt, 1975.

GEORGE LUCAS

Primary sources

THX–1138. 1971. Director.
American Graffiti. 1973. Director.
Star Wars. 1977. Director.
Corvette Summer. 1978. Executive Producer.
More American Graffiti. 1979. Executive Producer.
The Empire Strikes Back. 1980. Executive Producer.
Raiders of the Lost Ark. 1981. Executive Producer.
Twice Upon a Time. 1982. Executive Producer.
Return of the Jedi. 1983. Scriptwriter and Executive Producer.
Indiana Jones and the Temple of Doom. 1984. Executive Producer.
Mishima. 1985. Executive Producer.
Labyrinth. 1986. Executive Producer.
Latino. 1986. Executive Producer.
Howard the Duck. 1986. Executive Producer.
Willow. 1988. Scriptwriter and Executive Producer.
Tucker. 1988. Executive Producer.
Indiana Jones and the Last Crusade. 1989. Scriptwriter and Executive Producer.

Secondary sources

Attias, Diana, and Lindsay Smith, eds. *The Empire Strikes Back Notebook*. New York: Ballantine, 1980.
Cavell, Stanley. *Pursuits of Happiness: The Hollywood Comedy of Remarriage*. Cambridge, Mass.: Harvard University Press, 1981.
 The World Viewed: Reflections on the Ontology of Film. New York: Viking, 1971.
"The Empire Strikes Back!" *Time*. May 19, 1980.
"The Force Is Back with Us." *Newsweek*. May 19, 1980.
Jameson, Fredric. "Postmodernism and Consumer Society." *The Anti-Aesthetic: Essays on Postmodern Culture,* ed. Hal Foster. Port Townsend, Wash.: Bay Press, 1983.
Kael, Pauline. *Deeper into Movies*. Boston: Little, Brown, 1973.
 Hooked. New York: Dutton, 1989.
McConnell, Frank. *Storytelling and Mythmaking: Images from Film and Literature*. New York: Oxford University Press, 1979.
Mendelson, Edward. "Levity's Rainbow." *The New Republic*. July 9–16, 1990. Volume 203.
Pollock, Dale. *Skywalking: The Life and Films of George Lucas*. New York: Harmony Books, 1983.
Pye, Michael, and Lynda Miles. *The Movie Brats*. New York: Holt, Rinehart & Winston, 1979.

"*Rolling Stone* Interview: George Lucas." *Rolling Stone.* June 12, 1980. Issue 319.
The Star Wars Album. New York: Ballantine, 1977.
Weinberg, Larry. *Star Wars: The Making of the Movie.* New York: Random House, 1980.
Titelman, Carol, ed. *The Art of Star Wars.* New York: Ballantine, 1979.

BRUCE SPRINGSTEEN

Primary sources

Greetings from Asbury Park, N.J. 1973. Columbia.
The Wild, the Innocent, and the E Street Shuffle. 1973. Columbia.
Born to Run. 1975. Columbia.
Darkness on the Edge of Town. 1978. Columbia.
The River. 1980. Columbia.
Nebraska. 1982. Columbia.
Born in the U.S.A. 1984. Columbia.
Bruce Springsteen and the E Street Band Live/1975–1985. 1986. Columbia.
Tunnel of Love. 1987. Columbia.

Secondary sources

Bangs, Lester. *Psychotic Reactions and Carburetor Dung.* New York: Knopf, 1987.
Harrington, Richard. "Springsteen's Debt to Orbison." *The Washington Post.* January 28, 1987.
Holden, Stephen. "Springsteen's 'Live/1975–1985' Is Loaded with History." *The New York Times.* November 9, 1986.
Marcus, Greil. *Mystery Train: Images of America in Rock 'n' Roll Music.* New York: Dutton, 1975.
Marsh, Dave. *Born to Run: The Bruce Springsteen Story.* New York: Dell, 1981. *Glory Days: Bruce Springsteen in the 1980s.* New York: Pantheon, 1987.
Pattison, Robert. *The Triumph of Vulgarity: Rock Music in the Mirror of Romanticism.* New York: Oxford University Press, 1987.
"*Rolling Stone* Interview: Bruce Springsteen." *Rolling Stone.* December 6, 1984. Issue 436.
"*Rolling Stone* Interview: Bruce Springsteen." *Rolling Stone.* November 5–December 10, 1987. Issue 512.
Ward, Ed, Geoffrey Stokes, and Ken Tucker. *Rock of Ages: The Rolling Stone History of Rock & Roll.* New York: Summit Books, 1986.

SAM SHEPARD

Primary sources

PLAYS
Cowboys. Produced New York, 1964.
The Rock Garden. Produced New York, 1964.
Up to Thursday. Produced New York, 1965.
Dog. Produced New York, 1965.

Rocking Chair. Produced New York, 1965.

Chicago. Produced New York, 1965.

Icarus's Mother. Produced New York, 1965.

4-H Club. Produced New York, 1965.

Fourteen Hundred Thousand. Produced Minneapolis, 1966.

Red Cross. Produced New York, 1966.

La Turista. Produced New York, 1967.

Melodrama Play. Produced New York and London, 1967.

Forensic and the Navigators. Produced New York, 1967.

Cowboys #2. Produced New York, 1967.

The Holy Ghostly. Produced on tour, 1969.

The Unseen Hand. Produced New York, 1969.

Operation Sidewinder. Produced New York, 1970.

Shaved Splits. Produced New York, 1970.

Back Bog Beast Bait. Produced New York, 1971.

Cowboy Mouth, with Patti Smith. Produced Edinburgh and New York, 1971.

Mad Dog Blues. Produced New York, 1971.

The Tooth of Crime. Produced London and Princeton, New Jersey, 1972.

Blue Bitch. Televised 1972.

Nightwalk, with Megan Terry and Jean-Claude van Italie. Produced New York and London, 1973.

Little Ocean. Produced London, 1974.

Geography of a Horse Dreamer. Produced London and New Haven, Connecticut, 1974.

Action. Produced London, 1974.

Killer's Head. Produced New York, 1975.

Angel City. Produced San Francisco, 1976.

Suicide in B Flat. Produced New Haven, Connecticut, 1976.

The Sad Lament of Pecos Bill on the Eve of Killing His Wife. Produced San Francisco, 1976.

Curse of the Starving Class. Produced New York, 1976.

Inacoma. Produced San Francisco, 1977.

Buried Child. Produced San Francisco and New York, 1978.

Seduced. Produced Providence, Rhode Island and New York, 1978.

Tongues, with Joseph Chaikin. Produced San Francisco, 1978.

Savage/Love, with Joseph Chaikin. Produced New York, 1979.

True West. Produced San Francisco and New York, 1980.

Jackson's Dance, with Jacques Levy. Produced New Haven, Connecticut, 1980.

Superstitions. Music by Shepard and Catherine Stone. Produced New York, 1983.

Fool for Love. Produced San Francisco and New York, 1983.

A Lie of the Mind. Produced New York, 1985.

The War in Heaven. Radio broadcast, 1985.

States of Shock. Produced New York, 1991.

ANTHOLOGIES AND COLLECTED PROSE

Fool for Love and Other Plays. New York: Bantam, 1984.

Hawk Moon. Los Angeles: Black Sparrow Press, 1973.

Motel Chronicles. San Francisco: City Lights, 1982

Rolling Thunder Logbook. New York: Viking, 1977.
Seven Plays. New York: Bantam, 1981.
The Unseen Hand and Other Plays. New York: Bantam, 1986.

MOVIES
Me and My Brother. 1969. Scriptwriter.
Zabriskie Point. 1970. Scriptwriter.
Brand X. 1970. Actor.
Ringaleerio. 1971. Scriptwriter.
Renaldo and Clara. 1978. Scriptwriter.
Days of Heaven. 1978. Actor.
Resurrection. 1980. Actor.
Raggedy Man. 1981. Actor.
Frances. 1982. Actor.
The Right Stuff. 1983. Actor.
Country. 1984. Actor.
Paris, Texas. 1984. Scriptwriter.
Fool for Love. 1985. Actor.
Baby Boom. 1986. Actor.
Crimes of the Heart. 1987. Actor.
Far North. 1989. Director.
Steel Magnolias. 1989. Actor.
Bright Angel. 1990. Actor.
Defenseless. 1991. Actor.
Voyager. 1992. Actor.

MANUSCRIPTS
The Sam Shepard Papers, The Alderman Library, University of Virginia, Char-
 lottesville.

Secondary sources

Cott, Jonathan, ed. *Visions and Voices.* New York: Doubleday, 1987.
Hart, Lynda. *Sam Shepard's Metaphorical Stages.* Westport, Conn.: Greenwood
 Press, 1987.
King, Kimball. *Sam Shepard: A Casebook.* New York: Garland, 1988.
Lawrence, D. H. *Studies in Classic American Literature.* New York: Seltzer, 1923.
Lentricchia, Frank. "Don DeLillo." *Raritan.* VIII: 1–29.
Leverenz, David. *Manhood and the American Renaissance.* Ithaca: Cornell Univer-
 sity Press, 1989.
Mamet, David. *Hurlyburly.* New York: Grove Press, 1985.
 Streamers. New York: Knopf, 1977.
Marranca, Bonnie, ed. *American Dreams: The Imagination of Sam Shepard.* New
 York: Performing Arts Journal Publications, 1981.
Menand, Louis. "Is The New Yorker Mortal?" *The New Republic.* February 26,
 1990. Volume 202.

Mottram, Ron. *Inner Landscapes: The Theater of Sam Shepard*. Columbia: University of Missouri Press, 1984.

Olson, Charles. *Call Me Ishmael*. New York: Reynal & Hitchcock, 1947.

Oumano, Ellen. *Sam Shepard: The Life and Work of an American Dreamer*. New York: St. Martin's Press, 1986.

Rabe, David. *American Buffalo*. New York: Grove Press, 1977.
 Glengarry Glen Ross. New York: Grove Press, 1983.
 Sexual Perversity in Chicago and the Duck Variations. New York: Grove Press, 1978.

Richards, David. "Ssshhhh! It's Sam Shepard." *The Washington Post*. December 12, 1988.

Styron, William. "Darkness Visible." *Vanity Fair*. December 1989. Volume 52.

Truehart, Charles. "Reviewing the Old and the New Yorker." *The Washington Post*. February 27, 1990.

ANN BEATTIE

Primary sources

Chilly Scenes of Winter. New York: Doubleday, 1976.
Distortions. New York: Doubleday, 1976.
Secrets and Surprises. New York: Random House, 1978.
Falling in Place. New York: Random House, 1980.
The Burning House. New York: Random House, 1982.
Love Always. New York: Random House, 1985.
Where You'll Find Me. 1986; rpt. New York: Macmillan, 1987.
Picturing Will. New York: Random House, 1989.
What Was Mine. New York: Random House, 1991.

Secondary sources

Auster, Paul. *The Invention of Solitude*. New York: SUN, 1982.

Bausch, Richard. *The Last Good Time*. Garden City, N.Y.: Dial Press, 1984.
 Mr. Field's Daughter. New York: Simon & Schuster, 1989.

DeMott, Benjamin. "Did the 1960's Damage Fiction?" *The New York Times Book Review*. July 8, 1984.

Dodd, Susan. *No Earthly Notion*. New York: Viking, 1986.

Ehrenreich, Barbara and John. "The Professional-Managerial Class," in *Between Labor and Capital*. Pat Walker, ed. Boston: South End Press, 1979.

Ford, Richard. *The Ultimate Good Luck*. Boston: Houghton Mifflin, 1981.

Gaitskill, Mary. *Bad Behavior*. New York: Poseidon Press, 1988.

Gelfant, Blanche. *Women Writing in America: Voices in Collage*. Hanover, N.H.: University Press of New England, 1984.

Harrison, Jim. *Legends of the Fall*. New York: Delacorte Press/Seymour Lawrence, 1979.

Iyer, Pico. "The World According to Beattie." *Partisan Review*. 1983. Volume L: 548–53.

Mason, Bobbie Ann. *Spence and Lila*. New York: Harper & Row, 1988.
McGuane, Thomas. *Ninety-Two in the Shade*. New York: Penguin, 1972.
Minot, Susan. *Monkeys*. New York: Dutton, 1986.
Parini, Jay. "A Writer Comes of Age." *Horizon*. December 1982: 22–4.
Pesetsky, Bette. *Stories Up to a Point*. New York: Knopf, 1981.
Pfeil, Fred. *Another Tale to Tell: Politics and Narrative in Postmodern Culture*. New York: Verso, 1990.
Phillips, Jayne Ann. *Black Tickets*. New York: Delacorte, 1979.
Robison, Mary. *Oh!* New York: Knopf, 1981.
Sherrill, Martha. "Ann Beattie, Reluctant Voice of a Generation." *The Washington Post*. February 4, 1990.
Siegle, Robert. *Suburban Ambush: Downtown Writing and the Fiction of Insurgency*. Baltimore: The Johns Hopkins University Press, 1989.
Thompson, Jean. *The Gasoline Wars*. Urbana: University of Illinois Press, 1979.
Williams, Joy. *State of Grace*. Garden City, N.Y.: Doubleday, 1973.
Wolfe, Tom. *The Bonfire of the Vanities*. New York: Farrar, Straus & Giroux, 1987.
Wolff, Tobias. *Back in the World*. Boston: Houghton Mifflin, 1985.
 In the Garden of the North American Martyrs. New York: Ecco Press, 1981.
 This Boy's Life: A Memoir. New York: Atlantic Monthly Press, 1989.

SUE MILLER

Primary sources

The Good Mother. New York: Harper & Row, 1986.
Inventing the Abbots and Other Stories. New York: Harper & Row, 1987.
Family Pictures. New York: Harper & Row, 1990.

Secondary sources

Banks, Russell. *Affliction*. New York: Harper & Row, 1989.
 Continental Drift. New York: Harper & Row, 1985.
Barrett, Michele. *The Anti-Social Family*. London: Verso, 1982.
Baym, Nina. *Woman's Fiction: A Guide to Novels by and about Women in America, 1820–1870*. Ithaca, N.Y.: Cornell University Press, 1978.
Casey, John. *Spartina*. New York: Knopf, 1989.
Chodorow, Nancy. *The Reproduction of Mothering: Psychoanalysis and the Sociology of Gender*. Berkeley: University of California Press, 1978.
Coward, Rosalind. *Patriarchal Precedents: Sexuality and Social Relations*. London: Routledge & Kegan Paul, 1983.
Dillard, Annie. *Pilgrim at Tinker Creek*. New York: Harper's Magazine Press, 1974.
Dworkin, Andrea. *Intercourse*. New York: Free Press, 1987.

Pornography: Men Possessing Women. New York: Putnam, 1981.

Ehrenreich, Barbara. *The Hearts of Men: American Dreams and the Flight from Commitment.* New York: Anchor-Doubleday, 1983.

Ehrenreich, Barbara, with Elizabeth Hess and Gloria Jacobs. *Re-Making Love: The Feminization of Sex.* Garden City, N.Y.: Anchor-Doubleday, 1986.

Freud, Sigmund. "Family Romances." *The Standard Edition.* James Strachey, ed. London: Hogarth Press, 1964. Volume IX.

"Femininity." *The Standard Edition.* Volume XXII.

Friedan, Betty. *The Feminine Mystique.* New York: Norton, 1963.

Gallop, Jane. *Feminism and Psychoanalysis: The Daughter's Seduction.* Ithaca: Cornell University Press, 1982.

Gordon, Mary. *Final Payments.* New York: Random House, 1978.

Gould, Lois. *A Sea-Change.* New York: Simon & Schuster, 1976.

Such Good Friends. New York: Random House, 1970.

Griffen, Susan. *Pornography and Silence: Culture's Revenge Against Nature.* New York: Harper & Row, 1981.

Hendin, Josephine. *Vulnerable People: A View of American Fiction Since 1945.* New York: Oxford University Press, 1978.

Irigaray, Luce. *Speculum of the Other Woman.* 1974; rpt. Ithaca: Cornell University Press, 1985.

Jardine, Alice, and Paul Smith, eds. *Men in Feminism.* New York: Methuen, 1987.

Jong, Erica. *Fear of Flying.* New York: Holt, Rinehart & Winston, 1973.

Lacan, Jacques. *Feminine Sexuality: Jacques Lacan and the École Freudienne.* Juliet Mitchell and Jacqueline Rose, eds. New York: Norton, 1985.

Masters, William H., and Virginia E. Johnson. *Human Sexual Response.* Boston: Little, Brown, 1966.

Millett, Kate. *Sexual Politics.* Garden City, N.Y.: Doubleday, 1970.

Moi, Toril. *Sexual/Textual Politics: Feminist Literary Theory.* New York: Methuen, 1985.

Piercy, Marge. *Best Friends.* New York: Summit Books, 1982.

Fly Away Home. New York: Summit Books, 1984.

Rich, Adrienne. *Of Woman Born: Motherhood as Experience and Institution.* New York: Norton, 1976.

Rossner, Judith. *August.* Boston: Houghton Mifflin, 1983.

Looking for Mr. Goodbar. New York: Simon & Schuster, 1975.

Smiley, Jane. *The Age of Grief.* New York: Knopf, 1987.

The Greenlanders. New York: Knopf, 1988.

Ordinary Love & Good Will. New York: Knopf, 1989.

Stone, Robert. *Children of Light.* New York: Knopf, 1986.

A Flag for Sunrise. New York: Knopf, 1981.

"Sue Miller" in *Contemporary Literary Criticism: Yearbook 1986.* Detroit: Gale, 1987. 44:67–76.

Woolf, Virginia. *A Room of One's Own.* New York: Harcourt Brace, 1929.

Zinman, Toby Silverman. "The Good Old Days in *The Good Mother.*" *Modern Fiction Studies.* Autumn 1988. 34:405–12.

ETHAN MORDDEN

Primary sources

I've a Feeling We're Not in Kansas Anymore: Tales from Gay Manhattan. New York:
St. Martin's Press, 1985.
 Buddies. New York: St. Martin's Press, 1986.
 Everybody Loves You. New York: St. Martin's Press, 1989.

Secondary sources

Altman, Dennis. *The Homosexualization of America, the Americanization of the Ho-
mosexual*. New York: St. Martin's Press, 1982.
Andrews, Terry. *The Story of Harold*. New York: Holt, Rinehart & Winston,
 1978.
Boswell, James. *Christianity, Social Tolerance, and Homosexuality: Gay People in
 Western Europe from the Beginning of the Christian Era to the Fourteenth Century*.
 Chicago: University of Chicago Press, 1980.
Bram, Christopher. *Surprising Myself*. New York: Fine, 1987.
D'Emilio, John. *Sexual Politics, Sexual Communities: The Making of a Homosexual
 Minority in the United States, 1940–1970*. Chicago: University of Chicago
 Press, 1983.
Ferro, Robert. *The Family of Max Desir*. New York: Dutton, 1983.
Fierstein, Harvey. *Harvey Fierstein's Safe Sex*. New York: Atheneum, 1987.
 Torch Song Trilogy. 1980; rpt. New York: Villard, 1983.
Harris, Susan K. "Response," American Studies Association Convention Panel
 on "Beyond Panic: Male Homosexuality within American Culture." Octo-
 ber 1988.
Holleran, Andrew. *Dancer from the Dance*. New York: Morrow, 1978.
 Nights in Aruba. New York: Morrow, 1983.
Kramer, Larry. *Faggots*. New York: Random House, 1978.
 The Normal Heart. New York: NAL, 1985.
Leavitt, David. *Equal Affections*. New York: Weidenfeld & Nicolson, 1989.
 Family Dancing. New York: Knopf, 1984.
 The Lost Language of Cranes. New York: Knopf, 1986.
Maupin, Armistead. *Tales of the City*. New York: Harper & Row, 1978.
Miller, D. A. *The Novel and the Police*. Berkeley: University of California Press,
 1988.
Sedgewick, Eve Kosofsky. *Between Men: English Literature and Male Homosocial
 Desire*. New York: Columbia University Press, 1985.
 Epistemology of the Closet. Berkeley: University of California Press, 1990.
Sontag, Susan. *AIDS and Its Metaphors*. New York: Farrar, Straus & Giroux, 1989.
Van Leer, David. "The Beast of the Closet: Homosociality and the Pathology of
 Manhood." *Critical Inquiry*. Spring 1989. 15:587–605.
Weeks, Jeffrey. *Sexuality and Its Discontents*. London: Routledge & Kegan Paul,
 1985.
Whitmore, George. *Nebraska*. New York: Grove Press, 1987.

ALICE WALKER

Primary sources

FICTION

The Third Life of Grange Copeland. New York: Harcourt Brace Jovanovich, 1970.
In Love and Trouble: Stories of Black Women. New York: Harcourt Brace Jovanovich, 1973.
Meridian. New York: Harcourt Brace Jovanovich, 1976.
You Can't Keep a Good Woman Down. New York: Harcourt Brace Jovanovich, 1981.
The Color Purple. New York: Harcourt Brace Jovanovich, 1982.
The Temple of My Familiar. New York: Harcourt Brace Jovanovich, 1989.

POETRY

Once. New York: Harcourt Brace Jovanovich, 1968.
Five Poems. Detroit: Broadside Press, 1972.
Revolutionary Petunias and Other Poems. New York: Harcourt Brace Jovanovich, 1973.
Good Night, Willie Lee, I'll See You in the Morning. New York: Dial Press, 1979.
Horses Make a Landscape Look More Beautiful. New York: Harcourt Brace Jovanovich, 1984.
Her Blue Body Everything We Know: Earthling Poems, 1965–1990. San Diego: Harcourt Brace Jovanovich, 1991.

ESSAYS

In Search of Our Mother's Gardens: Womanist Prose. New York: Harcourt Brace Jovanovich, 1983.
Living by the Word. New York: Harcourt Brace Jovanovich, 1988.

Secondary sources

Awkward, Michael. *Inspiriting Influences: Tradition, Revision, and Afro-American Women's Novels.* New York: Columbia University Press, 1989.
Baker, Houston A., Jr. "In Dubious Battle." *New Literary History.* Winter 1987. 18:363–9.
 Modernism and the Harlem Renaissance. Chicago: University of Chicago Press, 1987.
Bambara, Toni Cade. *The Salt Eaters.* New York: Random House, 1980.
Bell, Bernard W. *The Afro-American Novel and Its Tradition.* Amherst: University of Massachusetts Press, 1987.
Bradley, David. "Alice Walker: Telling the Black Woman's Story." *The New York Times Magazine.* January 8, 1984.
 The Chaneysville Incident. New York: Harper & Row, 1981.

Carby, Hazel V. *Reconstructing Womanhood: The Emergence of the Afro-American Woman Novelist*. New York: Oxford University Press, 1987.

Chesnutt, Charles. *The Conjure Woman*. 1899; rpt. Ann Arbor: University of Michigan Press, 1969.

Cleaver, Eldridge. *Soul on Ice*. New York: McGraw Hill, 1968.

Cooke, Michael. *Afro-American Literature in the Twentieth Century: The Achievement of Intimacy*. New Haven, Conn.: Yale University Press, 1984.

Ellison, Ralph. *Invisible Man*. New York: Random House, 1957.

Shadow and Act. New York: Random House, 1964.

Erdrich, Louise. *The Beet Queen*. New York: Holt, Rinehart & Winston, 1986.

Love Medicine. New York: Holt, Rinehart & Winston, 1984.

Tracks. New York: Holt, Rinehart & Winston, 1988.

Gates, Henry Louis, Jr. *Figures in Black: Words, Signs, and the "Racial Self."* New York: Oxford University Press, 1987.

The Signifying Monkey: A Theory of Afro-American Literary Criticism. New York: Oxford University Press, 1988.

"What's Love Got to Do with It?" *New Literary History*. Winter 1987. 18:345 – 63.

Harper, Frances E. W. *Iola Leroy or Shadows Uplifted*. 1892; rpt. New York: Oxford University Press, 1988.

Hogue, Lawrence W. *Discourse and the Other*. Durham, N.C.: Duke University Press, 1986.

Hurston, Zora Neale. *Their Eyes Were Watching God*. 1937; rpt. Urbana: University of Illinois Press, 1980.

Jacobs, Harriet. *Incidents in the Life of a Slave Girl*. Jean Fagan Yellin, ed. 1861; rpt. Cambridge, Mass.: Harvard University Press, 1987.

Johnson, Charles. *Being & Race: Black Writers Since 1970*. Bloomington: Indiana University Press, 1988.

Jones, Gayl. *Eva's Man*. New York: Random House, 1976.

Joyce, Joyce A. "The Black Canon: Reconstructing Black American Literary Criticism." *New Literary History*. Winter 1987. 18:335–44.

Kauffman, Linda S. *Discourses of Desire: Gender, Genre, and Epistolary Fictions*. Ithaca: N.Y.: Cornell University Press, 1986.

Special Delivery. Chicago: University of Chicago Press, 1992.

Kingston, Maxine Hong. *The Woman Warrior*. New York: Knopf, 1977.

Larsen, Nella. *Quicksand and Passing*. 1928 and 1929; rpt. New Brunswick, N.J.: Rutgers University Press, 1986.

Locke, Alain. *The New Negro*. 1925; rpt. New York: Atheneum, 1980.

McDowell, Deborah. "The Changing Same: Generational Connections and Black Woman Novelists." *New Literary History*. Winter 1987. 18:281–302.

McPherson, James Alan. *Elbow Room*. Boston: Little, Brown, 1977.

Hue and Cry. Boston: Little, Brown, 1969.

Naylor, Gloria. *Linden Hills*. New York: Ticknor & Fields, 1985.

Mama Day. New York: Ticknor & Fields, 1988.

The Women of Brewster Place. New York: Viking, 1982.

Neilsen, Alda Lynn. *Reading Race: White American Poets and the Racial Discourse in the Twentieth Century*. Athens: University of Georgia Press, 1988.

Pryse, Marjorie, and Hortense J. Spillers. *Conjuring: Black Women, Fiction, and Literary Tradition.* Bloomington: Indiana University Press, 1985.

Reed, Ishmael. *Mumbo Jumbo.* Garden City, N.Y.: Doubleday, 1972.

Reckless Eyeballing. New York: St. Martin's Press, 1986.

Shange, Ntozake. *For Colored Girls Who Have Considered Suicide/When the Rainbow is Enuf.* New York: Macmillan, 1977.

Silko, Leslie Marmon. *Ceremony.* New York: Viking, 1977.

Smith, Barbara. "Toward a Black Feminist Criticism," in Elaine Showalter, ed. *New Feminist Criticism: Essays on Women, Literature, and Theory.* New York: Pantheon, 1985.

Smith, Valerie. *Self-Discovery and Authority in Afro-American Narrative.* Cambridge, Mass.: Harvard University Press, 1987.

Sollors, Werner. *Beyond Ethnicity: Consent and Descent in American Culture.* New York: Oxford University Press, 1987.

Stepto, Robert B. *From Behind the Veil: A Study of Afro-American Narrative.* Urbana: University of Illinois Press, 1979.

Tan, Amy. *The Joy Luck Club.* New York: Putnam, 1989.

Toomer, Jean. *Cane.* 1923; rpt. New York: Liveright, 1975.

Wideman, John Henry. *The Homewood Trilogy.* New York: Avon, 1985.

Williams, John A. *The Man Who Cried I Am.* Boston: Little, Brown, 1967.

Willis, Susan. *Specifying: Black Women Writing the American Experience.* Madison: University of Wisconsin Press, 1987.

Wilson, Harriet. *Our Nig.* 1859; rpt. New York: Random House, 1983.

Wright, Richard. *Native Son.* New York: Harper & Brothers, 1940.

GREGORY ORR

Primary sources

POETRY

Burning the Empty Nests. New York: Harper & Row, 1973.

Gathering the Bones Together. New York: Harper & Row, 1975.

Salt Wings. Charlottesville, Va.: Poetry East, 1980.

The Red House. New York: Harper & Row, 1980.

We Must Make a Kingdom of It. Middletown, Conn.: Wesleyan University Press, 1986.

New and Selected Poems. Middletown, Conn.: Wesleyan University Press, 1988.

CRITICISM

Stanley Kunitz: An Introduction to the Poetry. New York: Columbia University Press, 1985.

MANUSCRIPTS

Gregory Orr Papers, in possession of the author.

Secondary sources

Auden, W. H. *The Dyer's Hand, and Other Essays.* New York: Random House, 1962.

AWP Official Guide to Writing Programs. Paradise, Calif.: Dustbooks, 1990.

Breslin, James E. *From Modern to Contemporary: American Poetry, 1945–1965.* Chicago: University of Chicago Press, 1984.

A Directory of American Poets and Fiction Writers. New York: Poets and Writers, Inc., 1987.

Epstein, Joseph. "Who Killed Poetry?" *Commentary.* August 1988. 86:13–20.

Hall, Donald, ed., with David Lehman. *The Best American Poetry 1989.* New York: Scribner's, 1989.

"Death to the Death of Poetry." *Harper's.* September 1989. 279:72-6.

Poetry and Ambition: Essays 1982–88. Ann Arbor: University of Michigan Press, 1988.

Halpern, Daniel. *The American Poetry Anthology.* Boulder, Colo.: Westview Press, 1975.

Hass, Robert. *Twentieth-Century Pleasures: Prose on Poetry.* New York: Ecco Press, 1984.

Howard, Richard. *Alone with America.* 1969; enlarged ed. New York: Atheneum, 1980.

Jerome, Judson, ed. *Poet's Market.* Cincinnati, Ohio: Writer's Digest Books, 1987.

Keller, Lynn. *Re-Making It New: Contemporary American Poetry and the Modernist Tradition.* New York: Cambridge University Press, 1987.

Taylor, Henry. "Looking to the Golden Mountain: Poetry Reviewing." *Dictionary of Literary Biography Yearbook 1989.* J. M. Brook, ed. Detroit: Gale, 1989.

Thurson, Jarvis. "Little Magazines: An Imaginary Interview with Jarvis Thurson." *Missouri Review.* Fall 1983. 7:232-5.

Vendler, Helen. *The Music of What Happens.* Cambridge, Mass.: Belknap Press, 1988.

Part of Nature, Part of Us: Modern American Poets. Cambridge, Mass.: Harvard University Press, 1980.

Vinson, James, and D. L. Kirkpatrick, eds. *Contemporary Poets* (fourth edition). New York: St. Martin's Press, 1985.

Wallace, Ronald. *Vital Signs: Contemporary American Poetry from the University Presses.* Madison: University of Wisconsin Press, 1989.

West, James L. W., III. *American Authors and the Literary Marketplace Since 1900.* Philadelphia: University of Pennsylvania Press, 1988.

Yardley, Jonathan. "Blanking Verse in the L.A. Times," *The Washington Post.* May 11, 1987.

LOUISE GLUCK

Primary sources

POETRY

Firstborn. New York: NAL, 1968.

The House on Marshland. New York: Ecco Press, 1975.

Descending Figure. New York: Ecco Press, 1980.
The Triumph of Achilles. New York: Ecco Press, 1985.
Ararat. New York: Ecco Press, 1990.

ESSAYS

"Death and Absence," in Stephen Berg, ed. *Singular Voices: American Poetry Today*. New York: Avon, 1985.
"The Dreamer and the Watcher," in William Heyen, ed. *The Generation of 2000: Contemporary American Poets*. Princeton, N.J.: Ontario Review Press, 1984.
"Education of the Poet," in *Envoy*. Academy of American Poets. Number 52: 1989.

Secondary sources

Bedient, Calvin. "Birth, Not Death, Is the Hard Loss." *Parnassus*. 9. 1981: 168–86.
Dove, Rita. *Grace Notes: Poems*. New York: Norton, 1989.
 Thomas and Beulah: Poems. Pittsburgh: Carnegie-Mellon University Press, 1986.
Eliot, T. S. *Selected Prose of T. S. Eliot*. Frank Kermode, ed. New York: Harcourt Brace, 1975.
Gallagher, Tess. *Amplitude: New and Selected Poems*. St. Paul, Minn.: Graywolf Press, 1987.
 Instructions to the Double. Port Townsend, Wash.: Graywolf Press, 1976.
 Willingly. Port Townsend, Wash.: Graywolf Press, 1984.
Gelpi, Albert. "The Genealogy of Postmodernism: Contemporary American Poetry." *The Southern Review*. Summer 1990. 28: 517–41.
Hass, Robert. *Field Guide*. New Haven, Conn.: Yale University Press, 1973.
 Human Wishes. New York: Ecco Press, 1989.
 Praise. New York: Ecco Press, 1979.
Hulme, T. E. *Speculations*. 1924; rpt. New York: Harcourt Brace, 1961.
Nelson, Cary. *Our Last First Poets: Vision and History in Contemporary American Poetry*. Urbana: University of Illinois Press, 1981.
Olds, Sharon. *The Dead and the Living*. New York: Knopf, 1984.
 The Gold Cell. New York: Knopf, 1987.
Orwell, George. *The Collected Essays, Journals and Letters of George Orwell*. Volume IV. Sonia Orwell and Ian Angus, eds. London: Secher & Warburg, 1968.
Ostriker, Alicia. *Stealing the Language: The Emergence of Women's Poetry in America*. Boston: Little, Brown, 1986.
Pearce, Roy Harvey. *The Continuity of American Poetry*. Princeton, N.J.: Princeton University Press, 1961.
Perloff, Marjorie. *The Poetry of Indeterminacy: Rimbaud to Cage*. Princeton, N.J.: Princeton University Press, 1981.
Ryan, Michael. *God Hunger*. New York: Viking, 1989.
 In Winter. New York: Holt, Rinehart & Winston, 1981.
Soto, Gary. *The Elements of San Joaquin*. Pittsburgh: University of Pittsburgh Press, 1977.

Who Will Know Us? New Poems. San Francisco: Chronicle Books, 1990.
Williamson, Alan. *Introspection and Contemporary Poetry*. Cambridge, Mass.: Harvard University Press, 1984.

MICHAEL HERR

Primary sources

Dispatches. New York: Knopf, 1977.
Apocalypse Now. Narration, with Francis Ford Coppola and John Milius, Zoetrope Studios, 1979.
The Big Room. With Guy Peellaert. New York: Summit Books, 1986.
Full Metal Jacket. Screenplay, with Stanley Kubrick and Gustav Hasford. New York: Knopf, 1987.
Walter Winchell. New York: Knopf, 1990.

Secondary sources

Balaban, John. *After Our War*. Pittsburgh: University of Pittsburgh Press, 1974.
Baritz, Loren. *Backfire*. New York: Morrow, 1985.
Beidler, Philip D. *American Literature and the Experience of Vietnam*. Athens: University of Georgia Press, 1982.
 Re-Writing America: Vietnam Authors in their Generation. Athens: University of Georgia Press, 1991.
Bryan, C. D. B. "Barely Suppressed Screams: Getting a Bead on Vietnam War Literature." *Harper's*. June 1984. 268:67–72.
 Friendly Fire. New York: Putnam, 1976.
Caputo, Philip. *A Rumor of War*. New York: Holt, Rinehart & Winston, 1980.
Cohen, Stephen, ed. *Vietnam: Anthology and Guide to a Television History*. New York: Knopf, 1983.
Conrad, Joseph. *Heart of Darkness*. 1899; rpt. New York: Norton, 1972.
 The Nigger of the Narcissus. 1898; rpt. New York: Norton, 1979.
Del Vecchio, John. *The 13th Valley*. New York: Bantam, 1982.
Ehrhart, W. D., ed. *Carrying the Darkness: American Indochina – the Poetry of the Vietnam War*. New York: Avon, 1985.
 Unaccustomed Mercy: Soldier-Poets of the Vietnam War. Lubbock: Texas Tech University Press, 1989.
Emerson, Gloria. *Winners and Losers: Battles, Retreats, Gains, Losses, and Wins from a Long War*. New York: Harcourt Brace, 1976.
Fallows, James. "What Did You Do in the Class War, Daddy?" *The Washington Monthly*. February 1975. 8:29–36.
Fitzgerald, Frances. *Fire in the Lake*. Boston: Little, Brown, 1972.
Fussell, Paul. *The Great War and Modern Memory*. New York: Oxford University Press, 1975.
Glasser, Ronald. *365 Days*. New York: Braziller, 1971.
Greene, Graham. *The Quiet American*. New York: Viking, 1956.

Halberstam, David. *The Best and the Brightest.* New York: Random House, 1972.

Hasford, Gustav. *The Short-Timers.* New York: Harper & Row, 1979.

Heinemann, Larry. *Paco's Story.* New York: Farrar, Straus & Giroux, 1986.

Herring, George G. *America's Longest War: The United States in Vietnam, 1950–1975.* New York: Wiley, 1979.

Jeffords, Susan. *The Remasculinization of America: Gender and the Vietnam War.* Bloomington: Indiana University Press, 1989.

Karnow, Stanley. *Vietnam: A History.* New York: Viking, 1983.

Kovic, Ron. *Born on the Fourth of July.* New York: McGraw-Hill, 1976.

Lang, Daniel. *Casualties of War.* New York: Atlantic Monthly Press, 1988.

Lomperis, Timothy. *Reading the Wind: The Literature of the Vietnam War.* Durham, N.C.: Duke University Press, 1987.

Mailer, Norman. *Why Are We in Vietnam?* New York: Putnam, 1967.

Mason, Bobbie Ann. *In Country.* New York: Harper & Row, 1985.

Mason, Robert. *Chicken Hawk.* New York: Viking, 1983.

Myers, Thomas. *Walking Point: American Narratives of Vietnam.* New York: Oxford University Press, 1988.

O'Brien, Tim. *Going After Cacciato.* New York: Delacorte Press/Seymour Lawrence, 1978.

 If I Die in a Combat Zone. 1973; rev. ed. New York: Dell, 1979.

 The Things They Carried. New York: Houghton Mifflin/Seymour Lawrence, 1990.

Schaeffer, Susan Fromberg. *Buffalo Afternoon.* New York: Knopf, 1989.

Schell, Jonathan. *The Real War: The Classic Reporting on the Vietnam War.* New York: Pantheon, 1987.

Sheehan, Neil. *A Bright Shining Lie: John Paul Vann and America in Vietnam.* New York: Random House, 1988.

Stone, Robert. *Dog Soldiers.* Boston: Houghton Mifflin, 1973.

Taylor, Gordon O. *Chapters of Experience: Studies in 20th Century American Autobiography.* New York: St. Martin's Press, 1983.

Thompson, Hunter, with Ralph Steadman. *Fear and Loathing in Las Vegas.* New York: Popular Library, 1971.

Van Devanter, Lynda. *Home Before Morning: The Story of an Army Nurse in Vietnam.* New York: Beaufort Books, 1983.

Webb, James. *Fields of Fire.* Englewood Cliffs, N.J.: Prentice-Hall, 1978.

Weigl, Bruce. *Song of Napalm.* New York: Atlantic Monthly Press, 1988.

Wheeler, John. *Touched with Fire: The Future of the Vietnam Generation.* New York: Franklin Watts, 1984.

Wolfe, Tom. *The New Journalism.* New York: Harper & Row, 1973.

Wright, Stephen. *Meditations in Green.* New York: Scribner's, 1983.

Index

CAMBRIDGE STUDIES IN AMERICAN LITERATURE AND CULTURE

Continued from the front of the book